THE BEST OF
BROCHURE DESIGN

WILSON HARVEY. LONDON

ROCKPORT

CORPORATE BROCHURES

ANNUAL REPORTS

PRODUCT AND SERVICE BROCHURES

NON-PROFIT, EDUCATIONAL, INSTITUTIONAL, AND HEALTHCARE BROCHURES

SELF-PROMOTIONAL BROCHURES

ARTS, ENTERTAINMENT, AND EVENT BROCHURES

GLOUCESTER MASSACHUSETTS

ROCKPORT
PUBLISHERS

THE BEST OF
BROCHURE
DESIGN 07

WILSON HARVEY: LONDON

FIRST PUBLISHED IN THE UNITED STATES OF AMERICA BY
ROCKPORT PUBLISHERS, INC. 33 COMMERCIAL STREET,
GLOUCESTER, MASSACHUSETTS 01930-5089 TELEPHONE
(978) 282-9590 FAX (978) 283-2742 WWW.ROCKPUB.COM

ISBN 1-56496-960-0

10 9 8 7 6 5 4

DESIGNED AT WILSON HARVEY, LONDON (+44 (0)20 7420 7700)

COVER IMAGE. FRANK USHER SPRING 2002 BY APPETITE.
PHOTOGRAPHER ANDY CAMERON.CO.UK BY KIND
PERMISSION. PERIVAN WHITE DOVE WWW.PERIVAN.CO.UK

PRINTED IN CHINA

CONTENTS

INTRODUCTION

IT IS HARD TO DEFINE EXACTLY WHAT MAKES A REALLY GREAT
BROCHURE, BUT IF THERE IS ONE COMMON THREAD ACROSS ALL THE
WORK IN THIS EXTRAORDINARY REVIEW, IT IS SIMPLY THE PASSION. //
EACH AND EVERY PIECE PRESENTED HERE IS FILLED WITH THE HEART
AND SOUL OF A TRULY PASSIONATE DESIGNER AND PROVIDES AN
INSPIRATION TO EVERYONE WITH AN INTEREST IN DESIGN.

FOR A MOMENT IT LOOKED AS IF BROCHURES WOULD BE WIPED AWAY FOREVER BY THE EXCITEMENT OF THE NEW MEDIA BANDWAGON. BUT JUDGING BY THE INCREDIBLE QUALITY AND QUANTITY OF WORK WE'VE RECEIVED FOR THIS REVIEW, IT SEEMS WE WERE WRONG—THE BROCHURE IS HERE TO STAY.

SO WHAT IS IT ABOUT BROCHURES THAT'S SO SPECIAL? WHY DEDICATE A WHOLE BOOK TO THEM? BROCHURES HAVE AN INDESCRIBABLE POWER: THEY CAN OPEN DOORS, THEY CAN PERSUADE, THEY CAN SELL. A BROCHURE CAN TELL A STORY FOR YOU, IT CAN CHANGE PERCEPTIONS, IT CAN EVEN LIE FOR YOU. IT IS AN EXTREMELY VALUABLE ASSET AND, WHEN USED CORRECTLY, CAN BE A POWERFUL COMMUNICATION TOOL.

BUT WHAT MAKES A GOOD BROCHURE? AND WHAT MAKES A BAD ONE? DESIGN PREACHING (MINE AT LEAST) FOCUSES ON EXCELLENCE IN TERMS OF COMMUNICATION, INFORMATION HANDLING, APPROPRIATENESS, AND EFFECTIVENESS. THIS BOOK IS A REFRESHING LOOK AT WHAT WE AS DESIGNERS BELIEVE IS GOOD AND WHAT THE VISUALLY TRAINED EYE RECOGNIZES AS EXCEPTIONAL WORK. IT IS NOT NECESSARILY WHAT SOLD THE MOST PRODUCTS OR WHAT CREATED THE GREATEST BUZZ IN THE BOARD ROOM. BECAUSE OF THE QUALITY AND CONFIDENCE OF THE WORK, I HAVE LITTLE DOUBT THAT ALL THE WORK SURPASSED CLIENT EXPECTATIONS AND WORKED AS HIGHLY EFFECTIVE MARKETING TOOLS.

DESIGNING AND PRODUCING A BROCHURE IS AN EXTREMELY EMOTIONAL EXPERIENCE—EVERY CLIENT IS DIFFERENT AND EVERY BRIEF HAS ITS OWN CHALLENGES, BUT RECEIVING A BROCHURE SHOULD BE JUST AS EMOTIONAL. THE RECIPIENT SHOULD FEEL TANTALIZED BY THE PIECE, THEY SHOULD WANT TO TURN THE PAGE, THEY SHOULD BE SEDUCED BY IT. THIS BOOK IS A CELEBRATION OF SOME OF THAT WORK—WORK THAT MAKES YOU SIT UP AND TAKE NOTICE, WORK THAT EVOKES A REACTION, GOOD OR BAD, WORK THAT SLAPS YOU ROUND THE FACE, OR WORK THAT IS SIMPLY A CREDIT TO THE CLIENT FOR BREAKING THE MOLD AND LETTING IT HAPPEN.

IN COMPILING THIS VALUABLE RESOURCE, WE'VE TALKED WITH DESIGNERS ALL OVER THE WORLD, ALL WITH ONE COMMON PASSION—GOOD DESIGN. IT IS AN HONOR TO SHARE THEIR PASSION WITH YOU. OUR GRATITUDE GOES TO EVERYONE WHO GENEROUSLY SUBMITTED WORK. I'M ONLY SORRY WE COULDN'T SHOW IT ALL.

PAUL BURGESS AND THE TEAM AT WILSON HARVEY

208:WH
THE BEST OF BROCHURE DESIGN 07
WILSONHARVEY: LONDON

ARTWORKER:
PETE USHER

DESIGNERS:
PAUL BURGESS
WAI LAU
BEN WOOD
GRAHAM FARR
DAN ELLIOTT

JUDGES:
PAUL BURGESS
DAN ELLIOTT
WAI LAU
GRAHAM FARR
BEN WOOD

ART DIRECTOR:
PAUL BURGESS

CORPORATE BROCHURES

INTERBRAND // PINKHAUS // RADFORD WALLIS // KO CRÉATION // HAND MADE GROUP //
SALTERBAXTER // EMERY VINCENT DESIGN // LAVA GRAPHIC DESIGNERS // POULIN + MORRIS //
FORM // ROSE DESIGN ASSOCIATES // ATTIK // HORNALL ANDERSON DESIGN WORKS //
GRAPHICULTURE // DESIGN ASYLUM // NB:STUDIO // FABIO ONGARATO DESIGN //
CAMPAÑEROS // THIRTEEN DESIGN // BOSTOCK & POLLITT

:01

Breaking boundaries
Business law for
the real world

2002

Highway 407
Toronto Canada

ART DIRECTOR:
INTERBRAND

DESIGNER:
ZOE SCUTTS

PHOTOGRAPHER:
INTERBRAND

CLIENT:
UNICREDIT

SOFTWARE AND
HARDWARE:
PHOTOSHOP
QUARK
MAC G4

PRINTING:
ITALY

UK

>Una nuova banca…Un modo
diverso di guardare i mercati…
Uno sguardo oltre le prime
impressioni…Think again

The power behind
European finance

UniCredit Banca Mobiliare

001
INTERBRAND
UBM BROCHURE

Soon, most business-to-business commerce will take place in e-marketplaces on the Internet, yet few businesses are able to complete transactions online, even fewer have their business processes integrated, and practically none have an e-business strategy.

Despite these facts, e-business is booming. And if your company plans to be around in the next decade it will be eagerly embracing e-business too. Of course, it's not something you want to do simply because everybody else seems to be doing it. You want to do e-business because it can give your company a genuine edge.

And that's where Sterling Commerce comes in

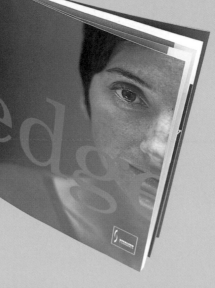

USA

ART DIRECTOR:	DESIGNER:	PRODUCTION	COPYWRITER:	CLIENT:	SOFTWARE AND	MATERIALS:	PRINTING:
CHRISTOPHER VICE	RAELENE MERCER	MANAGER:	FRANK	STERLING	HARDWARE:	MCCOY SILK +	GEORGE RICE &
		SUZANNE	CUNNINGHAM	COMMERCE	QUARKXPRESS	MOHAWK	SONS, CALIFORNIA
		BERNSTEIN			MAC	SUPERFINE	
						SMOOTH	

our knowledge is your edge

STERLING COMMERCE

One thing is for sure, you can't do it all from headquarters. You need help on the ground in your major markets around the world.

When you sell on the Internet, your market is global by definition. That's great, but how do you make it work?

So you saved 18% on 6,000 tons of copper in an online reverse auction. Now what?

Well, your savings are not just limited to finding lower cost goods. The real reason more and more of your purchasing and selling is going to shift to the Internet is that the payback is immediate. Doing business online is a concrete way to lower procurement costs, streamline your supply chain, broaden your selling channels and shorten your time to market.

But all these efficiencies don't just happen automatically. Online transactions have to be linked to outside shippers and financial institutions and to your own internal back-end systems.

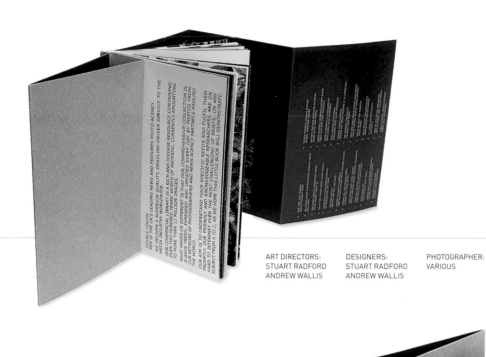

UK

ART DIRECTORS:
STUART RADFORD
ANDREW WALLIS

DESIGNERS:
STUART RADFORD
ANDREW WALLIS

PHOTOGRAPHER:
VARIOUS

CLIENT:
REX FEATURES

SOFTWARE:
QUARKXPRESS

MATERIALS:
CAIRN MULTI
BOARD 350GSM
GALERIE SILK
170GSM

PRINTING:
CTD CAPITA

003

RADFORD WALLIS
REX FEATURES

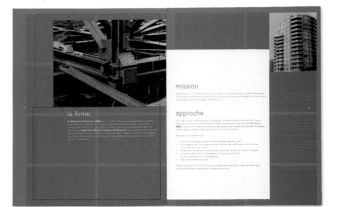

D.D'Aronco & Associés inc._
Ingénieurs-conseils

004

KO CRÉATION
D D'ARONCO & ASSOCIÉS
SELF-PROMO

ART DIRECTOR:
KO CRÉATION

DESIGNERS:
ANNIE LACHAPELLE
DENIS DULUDE

CLIENT:
D D'ARONCO &
ASSOCIÉS INC

SOFTWARE:
PHOTOSHOP
QUARKXPRESS

ART DIRECTOR:	DESIGNER:	PHOTOGRAPHER:	CLIENT:	SOFTWARE AND	MATERIALS:	PRINTING
ALESSANDRO	GIONA MAIARELLI	ALESSANDRO	LANIFICIO DEL	HARDWARE:	FEDRIGONI	OFFSET
ESTERI		ESTERI	CASENTINO	QUARK		
				MAC		

005
HAND MADE GROUP
LANIFICIO DEL CASENTINO
CORPORATE PROFILE

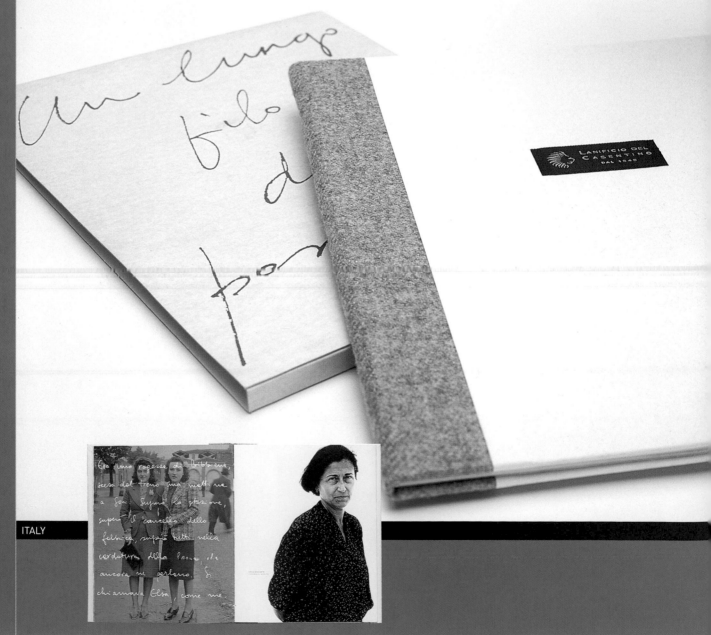

ITALY

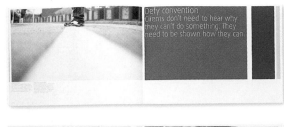

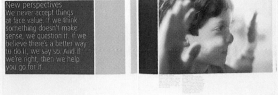

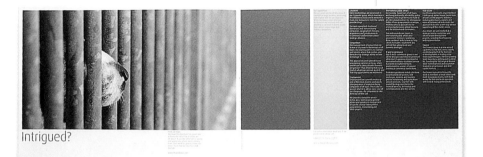

Intrigued?

ART DIRECTOR:
PENNY BAXTER

DESIGNER:
ANDREA CAREY

CLIENT:
TITE & LEWIS

SOFTWARE AND
HARDWARE:
QUARKXPRESS
MACINTOSH

MATERIALS:
MONADNOCK
ASTROLITE

PRINTING:
LITHO

UK

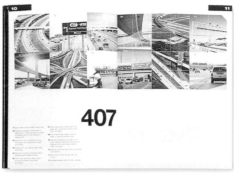

407

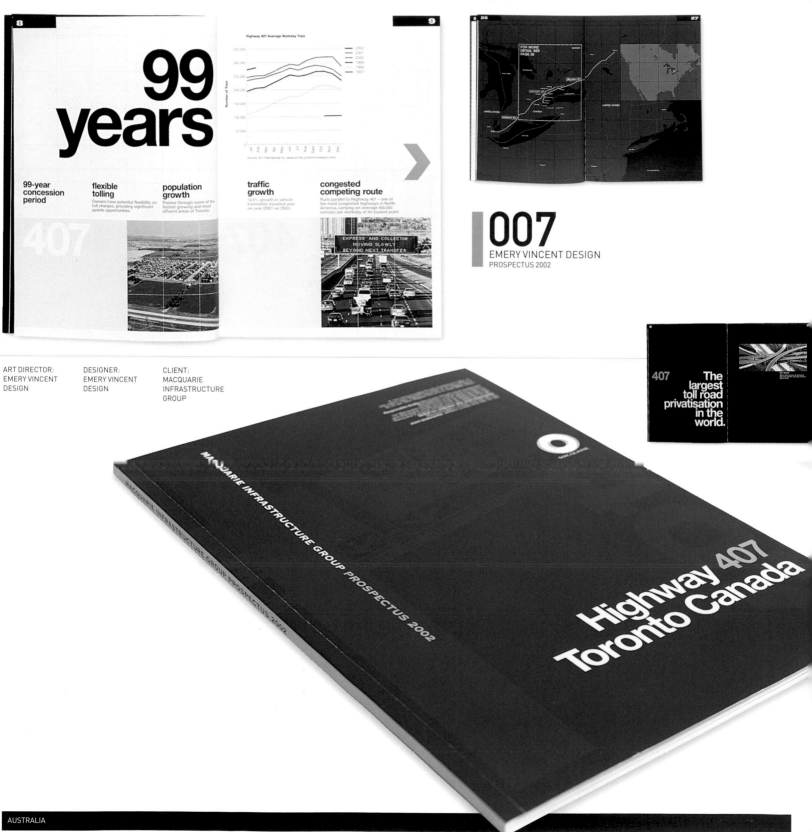

99 years

Highway 407 Average Workday Trips

99-year concession period

flexible tolling
Owners have potential flexibility on toll charges, providing significant upside opportunities.

population growth
Passes through some of the fastest growing and most affluent areas of Toronto.

traffic growth
12.8% growth in vehicle kilometres travelled year on year (2001 on 2000).

congested competing route
Runs parallel to Highway 401 – one of the most congested highways in North America, carrying on average 400,000 vehicles per workday at its busiest point.

007
EMERY VINCENT DESIGN
PROSPECTUS 2002

ART DIRECTOR:
EMERY VINCENT DESIGN

DESIGNER:
EMERY VINCENT DESIGN

CLIENT:
MACQUARIE INFRASTRUCTURE GROUP

407 The largest toll road privatisation in the world.

MACQUARIE INFRASTRUCTURE GROUP PROSPECTUS 2002

Highway 407 Toronto Canada

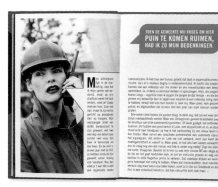

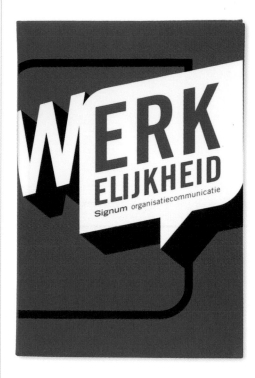

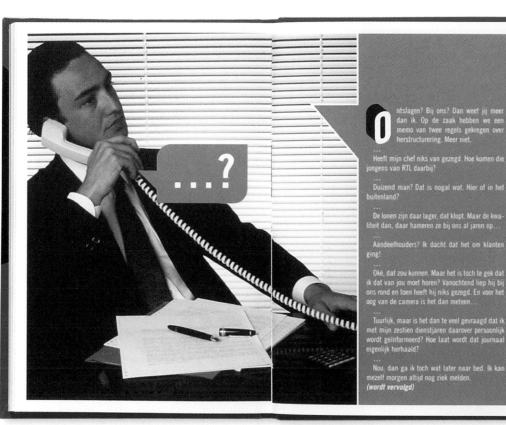

008
LAVA GRAPHIC DESIGNERS
WERKELIJKHEID (REALITY)

ART DIRECTOR:
YKE BARTELS

DESIGNERS:
YKE BARTELS
DAAN JANSSENS

PHOTOGRAPHER:
ROYALTY-FREE
STOCK PHOTOS

CLIENT:
SIGNUM

SOFTWARE AND
HARDWARE:
ILLUSTRATOR
QUARKXPRESS
MAC G4

MATERIALS:
CHRONOLUX

PRINTING:
RIJSER

THE NETHERLANDS

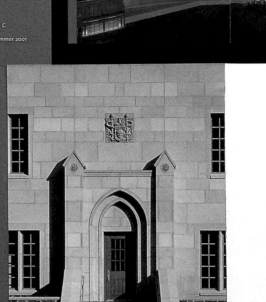

DUKE CLINIC
Summer 2001

DUKE CLINIC
Summer 2001

DETAIL VIEW OF
SOUTH ENTRANCE FROM THE GARDEN

009
POULIN + MORRIS
DUKE CLINIC
COMMEMORATIVE BOOK

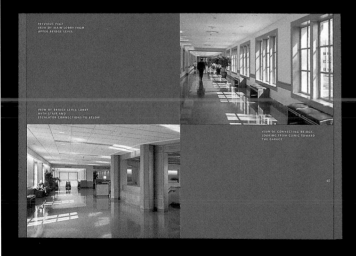

PREVIOUS PAGE
VIEW OF MAIN LOBBY FROM
UPPER BRIDGE LEVEL

VIEW OF BRIDGE LEVEL LOBBY
WITH STAIR AND
ESCALATOR CONNECTIONS TO BELOW

VIEW OF CONNECTING BRIDGE,
LOOKING FROM CLINIC TOWARD
THE GARAGE

USA

ART DIRECTOR:	DESIGNER:	CLIENT:	SOFTWARE:	MATERIALS:	PRINTING:
L. RICHARD POULIN	L. RICHARD POULIN	DUKE UNIVERSITY MEDICAL CENTER	QUARKXPRESS	SAPPI LUSTRO	HUTCHINSON ALLGOOD

"The new clinics are a marked improvement over the space we used to work in. They've allowed us to accommodate our patients better, and from a functional standpoint they just make more sense.

Rex McCallum, MD - Rheumatologist, physician liaison, Clinic renovation project

Pictured in the rheumatology clinic, which adjoins the endocrine/renal clinic.
The design allows the services to share space as needed, and makes it easier for caregivers to collaborate.

ART DIRECTORS:
PAULA BENSON
PAUL WEST

DESIGNERS:
TOM CRABTREE
CHRIS HILTON

CLIENT:
MTV

SOFTWARE:
FREEHAND
PHOTOSHOP
QUARKXPRESS

MATERIALS:
PAPER AND BOARD

PRINTING:
FOIL BLOCKED
COVER, 4-COLOR
LITHO + SPOT
VARNISH

UK

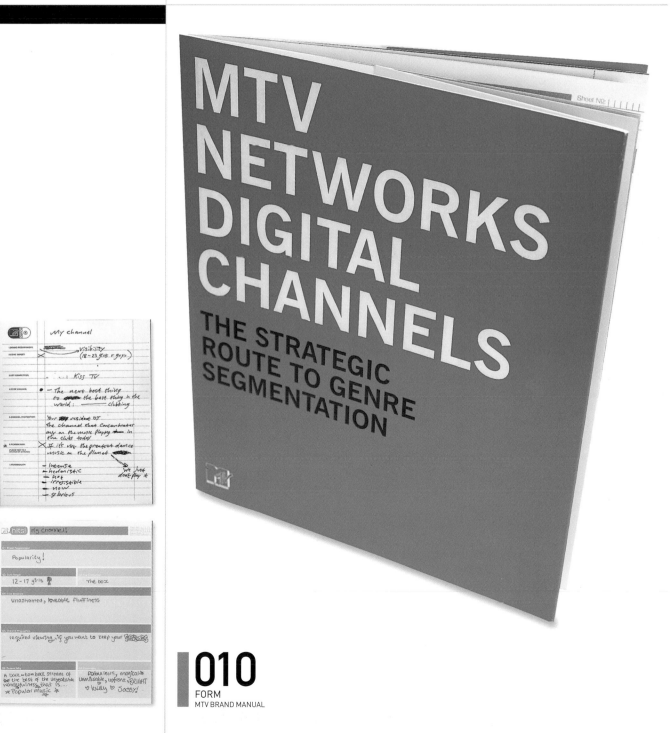

010

FORM
MTV BRAND MANUAL

TENDENZE PRIMAVERA-ESTATE 1999/SPRING-SUMMER 1999 TRENDS

Una stagione dedicata alle seduzioni tattili
A season dedicated to tactil seductions

BY ANGELO UBLENGHI

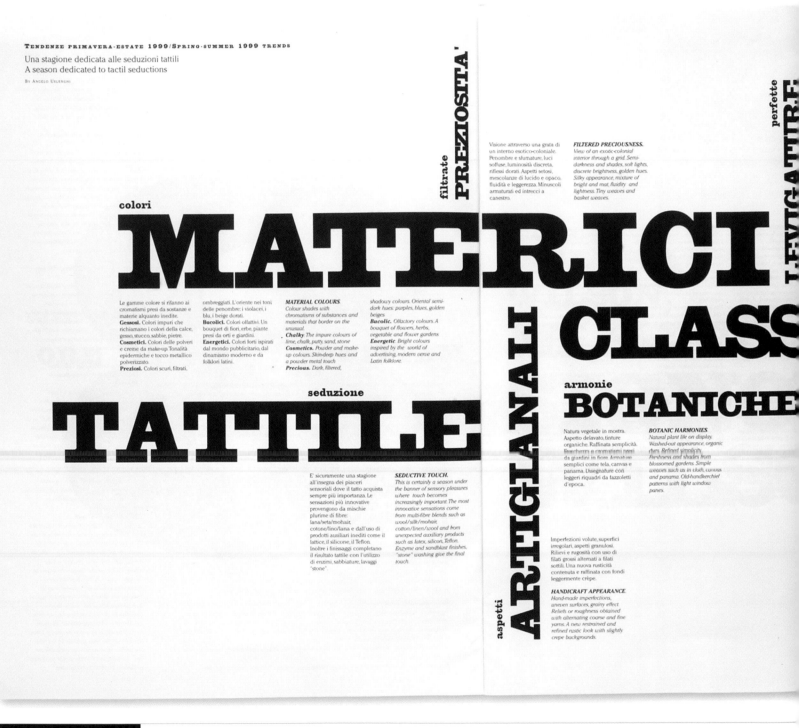

colori

filtrate PREZIOSITÀ

Visione attraverso una grata di un interno esotico-coloniale. Penombre e sfumature, luci soffuse, luminosità discreta, riflessi dorati. Aspetti setosi, mescolanze di lucido e opaco, fluidità e leggerezza. Minuscoli armaturati ed intrecci a canestro.

FILTERED PRECIOUSNESS.
View of an exotic-colonial interior through a grid. Semi-darkness and shades, soft lights, discrete brightness, golden hues. Silky appearance, mixture of bright and mat, fluidity and lightness. Tiny weaves and basket weaves.

perfette LEVIGATURE

MATERICI

Le gamme colore si rifanno ai cromatismi presi da sostanze e materie alquanto inedite.
Gessosi. Colori impuri che richiamano i colori della calce, gesso, stucco, sabbie, pietre.
Cosmetici. Colori delle polveri e creme da make-up. Tonalità epidermiche e tocco metallico polverizzato.
Preziosi. Colori scuri, filtrati,

ombreggiati. L'oriente nei toni delle penombre: i violacei, i blu, i beige dorati.
Bucolici. Colori olfattivi. Un bouquet di fiori, erbe, piante presi da orti e giardini.
Energetici. Colori forti ispirati dal mondo pubblicitario, dal dinamismo moderno e da folklori latini.

MATERIAL COLOURS.
Colour shades with chromatisms of substances and materials that border on the unusual.
Chalky. *The impure colours of lime, chalk, putty, sand, stone*
Cosmetics. *Powder and make-up colours. Skin-deep hues and a powder metal touch*
Precious. *Dark, filtered,*

shadowy colours. Oriental semi-dark hues: purples, blues, golden beiges
Bucolic. *Olfactory colours. A bouquet of flowers, herbs, vegetable and flower gardens*
Energetic. *Bright colours inspired by the world of advertising, modern verve and Latin folklore.*

CLASS

armonie

seduzione

TATTILE

ARTIGIANALI

BOTANICHE

E' sicuramente una stagione all'insegna dei piaceri sensoriali dove il tatto acquista sempre più importanza. Le sensazioni più innovative provengono da mischie plurime di fibre: lana/seta/mohair, cotone/lino/lana e dall'uso di prodotti ausiliari inediti come il lattice, il silicone, il Teflon. Inoltre i finissaggi completano il risultato tattile con l'utilizzo di enzimi, sabbiature, lavaggi "stone".

SEDUCTIVE TOUCH.
This is certainly a season under the banner of sensory pleasures where touch becomes increasingly important. The most innovative sensations come from multi-fibre blends such as wool/silk/mohair, cotton/linen/wool and from unexpected auxiliary products such as latex, silicon, Teflon. Enzyme and sandblast finishes, "stone" washing give the final touch.

Natura vegetale in mostra. Aspetto delavato, tinture organiche. Raffinata semplicità, filancheria e cromatismi presi da giardini in fiore. Armature semplici come tela, canvas e panama. Disegnature con leggeri riquadri da fazzoletti d'epoca.

BOTANIC HARMONIES.
Natural plant life on display. Washed-out appearance, organic dyes. Refined simplicity. Freshness and shades from blossomed gardens. Simple weaves such as in cloth, canvas and panama. Old-handkerchief patterns with light window panes.

aspetti

Imperfezioni volute, superfici irregolari, aspetti granulosi. Rilievi e rugosità con uso di filati grossi alternati a filati sottili. Una nuova rusticità contenuta e raffinata con fondi leggermente crêpe.

HANDICRAFT APPEARANCE.
Hand-made imperfections, uneven surfaces, grainy effect. Reliefs or roughness obtained with alternating coarse and fine yarns. A new restrained and refined rustic look with slightly crepe backgrounds.

ITALY

ART DIRECTOR:	DESIGNER:	CLIENT:	SOFTWARE AND HARDWARE:	MATERIALS:	PRINTING:
ALESSANDRO ESTERI	GIONA MAIARELLI	LANIFICIO DEL CASENTINO	QUARKXPRESS MAC	FEDRIGONI	OFFSET

CI

rivisitati

Basic modernizzato.
Ritorno a tipologie tradizionali
re-interpretate. Disegnature
spesso in bianco e nero ma
con interventi tecnologici.

CLASSICS REVISITED.
Modern basics. Traditional
reinterpretations return. Frequent
black and white motifs with
technological additions.

ORE **8** DEL MATTINO:

011

HAND MADE GROUP
LANIFICIO DEL CASENTINO NEWS

PRONTO
SIGNORA
WILSON,
MI SENTE
SIGNORA
WILSON?

News

Our second issue One hundred and fifty
years Anniversary The market at the
millenium's end Trends for Spring Summer
'99 The new collection at Prato Expo
Vogue Tessuti on Lanificio del Casentino
Oliviero Toscani on Utopia and other
projects Interviews. And more…

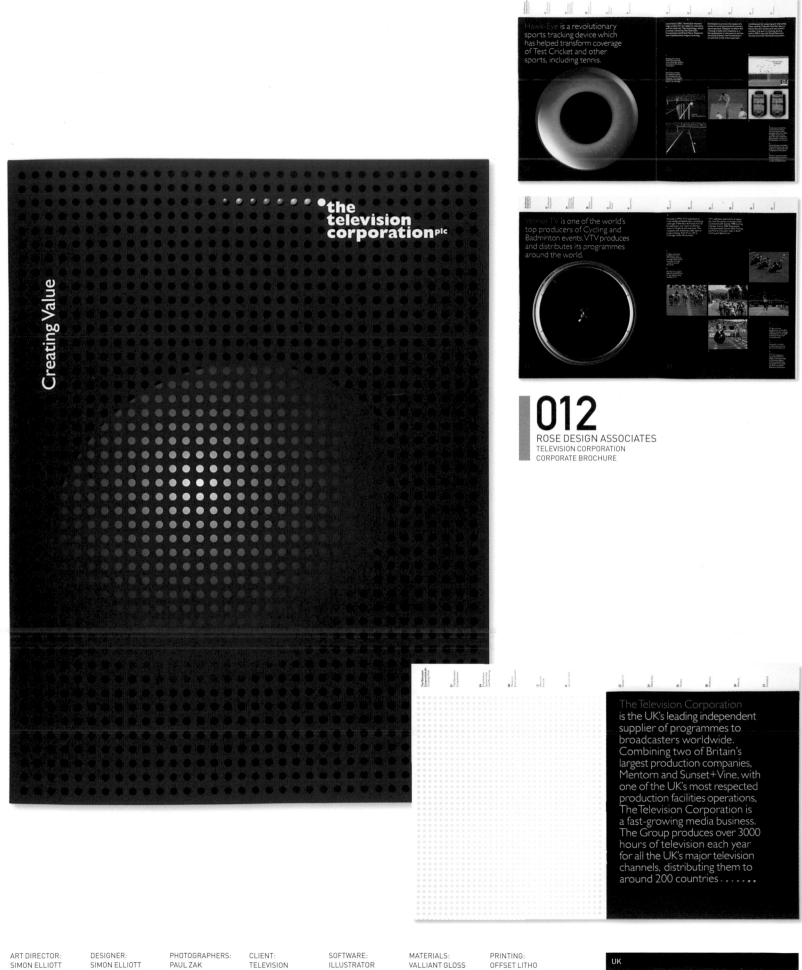

Hawk-Eye is a revolutionary
sports tracking device which
has helped transform coverage
of Test Cricket and other
sports, including tennis.

Venner TV is one of the world's
top producers of Cycling and
Badminton events. VTV produces
and distributes its programmes
around the world.

012

ROSE DESIGN ASSOCIATES
TELEVISION CORPORATION
CORPORATE BROCHURE

the
television
corporation plc

Creating Value

The Television Corporation
is the UK's leading independent
supplier of programmes to
broadcasters worldwide.
Combining two of Britain's
largest production companies,
Mentorn and Sunset+Vine, with
one of the UK's most respected
production facilities operations,
The Television Corporation is
a fast-growing media business.
The Group produces over 3000
hours of television each year
for all the UK's major television
channels, distributing them to
around 200 countries

ART DIRECTOR:	DESIGNER:	PHOTOGRAPHERS:	CLIENT:	SOFTWARE:	MATERIALS:	PRINTING:
SIMON ELLIOTT	SIMON ELLIOTT	PAUL ZAK	TELEVISION	ILLUSTRATOR	VALLIANT GLOSS	OFFSET LITHO
		LOL KEEGAN	CORPORATION PLC	PHOTOSHOP	ART	
				QUARKXPRESS		

UK

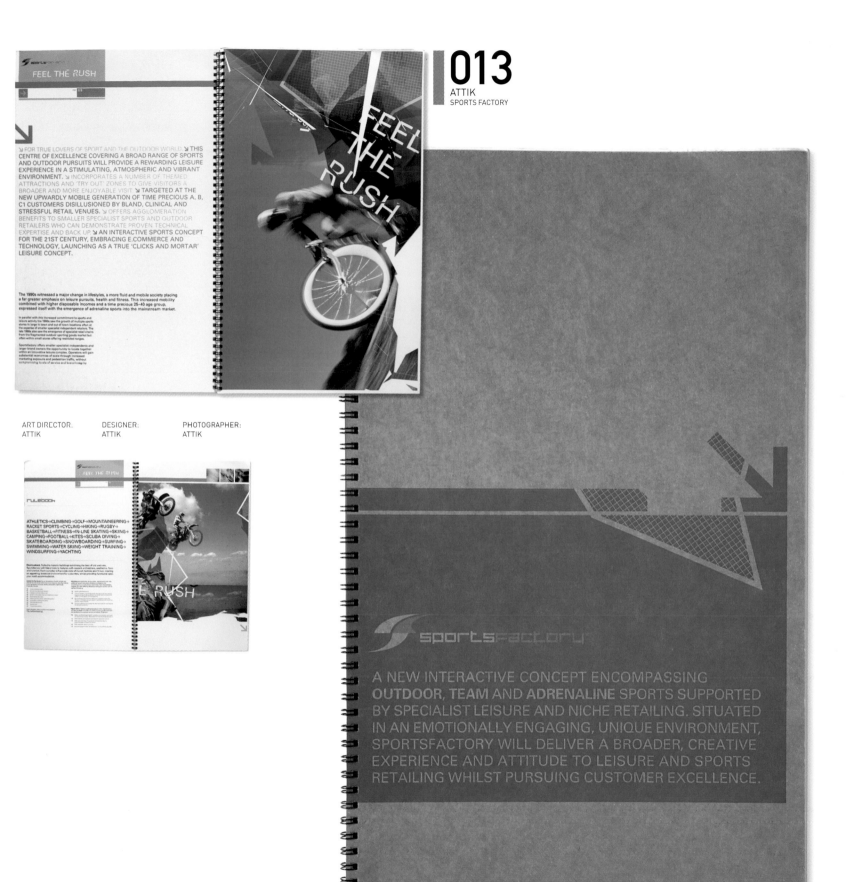

013

ATTIK
SPORTS FACTORY

ART DIRECTOR.
ATTIK

DESIGNER:
ATTIK

PHOTOGRAPHER:
ATTIK

ART DIRECTORS:
JACK ANDERSON
LARRY ANDERSON

DESIGNERS:
LARRY ANDERSON
BELINDA BOWLING
HOLLY CRAVEN
JAMES TEE
MICHAEL BRUGMAN

PHOTOGRAPHER:
ABRAMS
LACAGNINA STUDIO

CLIENT:
NOVELL INC

SOFTWARE:
QUARKXPRESS

MATERIALS:
COUGAR OPAQUE

PRINTING:
MACDONALD
PRINTING,
VANCOUVER

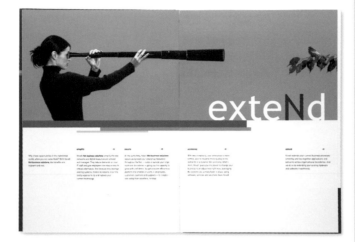

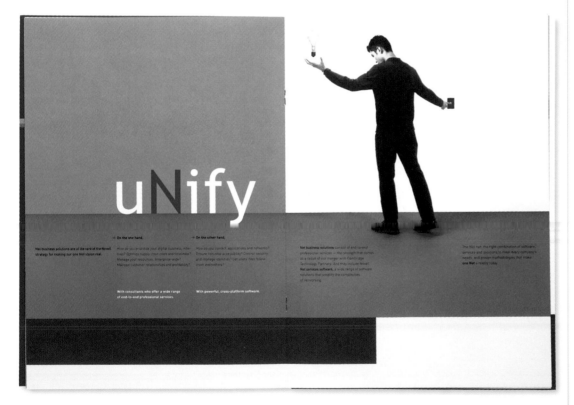

014

HORNALL ANDERSON
DESIGN WORKS
NOVELL 2002 CORPORATE BROCHURE

USA

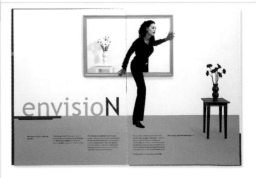

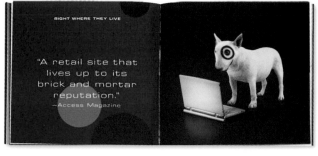

RIGHT WHERE THEY LIVE

"A retail site that lives up to its brick and mortar reputation."
—Access Magazine

SPOT ON

Nobody clicks past a Target TV spot. Our campaigns have been consistent hits on the small screen. Featuring product and target style in unique and innovative ways: Fine-tuned creative, unexpectedly great soundtracks and topflight production all combine with merchandise that exceeds expectations. Just watch the results.

ART DIRECTOR:
CHERYL WATSON

DESIGNERS:
CHERYL WATSON
SHARON McKENDRY

CLIENT:
TARGET

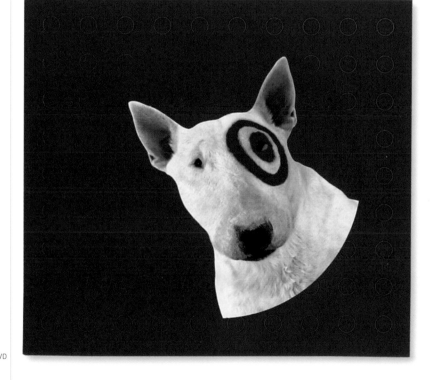

015
GRAPHICULTURE
TARGET BRAND BOOK & DVD

USA

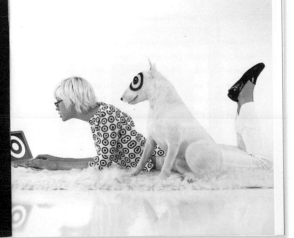

TARGET.COM HITS THE DOT

Target is a bona fide power in e-commerce. Nielsen NetRatings consistently rank target.com among the top twenty retail sites for total monthly unique visitors.* And we consistently rank in the top five among unique visitors at home and at work, outpacing our competitors' shopping sites.

*Unique visitors are calculated monthly. One unique visitor is defined as one individual who visits a Web site during the month, regardless of the number of visits.

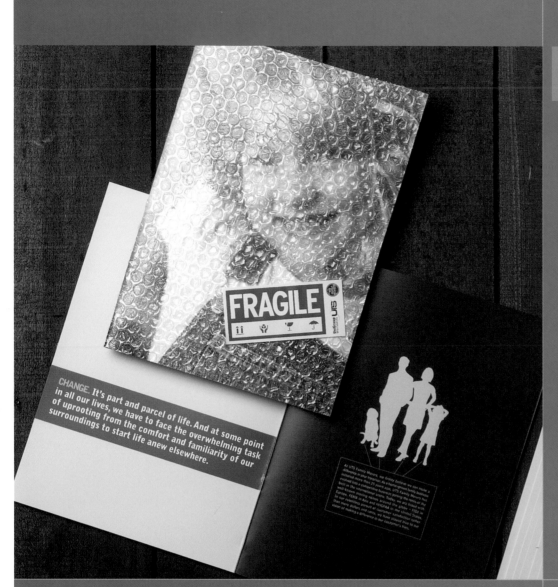

ART DIRECTOR:	DESIGNER:	CLIENT:	SOFTWARE:	MATERIALS:	PRINTING:
CHRISTOPHER LEE	KAI	UTS FAMILY MOVERS	FREEHAND PHOTOSHOP	MATT ARTPAPER	4C X 4C

SINGAPORE

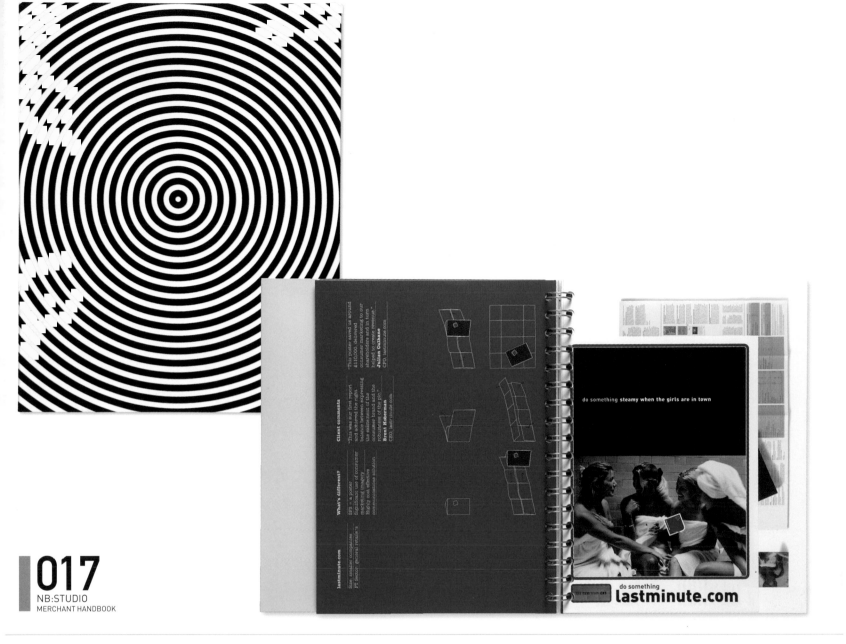

017
NB:STUDIO
MERCHANT HANDBOOK

ART DIRECTORS:
ALAN DYE
NICK FINNEY
BEN STOTT

DESIGNER:
NICK FINNEY

PHOTOGRAPHER:
NICK FINNEY

CLIENT:
MERCHANT

SOFTWARE AND
HARDWARE:
ILLUSTRATOR
PHOTOSHOP
QUARKXPRESS
SONY DIGITAL
CAMERA

MATERIALS:
IMAGINE 325/220GSM
NEW TAFFETA 280GSM
HELLO GLOSS 150GSM
KASKARD SPARROW
GREY 225GSM
XPOSE CLEAR 285GSM

PRINTING:
THE BEACON PRESS

UK

ART DIRECTOR:
FABIO ONGARATO

DESIGNERS:
STEFAN PIETSCH
YARRA LAURIE

CLIENT:
ELENBERG FRASER

MATERIALS:
PARILUX

PRINTING:
COLORCRAFT

ELENBERG FRASER

ARCHITECTURE
334 GEORGE STREET FITZROY MELBOURNE VICTORIA 3065
AUSTRALIA
TEL +61 3 9417 2855 FAX +61 3 9417 2866
MAILBOX-E@ELENBERGFRASER.COM.AU WWW.E-F.COM.AU

0205 Collins Hotel *Commercial development proposal, Melbourne Docklands 2002*
0204 Lion Headland *New house, Yaalong 2002-2004*
0205 Springvale Road *Office & distribution centre, Mulgrave 2002*
0202 Move-In *Commercial showroom, Melbourne 2002*
0201 Collins Gardens *Commercial development proposal, Melbourne Docklands 2002*
0102 Melbourne Foundation *Gallery structure, Melbourne 2001*
0101 Nixon House *House refurbishment & artists studio, Eltham 2001-2002*
0024 Kookai *New store fit out, Richmond 2001*
0025 Kookai *New store fit out, Chadstone 2001-2002*
0022 Watergate Place *Residential + commercial development, Melbourne Docklands 2001-2004*
0021 George & Argyle *New offices & showroom, Fitzroy 2001-2002*
0020 Kookai *New store fit out Castle Towers, Sydney 2001*
0019 Kookai *New store fit out (W.R. Sydney 2001*
0018 D24 *Commercial development, speculative proposal, Melbourne 2001*
0017 Sydney Town Hall *Competition entry, Sydney 2000*
0016 Theosophical Apartment *Penthouse apartment, Melbourne 2000*
0015 Webb Dock Bridge *Invited competition (short listed entry), Melbourne Docklands 2000*
0014 Hanover Foundation *Invited ideas competition, Melbourne 2000*
0013 Schwartz Beach House *House Refurbishment & Landscaping, Yaalong 2000*
0012 St Andrews Beach House *St Andrews Beach, Rye 2000*
0011 North East Stadium Precinct *Competition (winning entry), Melbourne Docklands 2000*
0010 Batman's Hill Precinct *Various sites, current shortlist, Melbourne Docklands 2000*
0009 Cheltenham *Warehouse refurbishment, Cheltenham 2000*
0008 Portsea Beach Apartments *Apartment planning proposal, Portsea 2000*
0005 Collins Street Lofts *Competition (short listed entry), Melbourne 2000*
9915 Queen Victoria Site *Competition (short listed entry), Melbourne 1999*
9911 TKTS2K *Ticket booth design competition, New York 1999*
9910 Hawthorn Tram Depot *Competition (short listed entry), Hawthorn 1999*
9909 Munro House *Extension and renovation, Hawthorn 1999-2002*
9908 International Dynamics *Office & warehousing, Richmond 1999-2000*
9907 Café-Hotel *Apartment conversion, North Melbourne 1999*
9906 Liberty Display Suite *Interiors prototype, Melbourne 1999*
9905 Apartment 1202 *Apartment fitout proposal, Melbourne 1999*
9904 Icon III *Office conversion, Richmond 1999*
9905 Icon II *Warehouse apartments, Richmond 1999*
9902 Museum of Modern Art at Heide *Competition entry, Melbourne 1998*
9901 Crumpei Factory *Warehouse apartments, Richmond 1999*
8817 Westgarth Duplex *Housing prototype, Westgarth 1998*
8816 Doncaster Park & Ride *Masterplanning studies, Doncaster 1998*
8815 House of the Future *Competition entry, Melbourne 1998*
8812 White Collar Pub *Prototype bar & cafe, Melbourne 1998*
8811 Mockridge Fountain *Competition entry, Melbourne 1998*
8810 Mainland Offices *Office fitout, Melbourne 1998*
8809 JCM Offices *Prototype office components, Brunswick 1998*
8808 Satellite Dish *Prototype bar & cafe, Melbourne 1998*
8807 Interdyn *Interior retail planning studies, Richmond 1998*
8805 Roof Garden *Extension & garden works, St Kilda 1998*
8804 Ferrari Bar *Interior studies, Melbourne 1998*
8803 Liberty Tower *Apartment building, Collins Street Melbourne 1998-2002*
8802 Icon I *Warehouse apartments, Richmond 1998*
8801 Leonardi Brandhouse *Advertising agency fit out, Richmond 1998*
9710 Shanghai Housing *Competition entry (commendation), Shanghai 1997*
9709 Docklands Northbank Display *Speculative proposal, Melbourne 1997*
9708 Spencer Square *Competition (winning entry), Melbourne 1997*
9707 Seegull Paddock *Masterplanning studies, Geelong 1997*
9706 Federation Square *Design competition, Melbourne 1997*
9705 Batman's Hill Precinct *Melbourne Docklands 1997*
9705 Surfworld *Masterplanning studies, Torquay 1997*
9702 St Johns Anglican Church site *Competition (winning entry), Camberwell 1998*
9701 Encel House *Extension and renovation, Williamstown 1997-2000*
9602 RMIT Sports Facility *Speculative proposal, Melbourne 1998*
9601 Dazzle Shed *Garden shed, Carlton 1996*

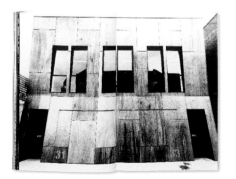

RMS SPOTVISION /01
MEET ME

SPOTVISION

ART DIRECTOR:
NIKOLAOS CHOTOS

DESIGNER:
NIKOLAOS CHOTOS

PHOTOGRAPHER:
NIKOLAOS CHOTOS

CLIENT:
RADIO MARKETING
SERVICE

SOFTWARE AND
HARDWARE:
QUARKXPRESS
MACINTOSH

MATERIALS:
BAVARIA

PRINTING:
4-COLOR +
SPOT COLOR

019
CAMPAÑEROS
RMS SPOTVISION

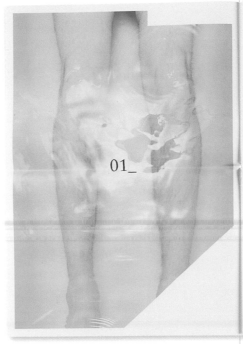

01_ PPC – PRE PRODUCTION CALL

THESE_ *Eine intensive Vorbereitung in Abstimmung mit dem Produktionshaus spart Arbeit, Zeit und Geld.* ERKLÄRUNG_ *Mehr Professionalität wird durch eine gründliche Vorbereitung erreicht. Der PPC hilft allen am Funkspot Beteiligten dabei, Einzelheiten der Produktion im Vorfeld mit dem Tonmeister und dem Regisseur abzustimmen. Unter PPC ist also das PPM des Funks zu verstehen.* STATEMENT_ *„Ein Werbefilm wird gedreht. Location: Australien. Top-Regisseur, Top-Idee, Top-Budget. Vorbereitung über Wochen; wichtigster Termin: PPM; Meeting den ganzen Tag, jedes Detail wird geklärt, der Dreh kann beginnen. Ergebnis: ein Cannes-Löwe. Ein Funkspot wird produziert. Location: renommiertes Funkstudio vor Ort. Top-Tonmeister, Top-Idee, Budget vorhanden. Vorbereitung zwischen Tür und Angel, wichtigster Termin: rechtzeitig im Taxi zum Studio zu sitzen. Die Produktion kann beginnen. Ergebnis: hätte besser sein können! Die Lösung: das PPM des Funks, der PPC. Alle Experten am Tisch, alle Details werden geklärt. Die Produktion kann beginnen. Ergebnis: Gold beim ADC. Denn: Gute Ideen müssen erstklassig umgesetzt werden. Das gilt auch für Funk!"* Hubertus von Lobenstein

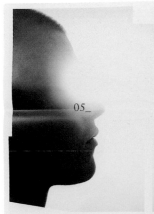

05_ INTERNATIONALE WETTBEWERBE

THESE_ *Auch in Deutschland gibt es gute Funkspots – sie brauchen nur mehr Aufmerksamkeit.* ERKLÄRUNG_ *Mit guten Funkspots können Agenturen im Kreativ-Ranking richtig Gas geben. Und damit es nicht bei nationalem Ruhm bleibt, werden die Gewinner-Spots beim RAMSES fit gemacht, um an internationalen Wettbewerben teilzunehmen. Hierfür spendiert die RMS eine englische Abmischung in einem Londoner Produktionshaus.* STATEMENT_ *„Seit unserem Symposium lohnt sich ein kreatives Funkspot für die Macher doppelt: Nicht nur auf inländischen Kreativ-Wettbewerben kann man in dieser Outsider-Disziplin leichter punkten (weil die Konkurrenz nicht so ausgeschlafen ist wie bei Print & TV), sondern zukünftig auch international. Denn die RMS sponsort den Gewinnern des RAMSES zukünftig einen Trip nach London in eins der besten Funkstudios zur Übersetzung der deutschen Produktion: für den Einsatz bei Wettbewerben rund um die Welt."* Oliver Voss

020
THIRTEEN DESIGN
BRISTOL LEGIBLE CITY:
FROM HERE TO THERE

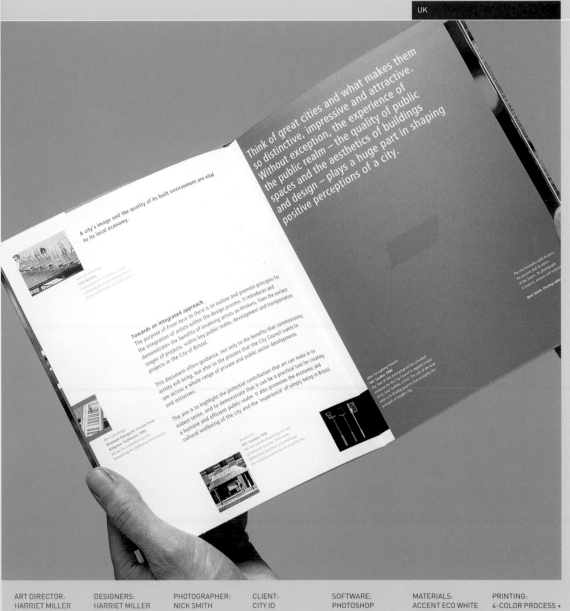

Think of great cities and what makes them so distinctive, impressive and attractive. Without exception, the experience of the public realm — the quality of public spaces and the aesthetics of buildings and design — plays a huge part in shaping positive perceptions of a city.

A city's image and the quality of its built environment are vital to its local economy.

Towards an integrated approach.
The purpose of *From here to there* is to outline and promote principles for the integration of artists within the design process. It introduces and demonstrates the benefits of involving artists as thinkers, from the earliest stages of projects, within key public realm, development and transportation projects in the City of Bristol.

This document offers guidance, not only to the benefits that commissioning artists will bring, but also to the process that the City Council wants to see across a whole range of private and public sector developments and initiatives.

The aim is to highlight the potential contribution that art can make in its widest sense, and to demonstrate that it can be a practical tool for creating a humane and efficient public realm. It also promotes the economic and cultural wellbeing of the city and the 'experience' of simply being in Bristol.

ART DIRECTOR:	DESIGNERS:	PHOTOGRAPHER:	CLIENT:	SOFTWARE:	MATERIALS:	PRINTING:
HARRIET MILLER	HARRIET MILLER DANIELLE WAY	NICK SMITH	CITY ID	PHOTOSHOP QUARKXPRESS	ACCENT ECO WHITE PHOENIX MOTION	4-COLOR PROCESS + 1 SPECIAL + SPOT VARNISH + SEAL

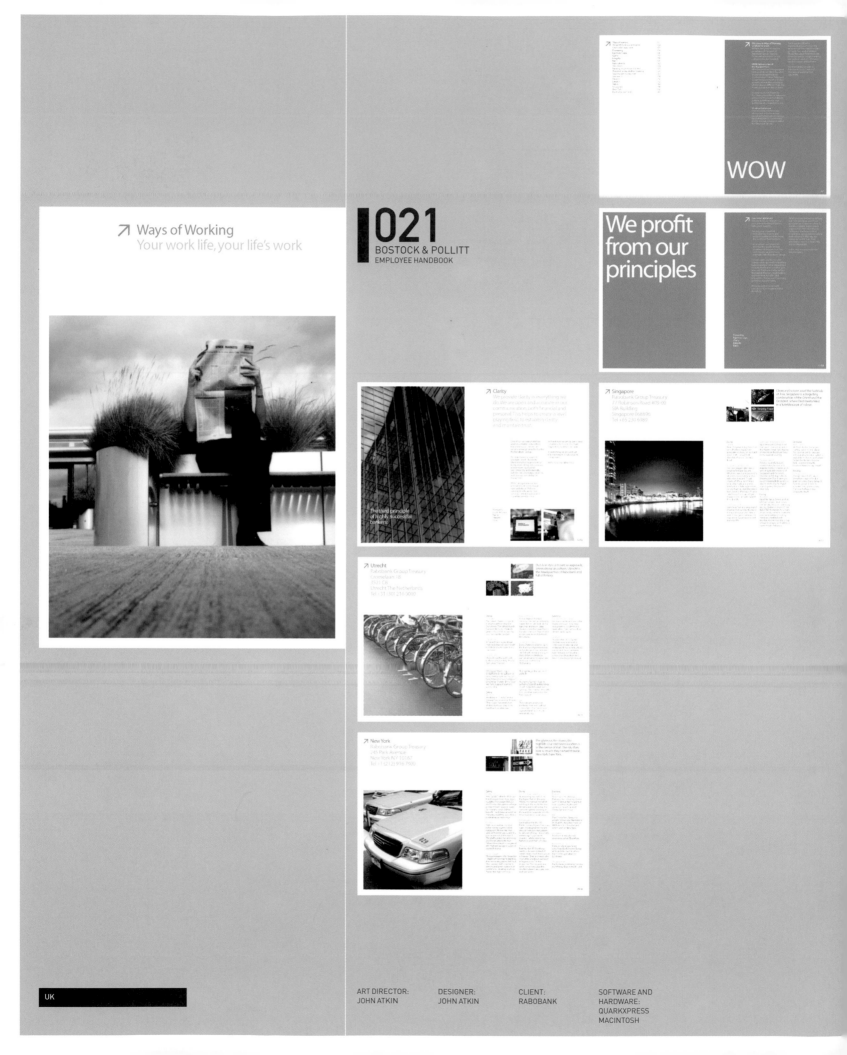

↗ Ways of Working
Your work life, your life's work

❘021
BOSTOCK & POLLITT
EMPLOYEE HANDBOOK

WOW

We profit
from our
principles

↗ Clarity
We provide clarity in everything we do. We are open and accurate in our communication, both financial and personal. This helps to create a level playing field, to establish clarity and maintain trust.

the third principle of highly successful bankers

↗ Singapore
Rabobank Group Treasury
77 Robinson Road #09-00
SIA Building
Singapore 068896
Tel +65 230 6989

↗ Utrecht
Rabobank Group Treasury
Croeselaan 18
3521 CB
Utrecht The Netherlands
Tel +31 (30) 216 0000

↗ New York
Rabobank Group Treasury
245 Park Avenue
New York NY 10167
Tel +1 (212) 916 7900

UK

ART DIRECTOR:
JOHN ATKIN

DESIGNER:
JOHN ATKIN

CLIENT:
RABOBANK

SOFTWARE AND
HARDWARE:
QUARKXPRESS
MACINTOSH

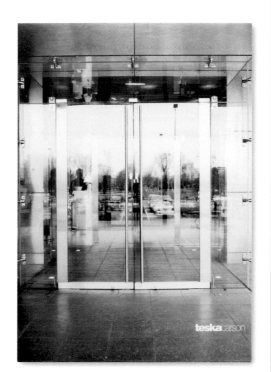

022
FABIO ONGARATO DESIGN
TESKA & CARSON CORPORATE PROFILE

ART DIRECTOR:	DESIGNER:	CLIENT:	MATERIALS:	PRINTING:
FABIO ONGARATO	RYAN GUPPY	TESKA & CARSON	PARILUX	GUNN & TAYLOR

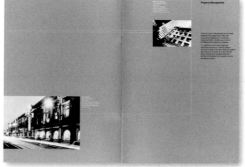

|023
ROSE DESIGN ASSOCIATES
WESTZONE LAUNCH BROCHURE

ART DIRECTOR:	DESIGNER:	PHOTOGRAPHER:	CLIENT:	SOFTWARE:	MATERIALS:	PRINTING:
SIMON ELLIOTT	SIMON ELLIOTT	PAUL ZAK	WESTZONE PUBLISHING LTD	ILLUSTRATOR PHOTOSHOP QUARKXPRESS	CYCLUS OFFSET VALLIANT GLOSS ART	OFFSET LITHO

UK

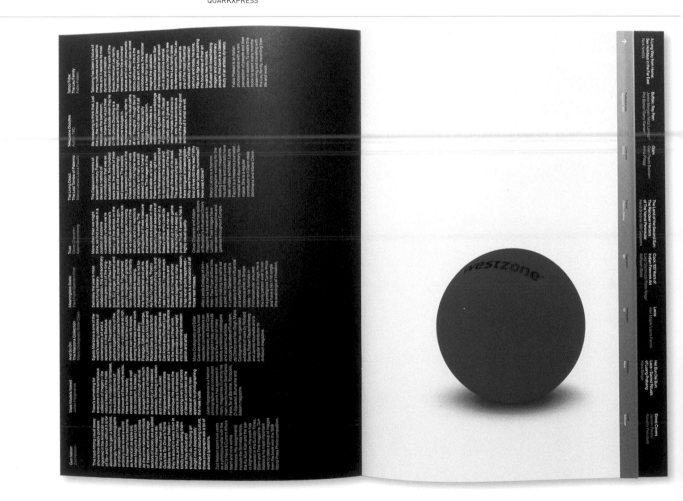

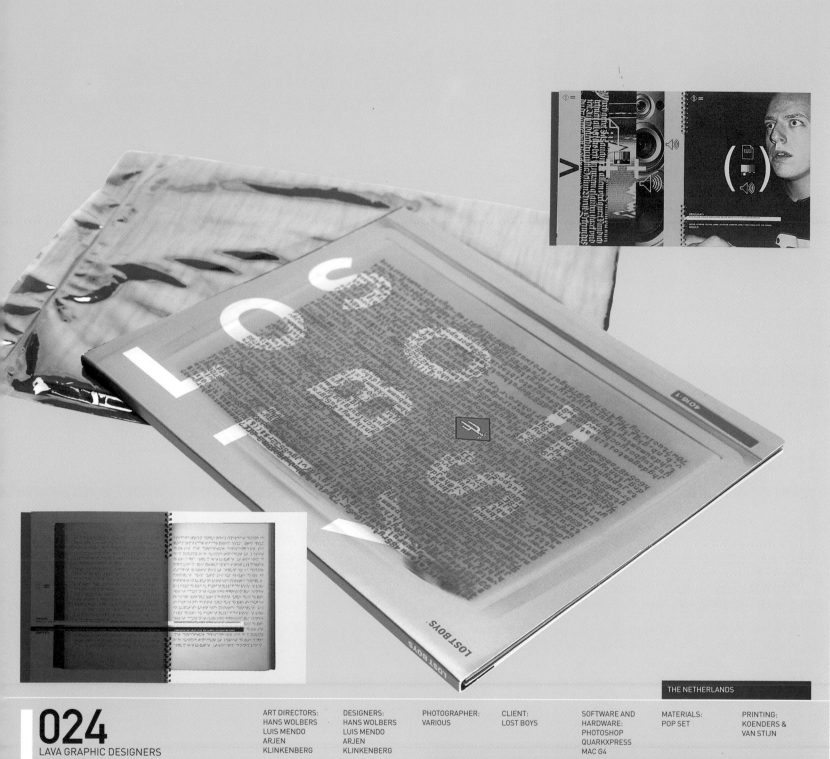

024

LAVA GRAPHIC DESIGNERS
LOST BOYS BROCHURE

ART DIRECTORS: HANS WOLBERS LUIS MENDO ARJEN KLINKENBERG	DESIGNERS: HANS WOLBERS LUIS MENDO ARJEN KLINKENBERG	PHOTOGRAPHER: VARIOUS	CLIENT: LOST BOYS	SOFTWARE AND HARDWARE: PHOTOSHOP QUARKXPRESS MAC G4	MATERIALS: POP SET	PRINTING: KOENDERS & VAN STIJN

ANNUAL REPORTS

LAVA GRAPHIC DESIGNERS // FABIO ONGARATO DESIGN // RADLEY YELDAR // SQUIRES & COMPANY // SALTERBAXTER // HAT-TRICK DESIGN // CAHAN & ASSOCIATES // FAUXPAS // EVOLVE // MUTABOR DESIGN // EMERY VINCENT DESIGN // 2D3D // VINJE DESIGN // SAS // METAL // ALLEMANN ALMQUIST & JONES // HORNALL ANDERSON DESIGN WORKS // KINETIC SINGAPORE // FROST DESIGN // CAMPAÑEROS // FOSTER DESIGN GROUP // CHIMERA DESIGN

.02

BBA GROUP

GROUP OVERVIEW 2001

GROEI

jaarverslag 1999

TAS

025

LAVA GRAPHIC DESIGNERS
SEVERAL/TAS JAARVESIDG

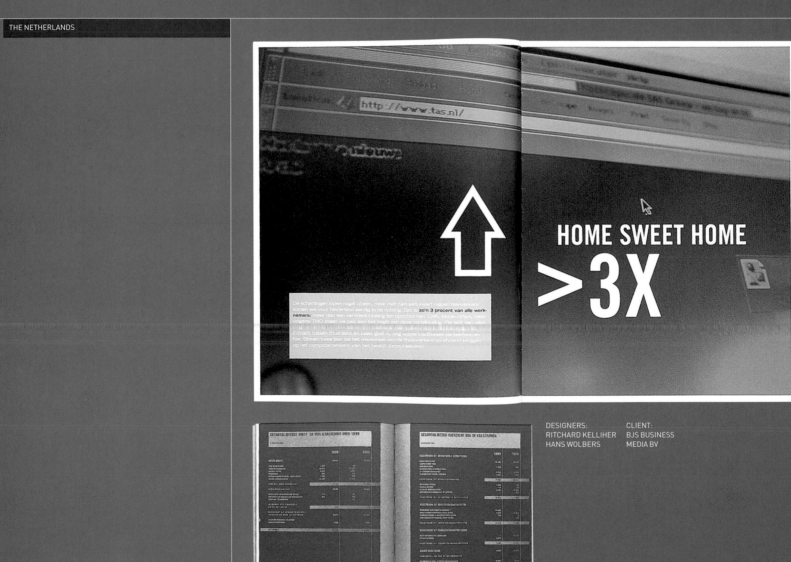

DESIGNERS:
RITCHARD KELLIHER
HANS WOLBERS

CLIENT:
BJS BUSINESS
MEDIA BV

026

FABIO ONGARATO DESIGN
ARNOLD BLOCK LEIBLER
2002 YEAR IN REVIEW

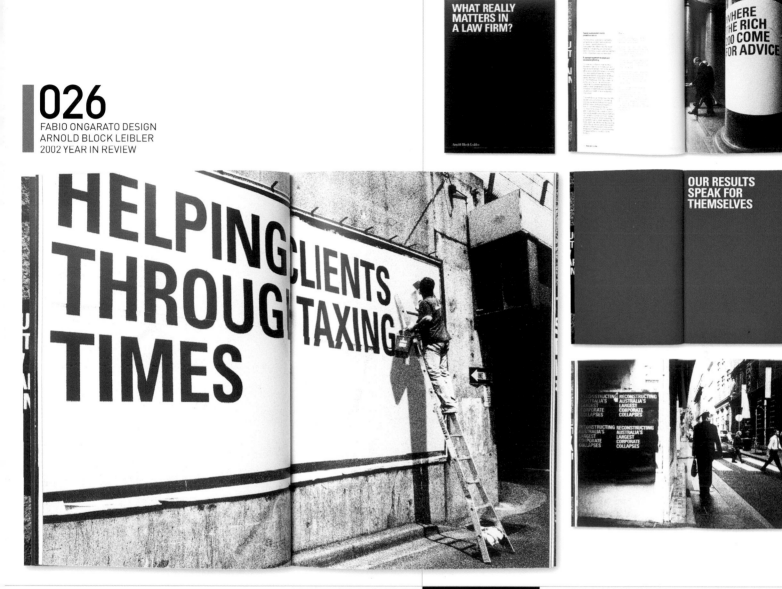

DESIGNER:
RYAN GUPPY

CLIENT:
ARNOLD BLOCK
LEIBLER

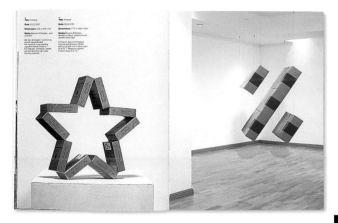

ART DIRECTOR:
ANDREW GORMAN

DESIGNER:
ROB RICHE

PHOTOGRAPHERS:
PAUL DIXON
ROB RICHE
JOHN EDWARDS

CLIENT:
GALLAHER GROUP
PLC

SOFTWARE AND
HARDWARE:
PHOTOSHOP
QUARKXPRESS
MAC

MATERIALS:
MANNO ART MATT

PRINTING:
6-COLOR LITHO
CTD CAPITA

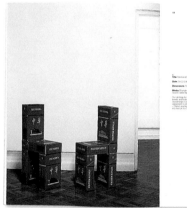

027
RADLEY YELDAR
GALLAHER ANNUAL
REPORT 2000

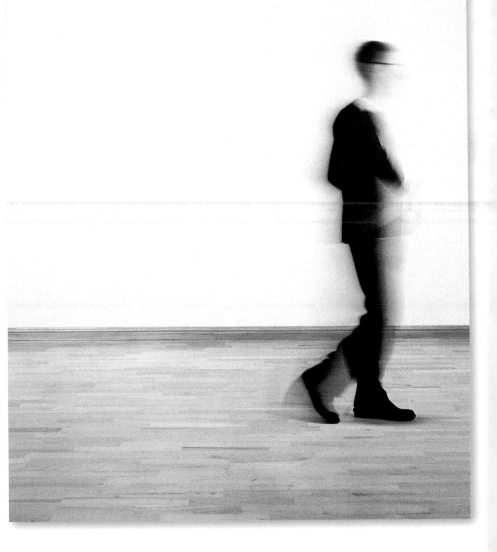

Gallaher Group Plc
Annual Review and Summary
Financial Statement 2000

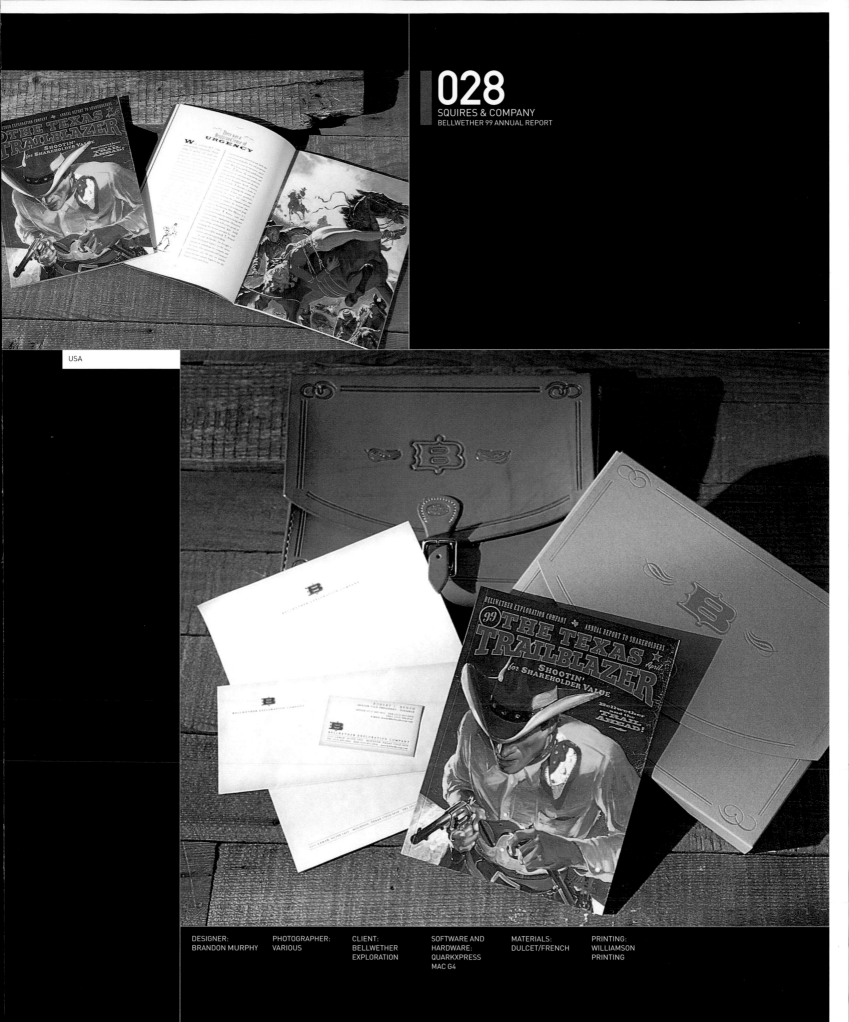

028

SQUIRES & COMPANY
BELLWETHER 99 ANNUAL REPORT

USA

DESIGNER:	PHOTOGRAPHER:	CLIENT:	SOFTWARE AND	MATERIALS:	PRINTING:
BRANDON MURPHY	VARIOUS	BELLWETHER EXPLORATION	HARDWARE: QUARKXPRESS MAC G4	DULCET/FRENCH	WILLIAMSON PRINTING

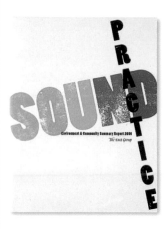

Eco-efficiency
Using fewer resources, and wasting less of those we do use, makes economic as well as environmental sense.

COMPARED TO 1995, WE NOW USE 33 PERCENT FEWER SOLVENTS AND GENERATE 45 PERCENT LESS HAZARDOUS WASTE AND 32 PERCENT LESS POLYCARBONATE SCRAP FOR EVERY UNIT OF PRODUCT THAT WE MANUFACTURE.

SOUND PRACTICE

The Christian Music Group (CMG) in the US has reduced by two-thirds the standard number of samples it orders for every new release. It has also changed its procedures to ensure that any samples that still remain surplus to requirements can be booked back into stock. This will significantly reduce product waste in the CMG offices.

Our impact
All aspects of our business use resources and create waste. Manufacturing is an area where we have undertaken formal reviews of the impacts resulting from this, and closely monitored our performance against some key indicators.

Our manufacturing sites use raw materials including polycarbonate, aluminium, solvents and inks. We continually strive to improve the efficiency of the process and minimise the quantity of material which is wasted, at the same time reducing the environmental impact caused by the wastes.

Some waste is inevitable. A proportion of the solvents used are emitted as vapours; these can present a health hazard in the working environment and contribute to smog formation when released to the atmosphere. Water-based effluents are treated on site and then discharged to sewer for further treatment. Any waste that can't be recycled, including hazardous waste, is sent for external disposal at landfill sites or incinerators.

We also use ozone depleting substances across our businesses, in air-conditioning and some fire protection systems. If released, these substances will damage the ozone layer.

Our performance
Solvents
We made good progress in solvent reduction, achieving a 31% drop in the quantity used and a 24% reduction per million units output (pmuo). This was significantly better than our target reduction of 5% pmuo.

The improvements were mainly due to a change of solvent specification at Uden (Netherlands) and improved controls at Jacksonville (US).

Hazardous waste
We reduced hazardous waste by 7%. This was equivalent to a 3% increase pmuo and fell short of our target 10% reduction pmuo. The main reason for this was the deferral of a new waste water treatment plant at Uden (now installed).

Polycarbonate efficiency
Procedural improvements at Toshiba-EMI (Japan) and Jacksonville contributed to a 16% reduction in polycarbonate scrap, equivalent to 10% pmuo. This was better than our 5% reduction target.

Ozone depleters
We record purchases of ozone depleting substances. No CFCs or halons were purchased. Purchases of HCFCs, used to maintain existing units or install new ones, increased by 5%. We also purchased 170kgs of HFCs as replacements for HCFCs. These gases are ozone friendly but have a high global warming potential.

4

5

ART DIRECTOR:
PENNY BAXTER

DESIGNER:
IVAN ANGELL

ILLUSTRATOR:
IVAN ANGELL

CLIENT:
THE EMI GROUP

SOFTWARE AND HARDWARE:
QUARKXPRESS
MAC

MATERIALS:
CYCLUS OFFSET

PRINTING:
LITHO + LETTERPRESS

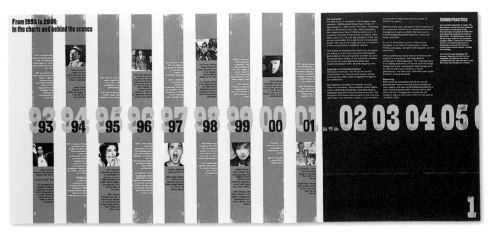

UK

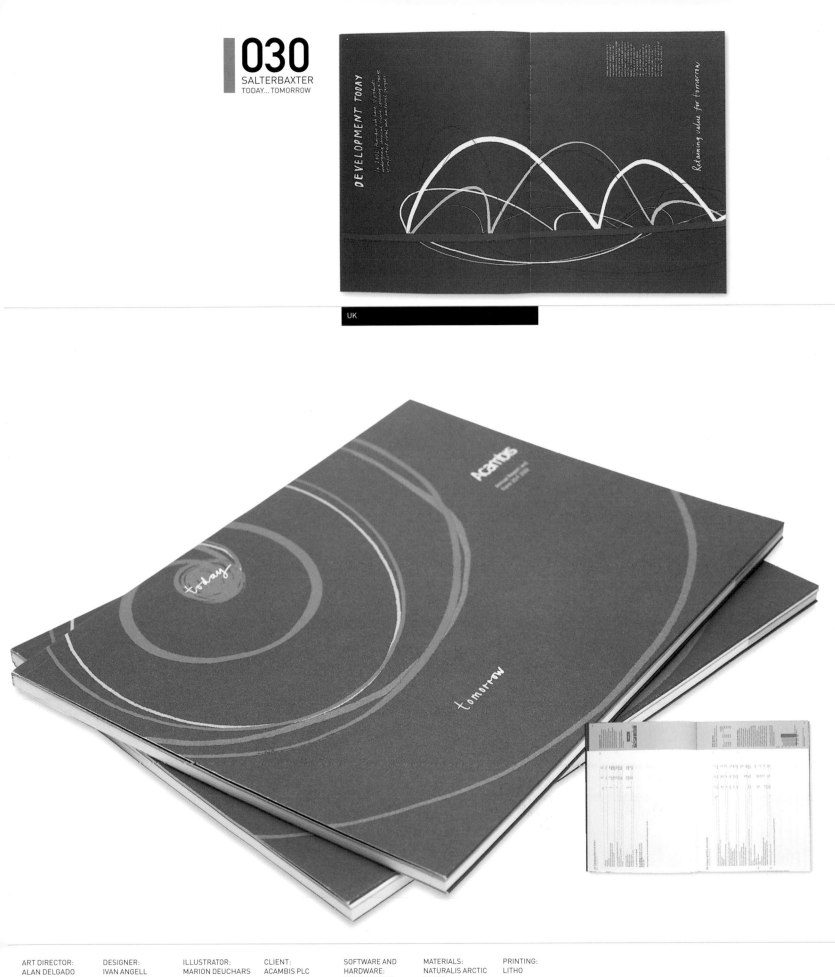

UK

ART DIRECTOR:	DESIGNER:	ILLUSTRATOR:	CLIENT:	SOFTWARE AND HARDWARE:	MATERIALS:	PRINTING:
ALAN DELGADO	IVAN ANGELL	MARION DEUCHARS	ACAMBIS PLC	QUARKXPRESS MAC	NATURALIS ARCTIC WHITE	LITHO

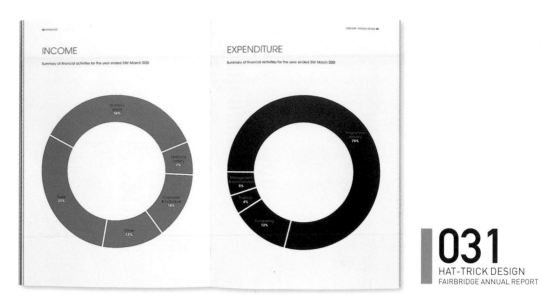

INCOME

Summary of financial activities for the year ended 31st March 2001

EXPENDITURE

Summary of financial activities for the year ended 31st March 2001

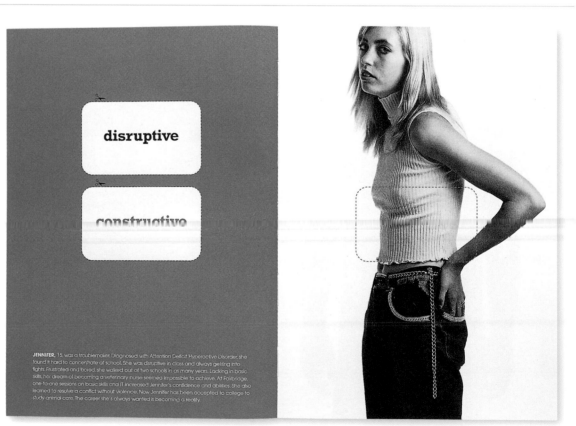

disruptive

constructive

JENNIFER, 15, was a troublemaker. Diagnosed with Attention Deficit Hyperactive Disorder, she found it hard to concentrate at school. She was disruptive in class and always getting into fights. Frustrated and bored she walked out of two schools in as many years. Lacking in basic skills, her dream of becoming a veterinary nurse seemed impossible to achieve. At Fairbridge, one-to-one sessions on basic skills and IT increased Jennifer's confidence and abilities. She also learned to resolve a conflict without violence. Now Jennifer has been accepted to college to study animal care. The career she's always wanted is becoming a reality.

DESIGNER:
HAT-TRICK DESIGN

CLIENT:
FAIRBRIDGE

SOFTWARE:
QUARKXPRESS

MATERIALS:
ODYSSEY

PRINTING:
LITHO

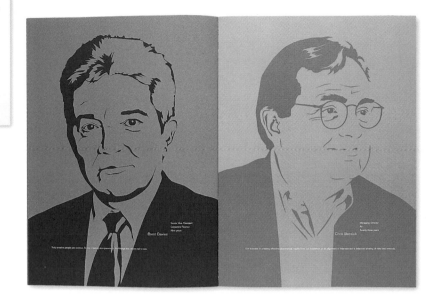

ART DIRECTOR:
BILL CAHAN

DESIGNER:
KEVIN ROBERSON

ILLUSTRATOR:
KEVIN ROBERSON

CLIENT:
GATX CAPITAL
CORPORATION

MATERIALS:
STARWHITE
VICKSLAVERSTIARA

PRINTING:
H. MACDONALD

TB2B

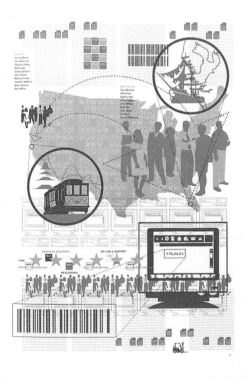

032
CAHAN & ASSOCIATES
GATX 2000 ANNUAL REPORT

ART DIRECTOR:	DESIGNER:	ILLUSTRATOR:	CLIENT:	SOFTWARE AND	MATERIALS:	PRINTING:
MARTIN STILLHART	MARTIN STILLHART	MARTIN STILLHART	VEREIN JOB	HARDWARE: QUARKXPRESS MAC	Z-OFFSET W	OFFSET

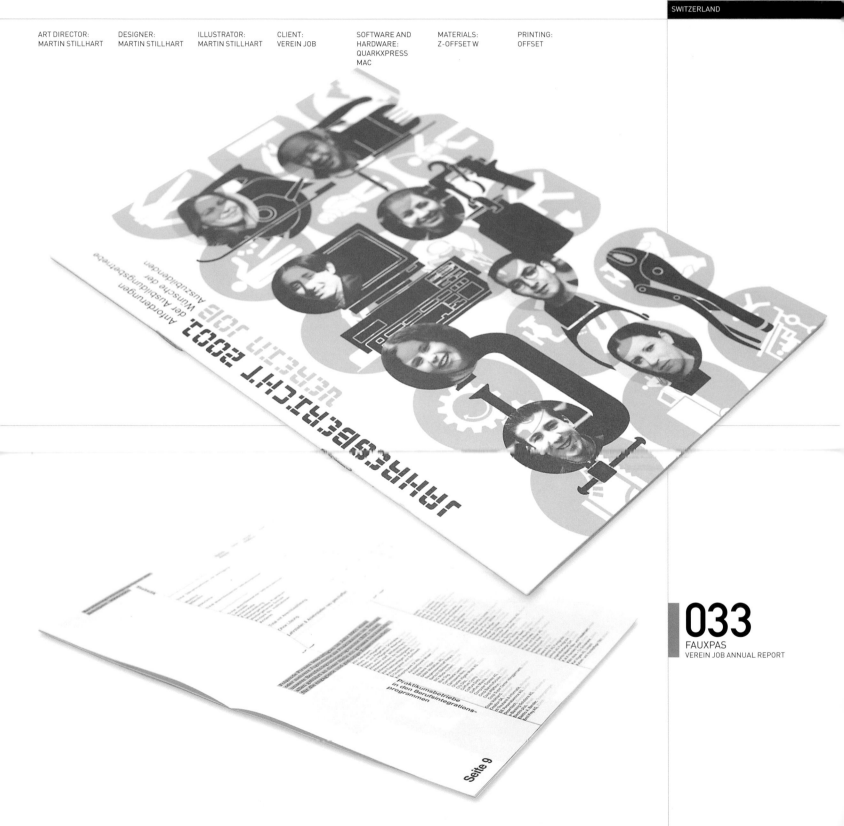

033
FAUXPAS
VEREIN JOB ANNUAL REPORT

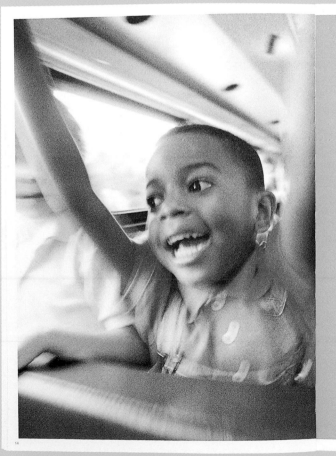

The Harrow Partnership was established in 1998, bringing together the council and private, public and community and voluntary organisations to provide better services and improve the quality of life for local residents through a programme of exploiting every possible opportunity for joint working.

Making a difference together

Mary Whitty, Chief Executive, is a member of the Partnership Steering Group, comprising key local agencies, which steers the overall development of the Partnership.

The Partnership consists of four themes: health and social care, environment and economy, lifelong learning, and strengthening communities. Each theme has a strategy group to agree and monitor the priorities for joint working; and also periodically holds stakeholder forums to consult and receive proposals from a larger group of stakeholders.

The partnership also stages an annual conference as well as community events.

The Health and Social Care Strategy Group includes representation from the Health Authority, as well as the principal NHS Trusts, the local authority, Primary Care Groups, the CHC, voluntary groups, Carers and representatives from cultural communities. The Partnership is, therefore, an inclusive one, bringing together the interests of both service users and providers.

A series of seven Strategy Development Groups (SDGs) plan and develop health and social care services for different client groups. The groups devise strategic plans to meet identified needs, agree action plans and monitor progress.

Membership is from across both statutory and non statutory agencies. Strategy Development Groups have a key responsibility to develop the effective involvement of users, Carers, voluntary organisations and cultural communities in their work programmes, drawing on their experience and expertise to enrich the quality of joint planning in Harrow.

Prior to issuing the plan this year, a leaflet was sent to every Harrow resident asking them to identify their most important issues. Improving health emerged overall as second only to reducing crime of the 36 issues identified, with children's health, older people's health, diabetes, coronary heart disease, strokes and cancer seen as particularly important.

One of the virtues of the Partnership is that partners can be involved across a wider spectrum of activities. The Health Authority is also represented on each of the other three Partnership Groups and is, therefore, playing an active part in joint working on areas such as tackling poverty, enhancing the environment and harnessing the benefits of information and communication technology.

1 Service users and patients
To provide good quality health and social care services, ensuring that promoting independence and community involvement are integral to service planning and delivery.

2 Supporting Carers
To provide practical support to Carers and to involve Carers and their representative organisations in service planning.

3 The community
To start to address inequalities in health and the underlying causes of poor health (including poor housing and low income), to meet the healthcare needs of all sections of the community and to develop further the capacity of local voluntary organisations to provide services.

4 Children and young people
To improve the life chances of children and young people.

The four areas chosen as priority actions for the health and social care theme of the Harrow Partnership in 2000/2001

034

EVOLVE
NHS: BRENT AND HARROW
ANNUAL REPORT

UK

ART DIRECTOR:
DONNA HOUGHTON

DESIGNER:
JONATHAN HAWKES

CLIENT:
NHS: BRENT +
HARROW

SOFTWARE AND
HARDWARE:
QUARKXPRESS
MAC G4

PRINTING:
2-COLOR LITHO

ART DIRECTOR:
JOHANNES PLASS

DESIGNER:
CHRISTIAN DWORAK

ILLUSTRATOR/
PHOTOGRAPHER:
CARSTEN RAFFEL

CLIENT:
SINNER SCHRADER

MATERIALS:
ZANDERS MEDLEY
PURE

PRINTING:
DRUCKEREI
HARTUNG

035
MUTABOR DESIGN
SINNER SCHRADER ANNUAL REPORT

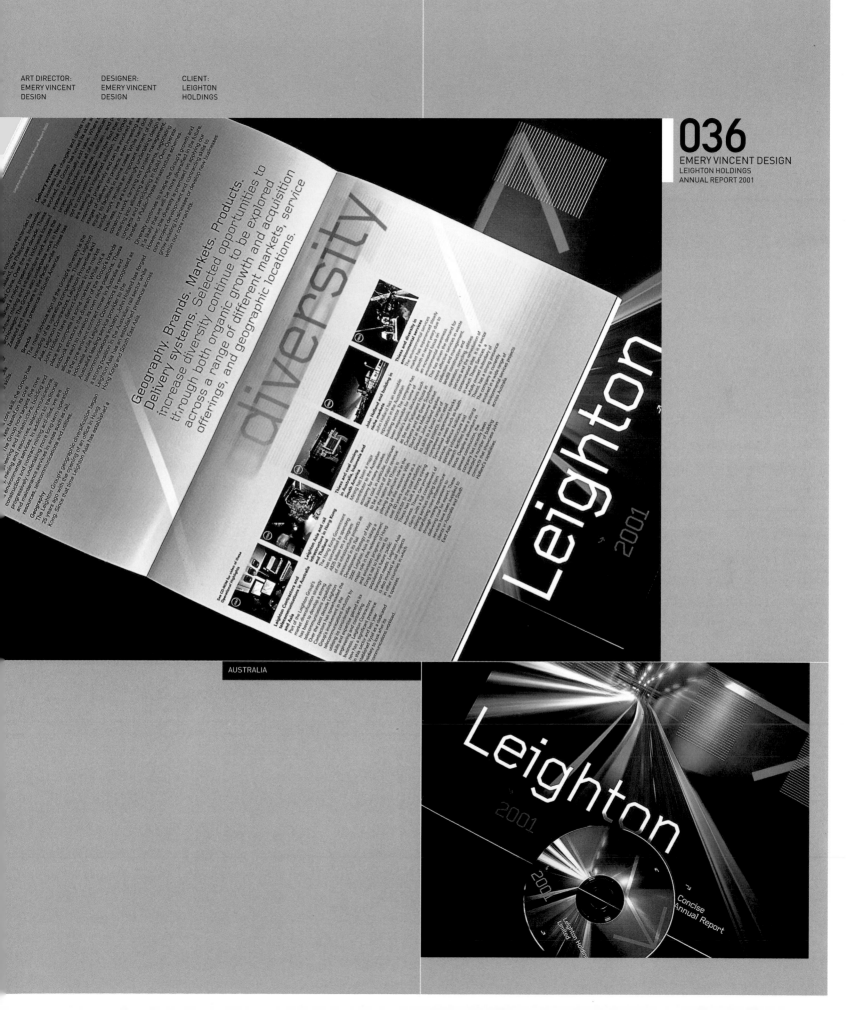

ART DIRECTOR:
EMERY VINCENT
DESIGN

DESIGNER:
EMERY VINCENT
DESIGN

CLIENT:
LEIGHTON
HOLDINGS

036
EMERY VINCENT DESIGN
LEIGHTON HOLDINGS
ANNUAL REPORT 2001

AUSTRALIA

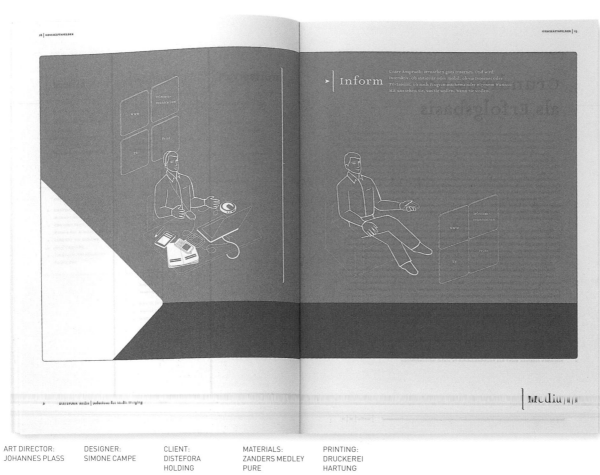

ART DIRECTOR:
JOHANNES PLASS

DESIGNER:
SIMONE CAMPE

CLIENT:
DISTEFORA
HOLDING

MATERIALS:
ZANDERS MEDLEY
PURE

PRINTING:
DRUCKEREI
HARTUNG

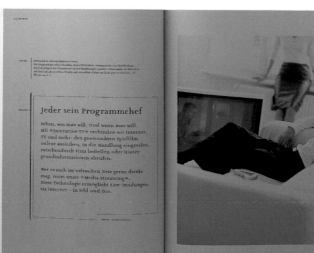

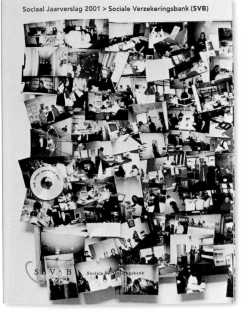

Sociaal Jaarverslag 2001 > Sociale Verzekeringsbank (SVB)

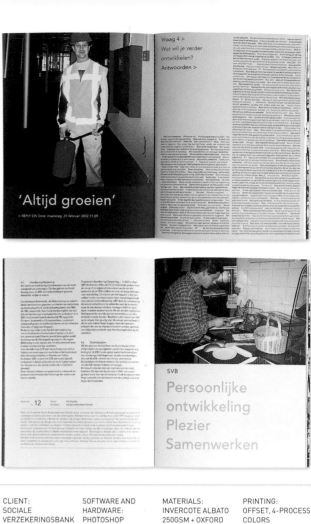

'Altijd groeien'
> REPLY ON Date: maandag, 25 februari 2002 11:09

SVB

Persoonlijke
ontwikkeling
Plezier
Samenwerken

THE NETHERLANDS

ART DIRECTORS:
TIEMEN HARDER
YEW-KEE CHUNG

DESIGNERS:
TIEMEN HARDER
YEW-KEE CHUNG

PHOTOGRAPHER:
STAFF OF SOCIALE
VERZEKERINGSBANK

CLIENT:
SOCIALE
VERZEKERINGSBANK

SOFTWARE AND
HARDWARE:
PHOTOSHOP
QUARKXPRESS
MAC

MATERIALS:
INVERCOTE ALBATO
250GSM + OXFORD
120GSM

PRINTING:
OFFSET, 4-PROCESS
COLORS

Sociaal Jaarverslag 2001 > Sociale Verzekeringsbank (SVB)

taal
foto's

537 Reacties

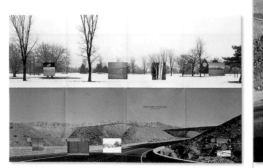

ART DIRECTOR:
BILL CAHAN

DESIGNER:
BOB DINETZ

CLIENT:
PROVIDIAN
FINANCIAL

SOFTWARE:
ILLUSTRATOR
PHOTOSHOP
QUARKXPRESS

MATERIALS:
UTOPIA 2 DULL

PRINTING:
LITHOGRAPHIX

039
CAHAN & ASSOCIATES
PROVIDIAN 2000 ANNUAL REPORT

04

PLEA-SAN-TON, CA

USA

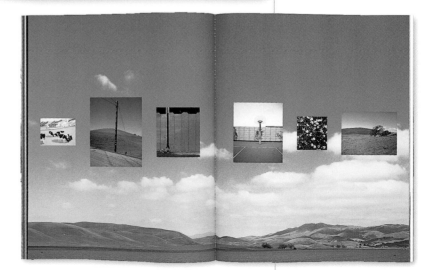

VaxGen

1200 days of progress

ART DIRECTOR:
ANDREAS KELLER

DESIGNER:
ANDREAS KELLER

PHOTOGRAPHER:
JAMES CHIANG

CLIENT:
VAXGEN, INC

SOFTWARE AND
HARDWARE:
QUARKXPRESS
MAC

MATERIALS:
FRENCH PAPER
SMART WHITE

PRINTING:
ANDERSON
LITHOGRAPH

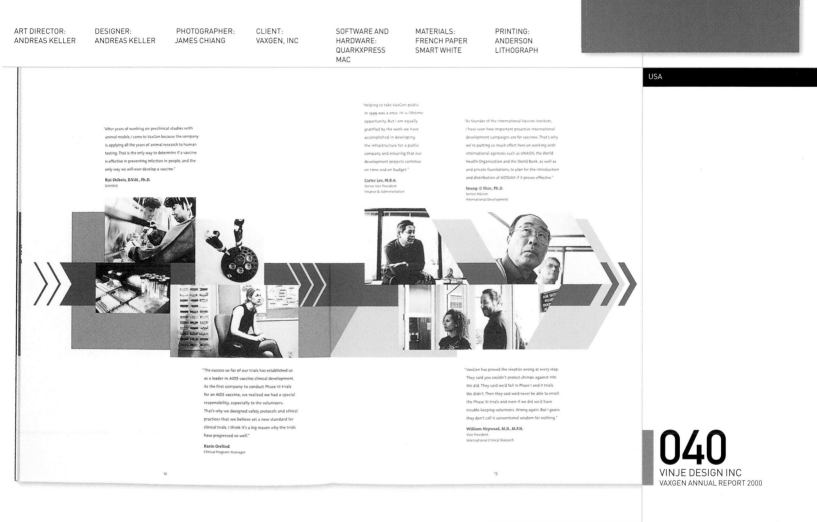

"After years of working on preclinical studies with animal models, I came to VaxGen because the company is applying all the years of animal research to human testing. That is the only way to determine if a vaccine is effective in preventing infection in people, and the only way we will ever develop a vaccine."

Riri Shibata, D.V.M., Ph.D.
Scientist

"Helping to take VaxGen public in 1999 was a once-in-a-lifetime opportunity. But I am equally gratified by the work we have accomplished in developing the infrastructure for a public company and ensuring that our development projects continue on time and on budget."

Carter Lee, M.B.A.
Senior Vice President
Finance & Administration

"As founder of the International Vaccine Institute, i have seen how important proactive international development campaigns are for vaccines. That's why we're putting so much effort here on working with international agencies such as UNAIDS, the World Health Organization and the World Bank, as well as and private foundations, to plan for the introduction and distribution of AIDSVAX if it proves effective."

Seung-il Shin, Ph.D.
Senior Advisor
International Development

"The success so far of our trials has established us as a leader in AIDS vaccine clinical development. As the first company to conduct Phase III trials for an AIDS vaccine, we realized we had a special responsibility, especially to the volunteers. That's why we designed safety protocols and ethical practices that we believe set a new standard for clinical trials. I think it's a big reason why the trials have progressed so well."

Karin Orelind
Clinical Program Manager

"VaxGen has proved the skeptics wrong at every step. They said you couldn't protect chimps against HIV. We did. They said we'd fail in Phase I and II trials. We didn't. Then they said we'd never be able to enroll the Phase III trials and even if we did we'd have trouble keeping volunteers. Wrong again. But I guess they don't call it conventional wisdom for nothing."

William Heyward, M.D., M.P.H.
Vice President
International Clinical Research

12

13

040

VINJE DESIGN INC
VAXGEN ANNUAL REPORT 2000

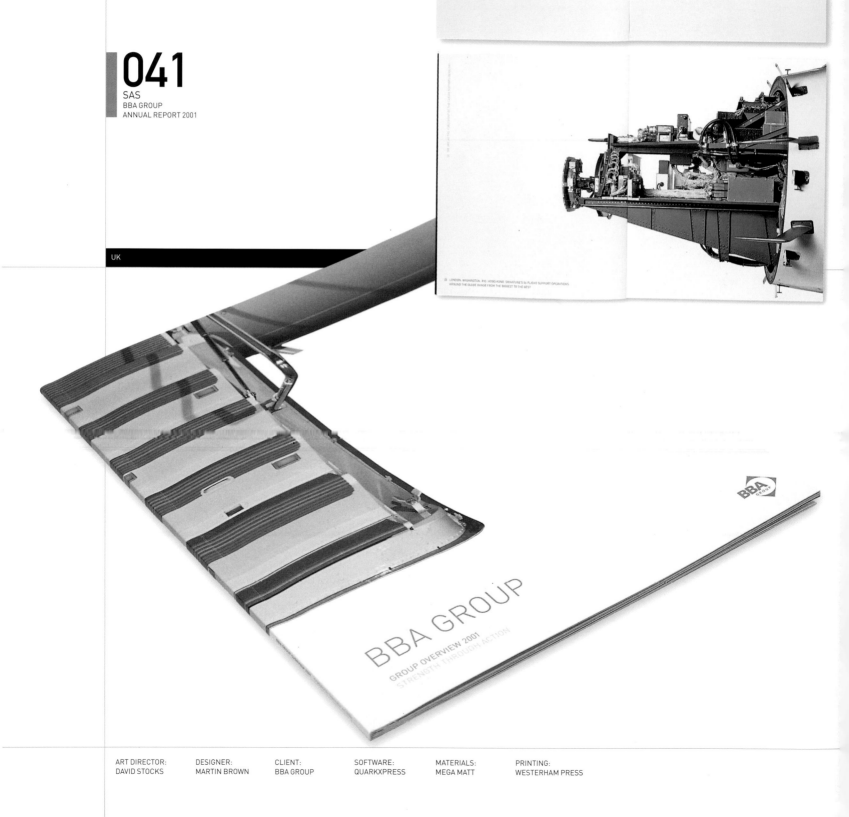

DIFFICULT TIMES. FOR US.
FOR EVERYONE ELSE.
So what did we do?

WE STRENGTHENED OUR
POSITION. WE BOUGHT WELL:
STRATEGIC ACQUISITIONS.
WE CUT COSTS. WE GREW
SALES. WE DID BETTER
THAN OUR COMPETITORS.

And what will we do next?

WE'LL CONTINUE: TO
GROW OUR SERVICES,
OUR BUSINESSES AND
THE MARKETS THAT WE'RE
IN. WE'LL CONTINUE TO
CREATE VALUE. MAKING
MORE OF WHAT WE HAVE.

041

SAS
BBA GROUP
ANNUAL REPORT 2001

UK

BBA GROUP
GROUP OVERVIEW 2001

ART DIRECTOR:	DESIGNER:	CLIENT:	SOFTWARE:	MATERIALS:	PRINTING:
DAVID STOCKS	MARTIN BROWN	BBA GROUP	QUARKXPRESS	MEGA MATT	WESTERHAM PRESS

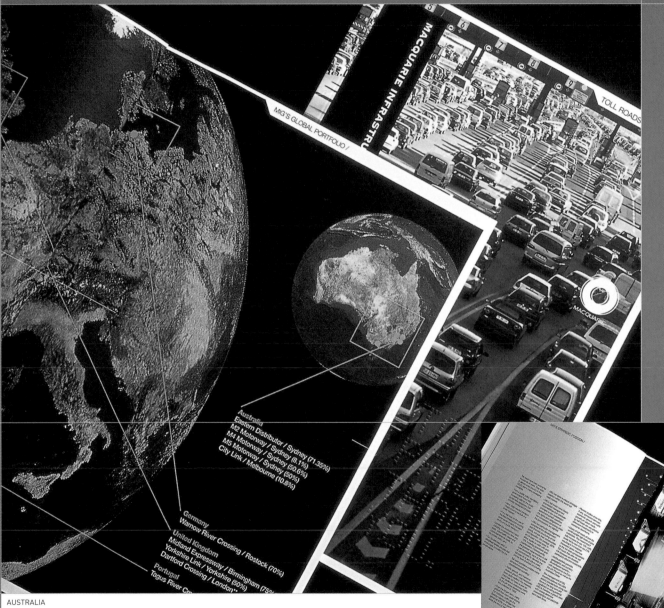

AUSTRALIA

ART DIRECTOR:
EMERY VINCENT
DESIGN

DESIGNER:
EMERY VINCENT
DESIGN

CLIENT:
MACQUARIE
INFRASTRUCTURE
GROUP

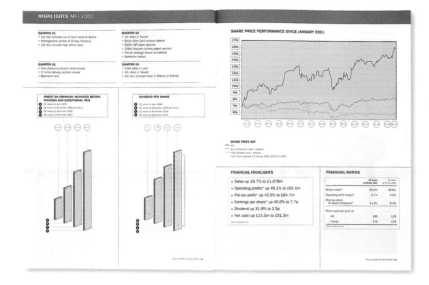

ART DIRECTORS:
MIKE HALL
GILMAR WENDT

DESIGNER:
EMMA SLATER

ILLUSTRATORS:
ROGER TAYLOR
JOHN SEE

CLIENT:
MFI GROUP

SOFTWARE:
QUARKXPRESS

MATERIALS:
COLORITE

PRINTING:
FULMAR

UK

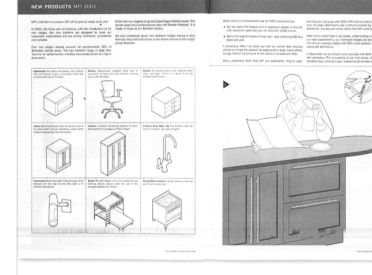

043

SAS
MFI GROUP 2001
ANNUAL REPORT

Valentis 2001 Annual Report

Statistics don't lie.

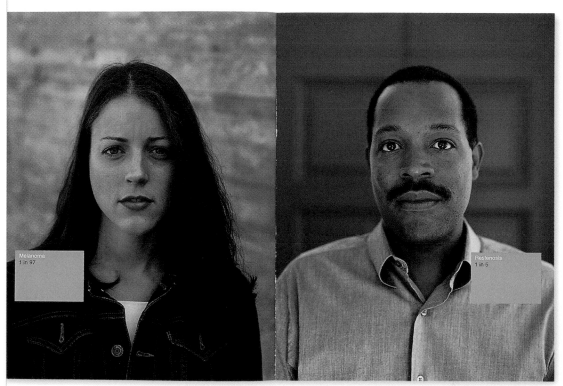

Melanoma
1 in 97

Restenosis
1 in 5

ART DIRECTOR:
BILL CAHAN

DESIGNER:
SHARRIE BROOKS

CLIENT:
VALENTIS

MATERIALS:
UTOPIA 2 DULL 80#

PRINTING:
COLOR GRAPHICS

Genemedicine™ Products Valentis' Genemedicine™ products provide novel methods of producing therapeutic proteins in their most natural and active forms at specific sites within the body. Upon delivery, genes formulated with synthetic delivery systems enter targeted cells and produce the therapeutic proteins. The fidelity, specificity, and duration of expression within the target cells can be controlled by Valentis' proprietary gene regulation systems.

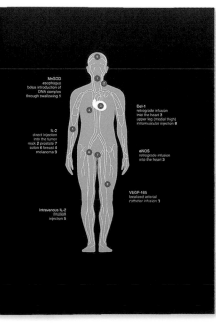

MnSOD
esophagus
bolus introduction of
DNA complex
through swallowing 1

Del-1
retrograde infusion
into the heart 3
upper leg (medial thigh)
intramuscular injection 8

IL-2
direct injection
into the tumor
neck 2 prostate 7
colon 6 breast 4
melanoma 9

eNOS
retrograde infusion
into the heart 3

VEGF-165
localized arterial
catheter infusion 1

Intravenous IL-2
infusion
injection 5

044
CAHAN & ASSOCIATES
VALENTIS 2001 ANNUAL REPORT

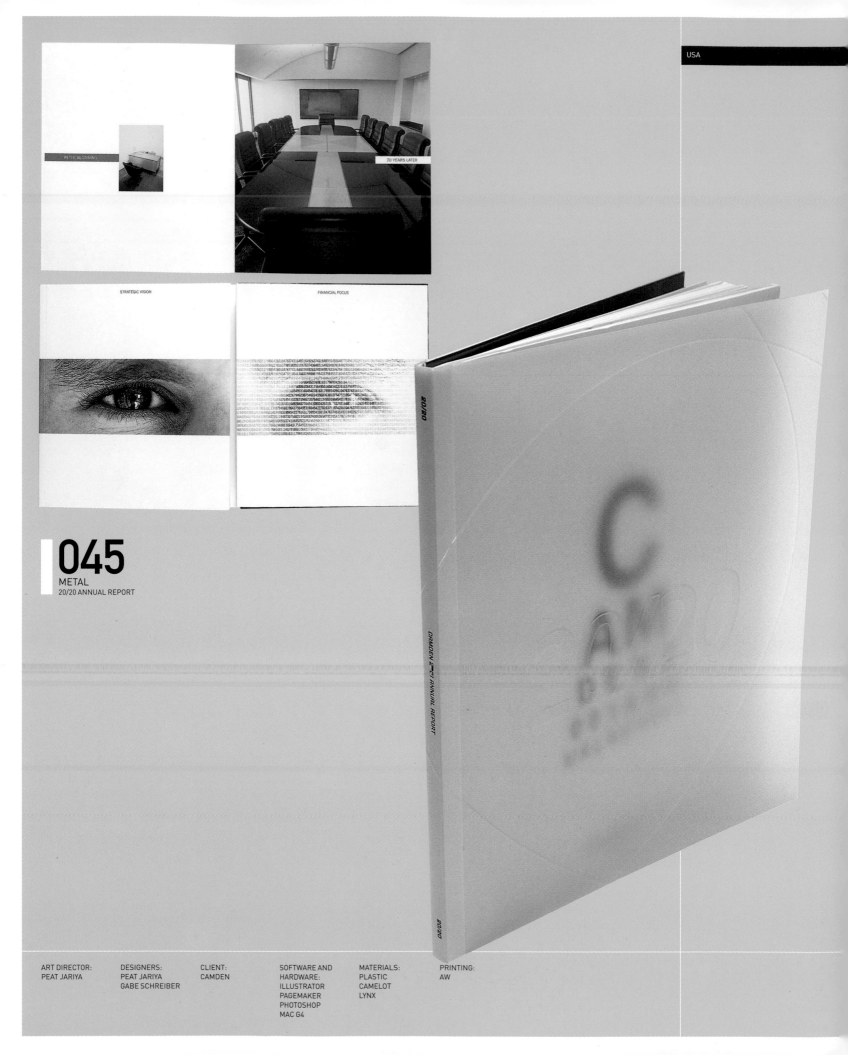

IN THE BEGINNING

20 YEARS LATER

STRATEGIC VISION

FINANCIAL FOCUS

045
METAL
20/20 ANNUAL REPORT

20/20

CAMDEN 2020 ANNUAL REPORT

20/20

ART DIRECTOR:	DESIGNERS:	CLIENT:	SOFTWARE AND	MATERIALS:	PRINTING:
PEAT JARIYA	PEAT JARIYA	CAMDEN	HARDWARE:	PLASTIC	AW
	GABE SCHREIBER		ILLUSTRATOR	CAMELOT	
			PAGEMAKER	LYNX	
			PHOTOSHOP		
			MAC G4		

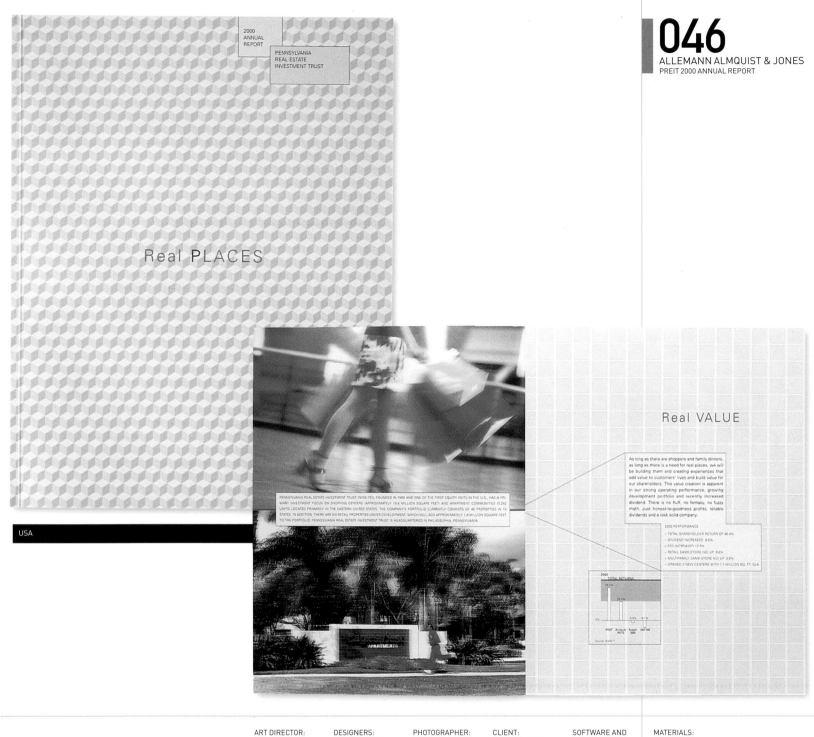

2000
ANNUAL
REPORT

PENNSYLVANIA
REAL ESTATE
INVESTMENT TRUST

Real PLACES

USA

Real VALUE

As long as there are shoppers and family dinners, as long as there is a need for real places, we will be building them and creating experiences that add value to customers' lives and build value for our shareholders. This value creation is apparent in our strong operating performance, growing development portfolio and recently increased dividend. There is no fluff, no fantasy, no fuzzy math. Just honest-to-goodness profits, reliable dividends and a rock solid company.

PENNSYLVANIA REAL ESTATE INVESTMENT TRUST (NYSE:PEI), FOUNDED IN 1960 AND ONE OF THE FIRST EQUITY REITS IN THE U.S., HAS A PRIMARY INVESTMENT FOCUS ON SHOPPING CENTERS (APPROXIMATELY 10.8 MILLION SQUARE FEET) AND APARTMENT COMMUNITIES (7,242 UNITS) LOCATED PRIMARILY IN THE EASTERN UNITED STATES. THE COMPANY'S PORTFOLIO CURRENTLY CONSISTS OF 46 PROPERTIES IN 10 STATES. IN ADDITION, THERE ARE SIX RETAIL PROPERTIES UNDER DEVELOPMENT, WHICH WILL ADD APPROXIMATELY 1.8 MILLION SQUARE FEET TO THE PORTFOLIO. PENNSYLVANIA REAL ESTATE INVESTMENT TRUST IS HEADQUARTERED IN PHILADELPHIA, PENNSYLVANIA.

2000 PERFORMANCE
- TOTAL SHAREHOLDER RETURN OF 48.4%
- DIVIDEND INCREASED 8.5%
- FFO INCREASED 12.6%
- RETAIL SAME-STORE NOI UP 6.6%
- MULTIFAMILY SAME-STORE NOI UP 3.6%
- OPENED 3 NEW CENTERS WITH 1.7 MILLION SQ. FT. GLA

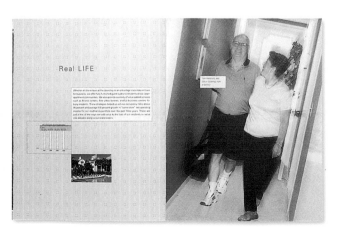

Real LIFE

ART DIRECTOR:
JAN ALMQUIST

DESIGNERS:
JAN ALMQUIST
LINNAE DESILVA

PHOTOGRAPHER:
VARIOUS

CLIENT:
PENNSYLVANIA
REAL ESTATE
INVESTMENT TRUST

SOFTWARE AND
HARDWARE:
ILLUSTRATOR
PHOTOSHOP
QUARKXPRESS
MAC G4

MATERIALS:
MOHAWK
SUPERFINE
TEXT/COVER

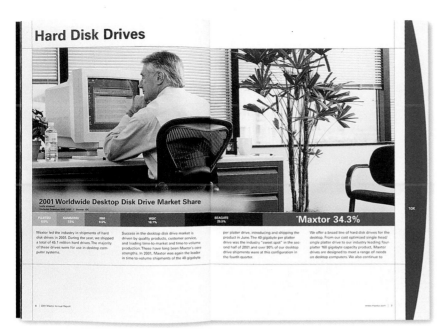

Hard Disk Drives

2001 Worldwide Desktop Disk Drive Market Share

| FUJITSU 6.5% | SAMSUNG 7.5% | IBM 9.5% | WDC 16.7% | SEAGATE 25.5% | *Maxtor 34.3% |

Maxtor led the industry in shipments of hard disk drives in 2001. During the year, we shipped a total of 45.1 million hard drives. The majority of these drives were for use in desktop computer systems.

Success in the desktop disk drive market is driven by quality products, customer service, and leading time-to-market and time-to-volume production. These have long been Maxtor's core strengths. In 2001, Maxtor was again the leader in time-to-volume shipments of the 40 gigabyte

per platter drive, introducing and shipping the product in June. The 40 gigabyte per platter drive was the industry "sweet spot" in the second half of 2001 and over 90% of our desktop drive shipments were at this configuration in the fourth quarter.

We offer a broad line of hard disk drives for the desktop. From our cost optimized single head/single platter drive to our industry leading four-platter 160 gigabyte capacity product, Maxtor drives are designed to meet a range of needs on desktop computers. We also continue to

10K

|047

HORNALL ANDERSON
DESIGN WORKS
MAXTOR 2001 ANNUAL REPORT

THE FUTURE
2002 and Beyond

Maxtor 2001 10K

USA

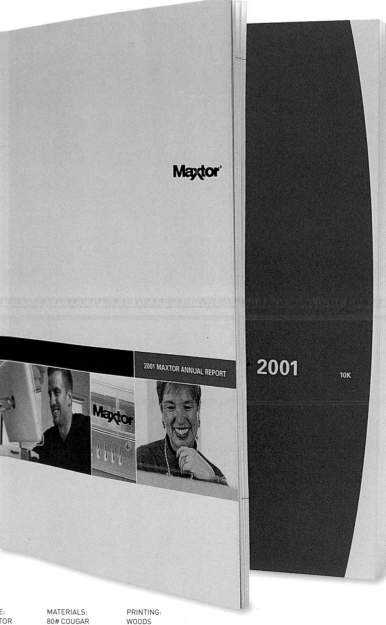

2001 MAXTOR ANNUAL REPORT

2001 10K

ART DIRECTOR:	DESIGNERS:	PHOTOGRAPHER:	CLIENT:	SOFTWARE:	MATERIALS:	PRINTING:
LISA CERVENY	LISA CERVENY ANDREW WICKLUND	ALAN ABRAMOWITZ	MAXTOR	ILLUSTRATOR PHOTOSHOP QUARKXPRESS	80# COUGAR OPAQUE + 60# COUGAR OPAQUE	WOODS LITHOGRAPHICS

048

CAHAN & ASSOCIATES
BRE PROPERTIES 2001
ANNUAL REPORT

ART DIRECTOR:
BILL CAHAN

DESIGNER:
KEVIN ROBERSON

CLIENT:
BRE PROPERTIES

SOFTWARE:
PHOTOSHOP
QUARKXPRESS

MATERIALS:
COUGAR VELLUM

PRINTING:
HEMLOCK
PRINTERS

USA

THEIR PERFECT DREAM HOUSE ISN'T A HOUSE AT ALL.

amara holdings limited annual report 2001 Ascend

Ascend

SINGAPORE

ART DIRECTORS:
LENG SOH
PANN LIM
ROY POH

DESIGNERS:
LENG SOH
PANN LIM
ROY POH

ILLUSTRATORS:
LENG SOH
PANN LIM
ROY POH

CLIENT:
AMARA SINGAPORE

SOFTWARE AND
HARDWARE:
FREEHAND
PHOTOSHOP
MAC

MATERIALS:
ART PAPER + MAN-
MADE GRASS PATCH

PRINTING:
5CX5C + GLOSS
VARNISH

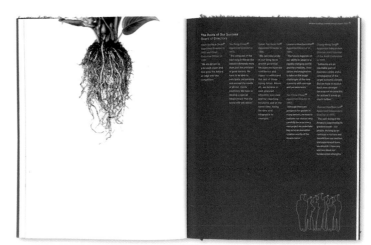

049
KINETIC SINGAPORE
ASCEND

Ascend

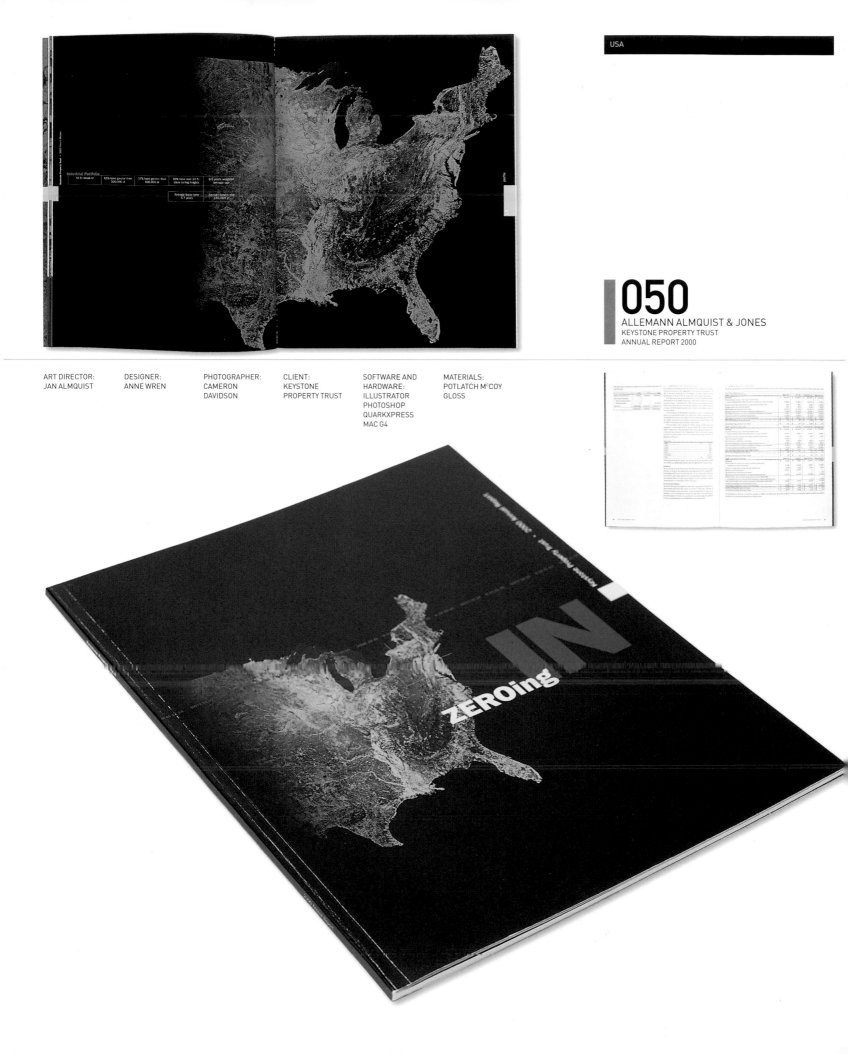

050

ALLEMANN ALMQUIST & JONES
KEYSTONE PROPERTY TRUST
ANNUAL REPORT 2000

ART DIRECTOR:
JAN ALMQUIST

DESIGNER:
ANNE WREN

PHOTOGRAPHER:
CAMERON
DAVIDSON

CLIENT:
KEYSTONE
PROPERTY TRUST

SOFTWARE AND
HARDWARE:
ILLUSTRATOR
PHOTOSHOP
QUARKXPRESS
MAC G4

MATERIALS:
POTLATCH McCOY
GLOSS

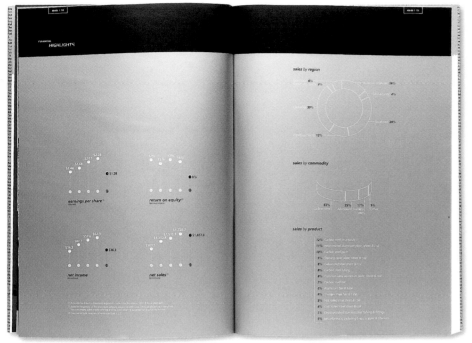

sales by region

sales by commodity

sales by product

earnings per share

return on equity

net income

net sales

051
METAL
RS01

ART DIRECTOR:
PEAT JARIYA

DESIGNERS:
PEAT JARIYA
GABE SCHREIBER

CLIENT:
RELIANCE STEEL
& ALU

SOFTWARE AND
HARDWARE:
ILLUSTRATOR
PAGEMAKER
PHOTOSHOP
MAC G4

MATERIALS:
POTLATCH McCOY

PRINTING:
AW

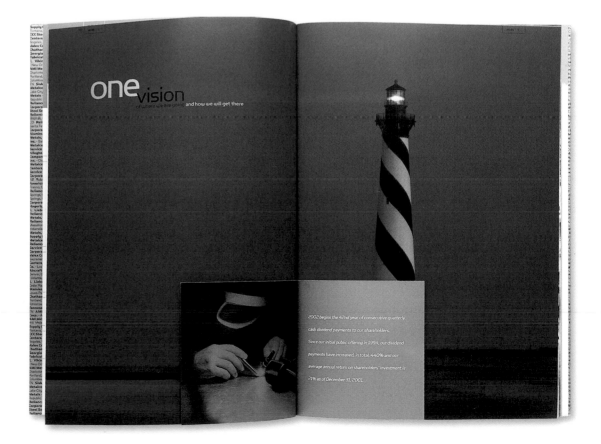

one vision of where we are going and how we will get there

2002 begins the 42nd year of consecutive quarterly
cash dividend payments to our shareholders.
Since our initial public offering in 1994, our dividend
payments have increased, in total, 440% and our
average annual return on shareholders' investment is
21% as of December 31, 2001.

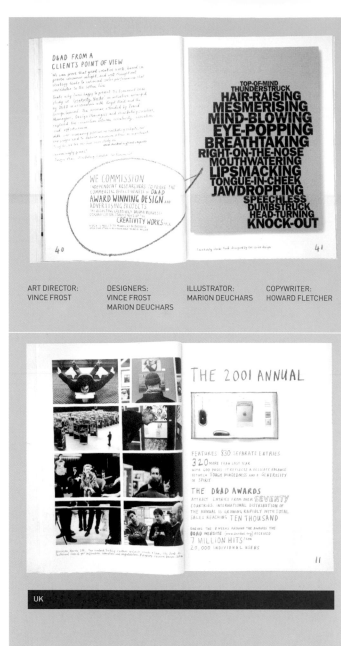

ART DIRECTOR:
VINCE FROST

DESIGNERS:
VINCE FROST
MARION DEUCHARS

ILLUSTRATOR:
MARION DEUCHARS

COPYWRITER:
HOWARD FLETCHER

CLIENT:
D&AD BRITISH
DESIGN & ART
DIRECTION

PAPER/MATERIALS:
PREMIER PAPER
CLASSIC PAPER
CYCLUS OFFSET

PRINTING:
VENTURA

UK

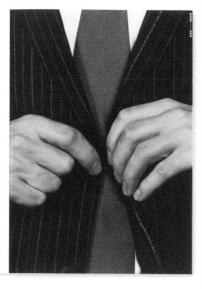

053
CAMPAÑEROS
COR GESCHÄFTSBERICHT 2001

ART DIRECTORS:	DESIGNER:	PHOTOGRAPHER:	CLIENT:	SOFTWARE AND	MATERIALS:	PRINTING:
GIULIA QUATTROVENTI	MICHAEL LAU	MICHAEL LAU	COR AG	HARDWARE:	NOBLESSE	4-COLOR +
MICHAEL LAU				QUARKXPRESS		4 SPECIALS
				MAC		

Relationships

It's putting longstanding relationships ... before short-term goals.
We've been a valued supplier to many of our pharmaceutical customers for more than 40 years.

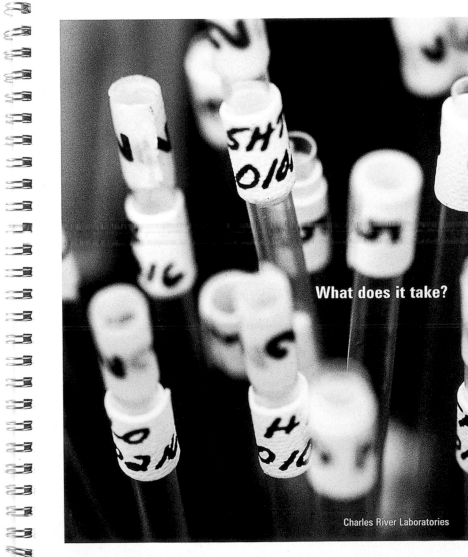

Trust

ART DIRECTOR:	DESIGNER:	CLIENT:	PRINTING:
EDWIN FOSTER	RYAN WADE	CHARLES RIVER	WE ANDREWS 6/6
		LABORATORIES	SHEETFED

054
FOSTER DESIGN GROUP
CHARLES RIVER LABORATORIES 2001

What does it take?

Charles River Laboratories

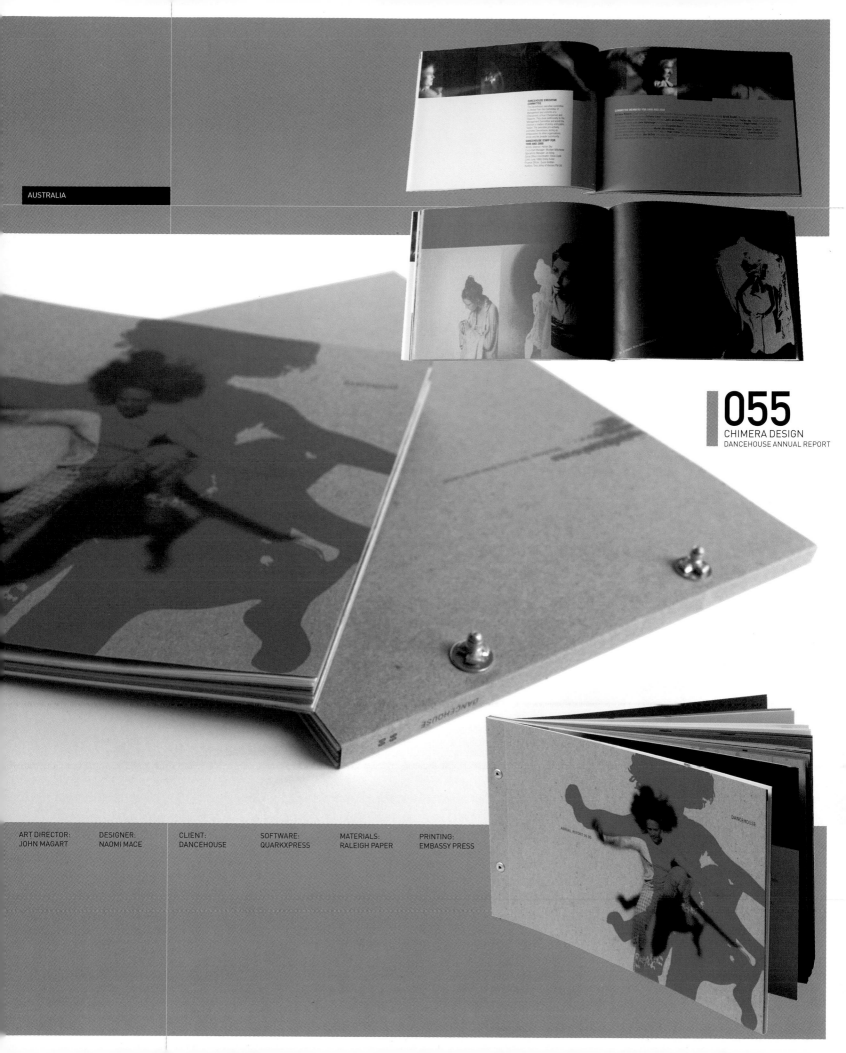

055
CHIMERA DESIGN
DANCEHOUSE ANNUAL REPORT

ART DIRECTOR:	DESIGNER:	CLIENT:	SOFTWARE:	MATERIALS:	PRINTING:
JOHN MAGART	NAOMI MACE	DANCEHOUSE	QUARKXPRESS	RALEIGH PAPER	EMBASSY PRESS

PRODUCT AND SERVICE BROCHURES

CAMPAÑEROS // KO CRÉATION // USINE DE BOUTONS // MADE THOUGHT // FROST DESIGN //
MORLA DESIGN // CAHAN & ASSOCIATES // HAT-TRICK DESIGN // OUT OF THE BLUE //
HEBE. WERBUNG & DESIGN // THE KITCHEN // ATTIK // HAND MADE GROUP // DESIGN5 //
EMERSON, WAJDOWICZ STUDIOS // C375 // PENTAGRAM SF // FAUXPAS // SEA DESIGN // Q //
WILLOUGHBY DESIGN GROUP // NB:STUDIO // MARIUS FAHRNER DESIGN // ROSE DESIGN
ASSOCIATES // BLOK DESIGN // UNA (LONDON) DESIGNERS // FABIO ONGARATO DESIGN //
MUTABOR DESIGN // AJANS ULTRA // HAMBLY & WOOLLEY // IRIDIUM, A DESIGN COMPANY //
DESIGN ASYLUM // EMERY VINCENT DESIGN

:03

GERMANY

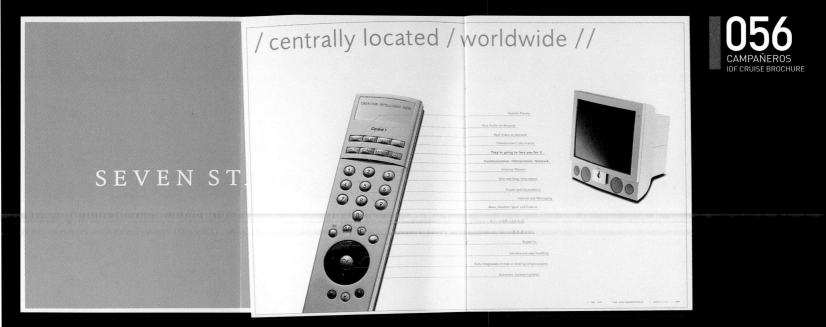

ART DIRECTOR:
MARTIN KAHRMANN

DESIGNER:
MARTIN KAHRMANN

ILLUSTRATOR:
MARTIN KAHRMANN

CLIENT:
IDF

SOFTWARE AND
HARDWARE:
QUARKXPRESS
MAC

PAPER/MATERIAL:
LUXO SANT OFFSET

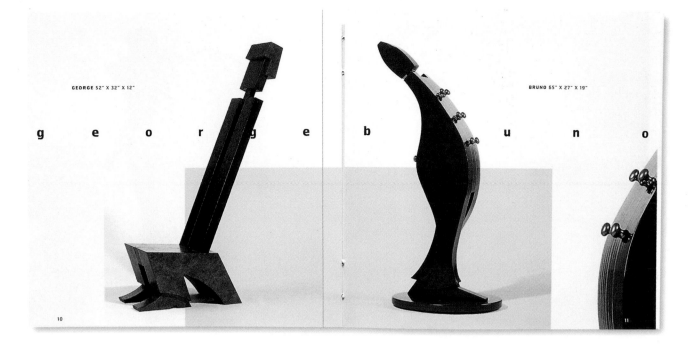

GEORGE 52" X 32" X 12" BRUNO 65" X 27" X 19"

g e o r g e b u n o

10 11

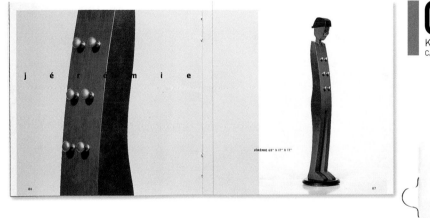

jérémie

JÉRÉMIE 68" X 17" X 12"

06 07

057
KO CRÉATION
CARIGNAN SELF-PROMO

ART DIRECTOR. DESIGNER. CLIENT. SOFTWARE.
ANNIE LACHAPELLE ANNIE LACHAPELLE CARIGNAN QUARKXPRESS

ca ri gna n

ANTOINETTE | ARNO | ARTHUR | BERTA | BRUNO | GEORGE | JÉRÉMIE | JÉRÔMES | KATIA | MERLIN | WILBROD

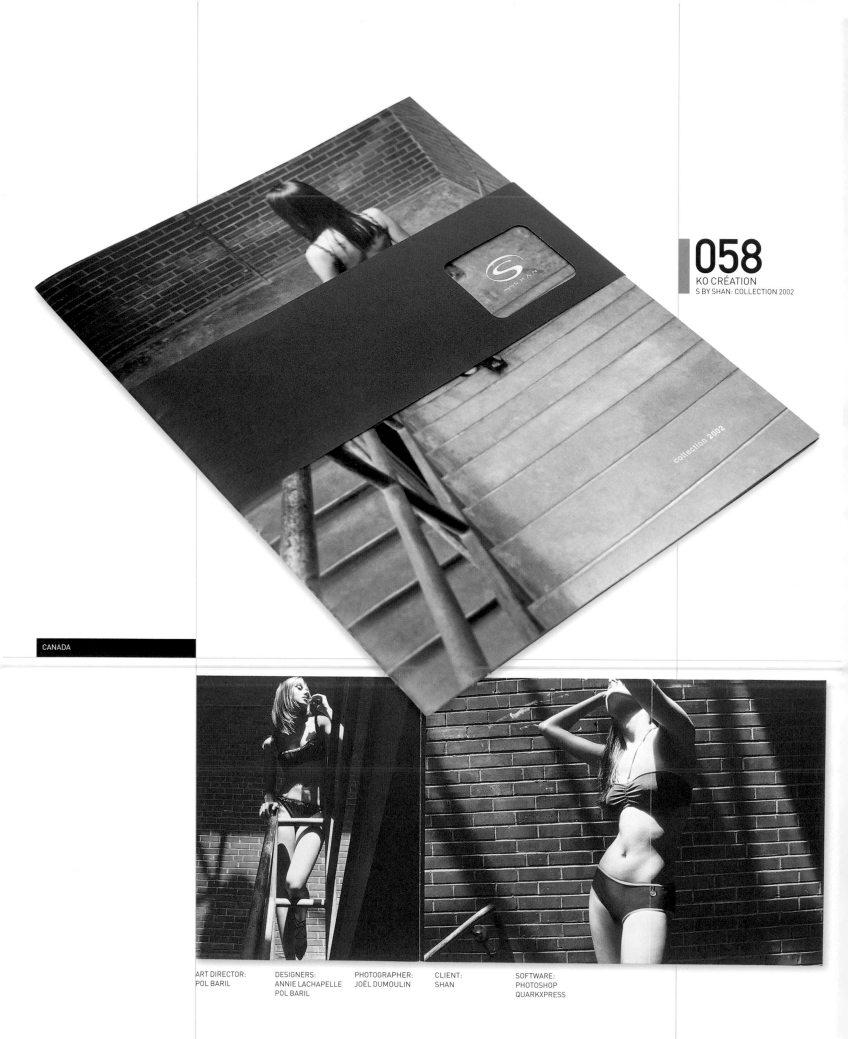

CANADA

ART DIRECTOR:
POL BARIL

DESIGNERS:
ANNIE LACHAPELLE
POL BARIL

PHOTOGRAPHER:
JOËL DUMOULIN

CLIENT:
SHAN

SOFTWARE:
PHOTOSHOP
QUARKXPRESS

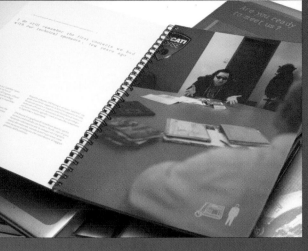

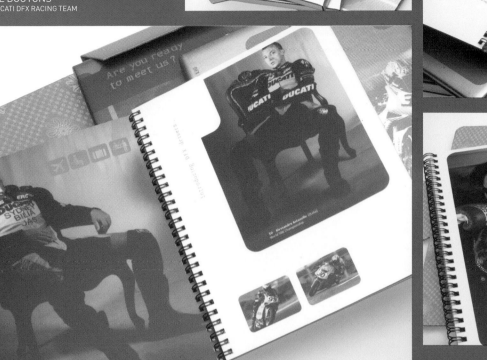

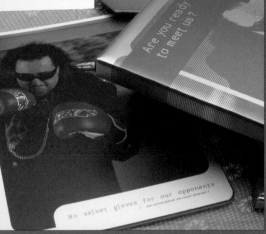

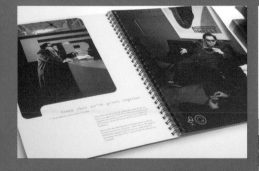

ART DIRECTORS:
LIONELLO BOREAN
CHIARA GRANDESSO

DESIGNER:
LIONELLO BOREAN
CHIARA GRANDESSO

CLIENT:
PIRELLI/DUCATI DFX
RACING TEAM

PRINTING:
CMYK + GOLD

ITALY

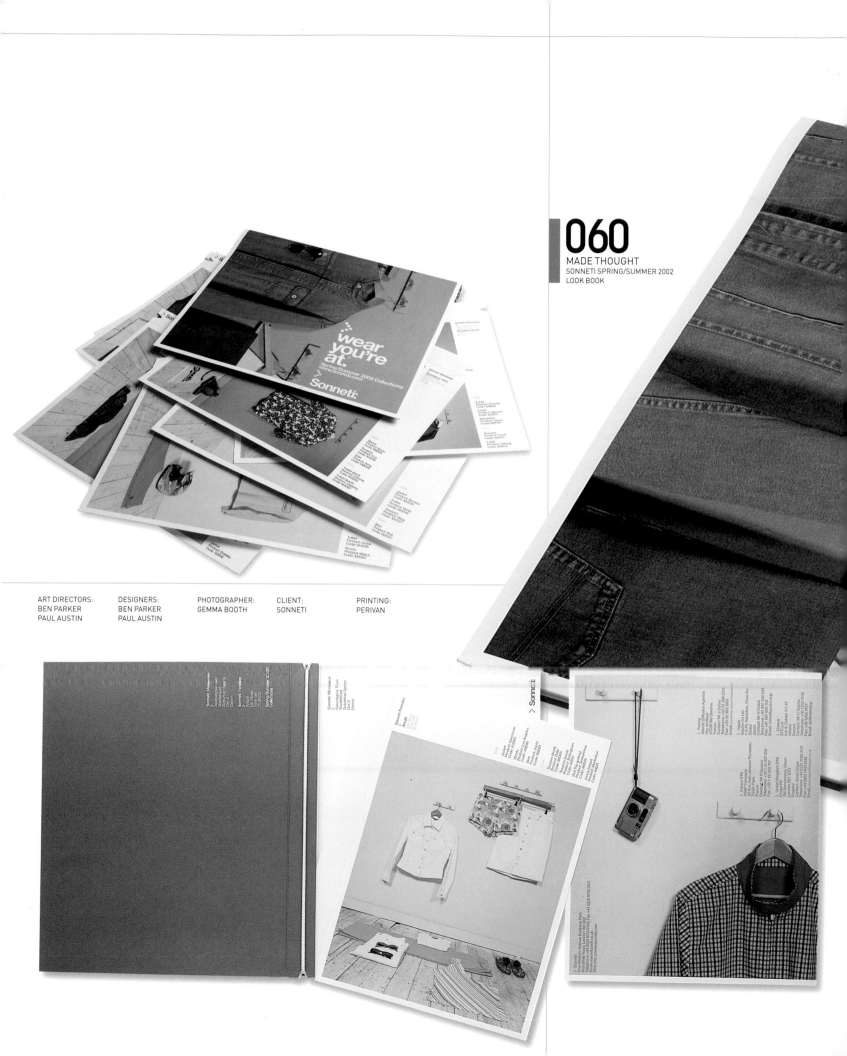

ART DIRECTORS:
BEN PARKER
PAUL AUSTIN

DESIGNERS:
BEN PARKER
PAUL AUSTIN

PHOTOGRAPHER:
GEMMA BOOTH

CLIENT:
SONNETI

PRINTING:
PERIVAN

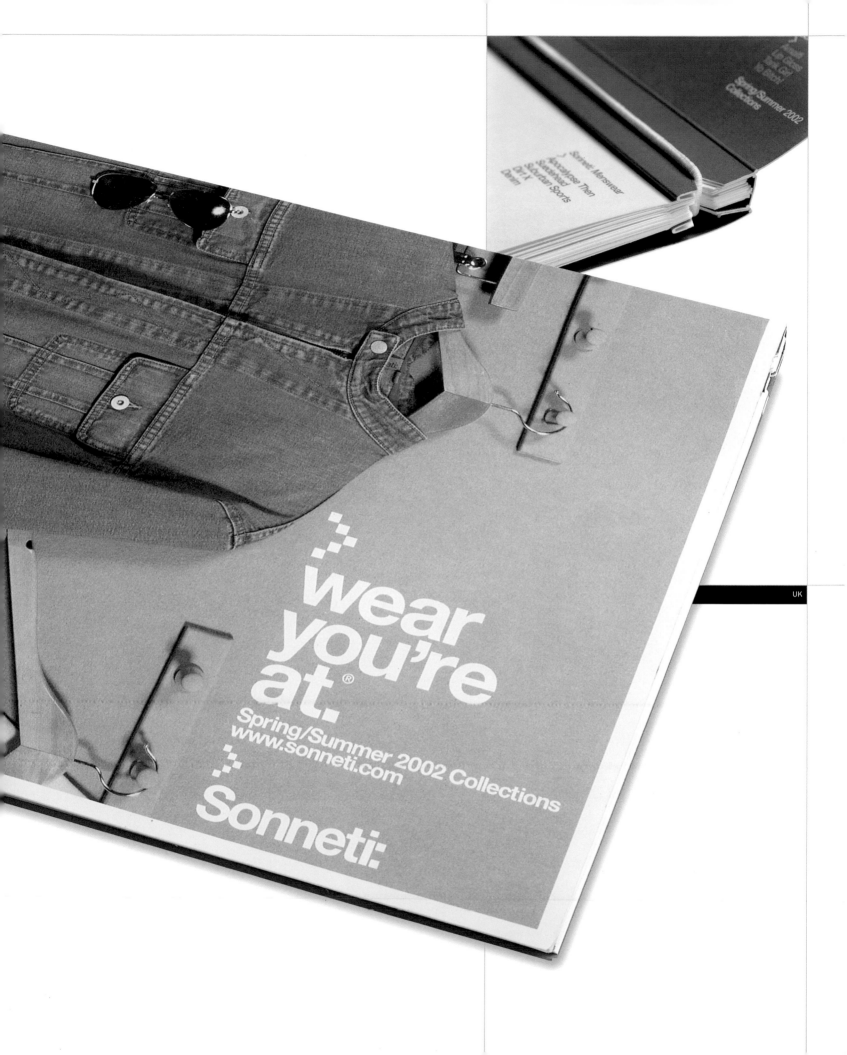

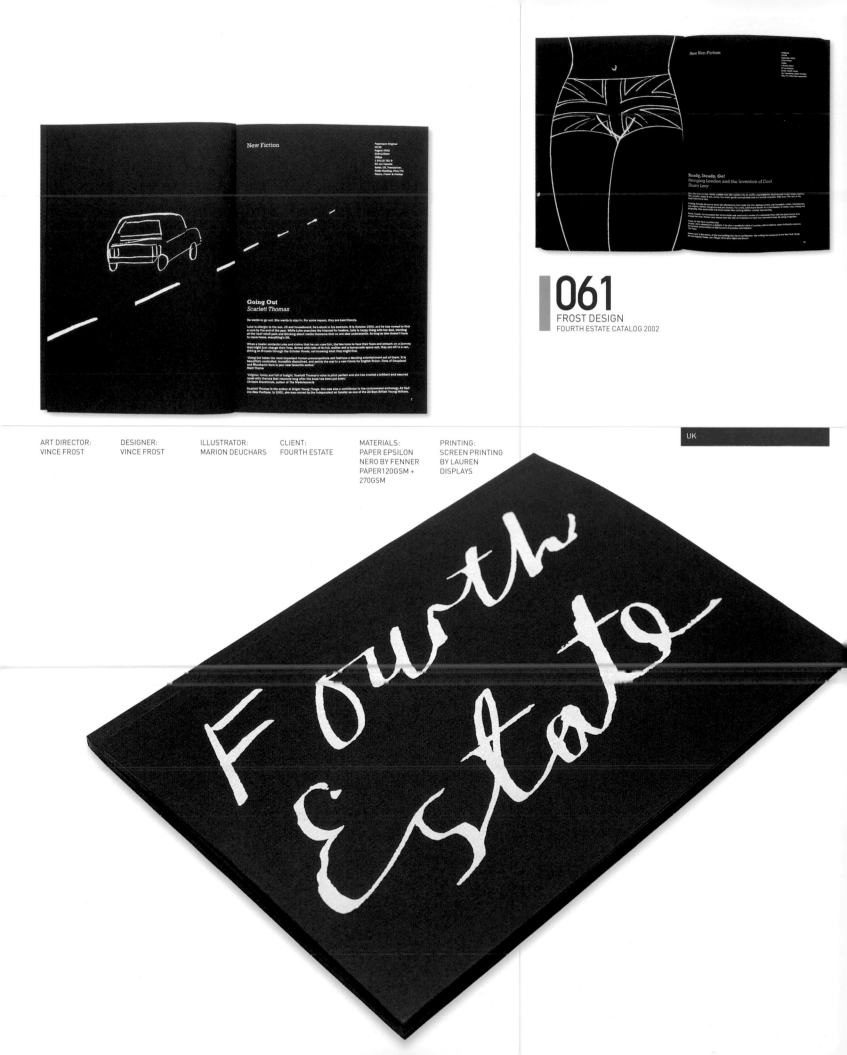

New Fiction

Paperback Original
£9.99
August 2002
216x135mm
208pp
1.84115 762 9
BC ero Canada
Serial, US, Translation,
Radio Reading, Film/TV,
Peters, Fraser & Dunlop

Going Out
Scarlett Thomas

He wants to go out. She wants to stay in. For some reason, they are best friends.

Luke is allergic to the sun. 25 and housebound, he's stuck in his bedroom. It is October 2000, and he has vowed to find a cure by the end of the year. While Luke searches the Internet for healers, Julie is happy living with her dad, working at the local retail park and thinking about maths theorems that no one else understands. As long as she doesn't have to leave home, everything's OK.

When a healer contacts Luke and claims that he can cure him, the two have to face their fears and embark on a journey that might just change their lives. Armed with rolls of tin foil, wellies and a homemade space suit, they set off in a van, driving on B-roads through the October floods, not knowing what they might find.

'Going Out takes the most important human preoccupations and fashions a dazzling entertainment out of them. It is beautifully controlled, incredibly disciplined, and points the way to a new future for English fiction. Fans of Coupland and Murakami here is your new favourite author.'
Matt Thorne

'Original, funny and full of insight. Scarlett Thomas's voice is pitch perfect and she has created a brilliant and assured novel with themes that resonate long after the book has been put down.'
Chrissie Glazebrook, author of The Madolescents

Scarlett Thomas is the author of Bright Young Things. She was also a contributor to the controversial anthology All Hail the New Puritans. In 2001, she was named by the Independent on Sunday as one of the 20 Best British Young Writers.

New Non-Fiction

Hardback
£12.99
September 2002
234x153mm
300pp
1 84115 552 8
All ero Canada,
Serial, Radio Reading,
US, Translation, Radio Reading,
Film/TV w/Ben Films associated

Ready, Steady, Go!
Swinging London and the Invention of Cool
Shawn Levy

ART DIRECTOR:
VINCE FROST

DESIGNER:
VINCE FROST

ILLUSTRATOR:
MARION DEUCHARS

CLIENT:
FOURTH ESTATE

MATERIALS:
PAPER EPSILON
NERO BY FENNER
PAPER120GSM +
270GSM

PRINTING:
SCREEN PRINTING
BY LAUREN
DISPLAYS

|061
FROST DESIGN
FOURTH ESTATE CATALOG 2002

UK

062
MORLA DESIGN
WORLD EXPLORER CRUISES:
BROCHURE

USA

ART DIRECTOR:	DESIGNERS:	CLIENT:	SOFTWARE:	MATERIALS:	PRINTING:
JENNIFER MORLA	JENNIFER MORLA	WORLD EXPLORER	ILLUSTRATOR	70# LUNA TEXT	GRAPHIC ARTS
	CARRIE FERGUSON	CRUISES	QUARKXPRESS	GLOSS	CENTER

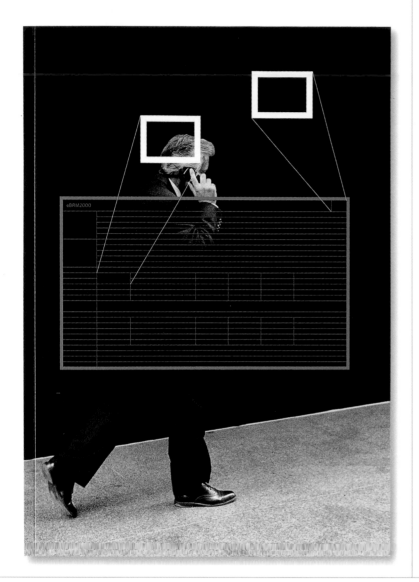

USA

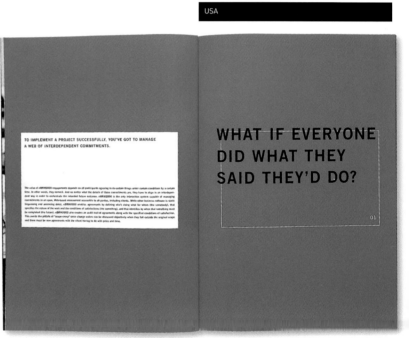

TO IMPLEMENT A PROJECT SUCCESSFULLY, YOU'VE GOT TO MANAGE
A WEB OF INTERDEPENDENT COMMITMENTS.

WHAT IF EVERYONE
DID WHAT THEY
SAID THEY'D DO?

ART DIRECTOR:
BILL CAHAN

DESIGNER:
KEVIN ROBERSON

CLIENT:
ACTION
TECHNOLOGIES

MATERIALS:
VINTAGE VELVET 80#

PRINTING:
LITHO

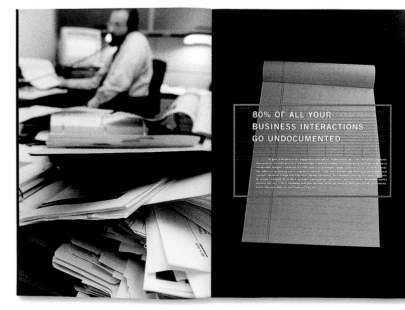

80% OF ALL YOUR
BUSINESS INTERACTIONS
GO UNDOCUMENTED.

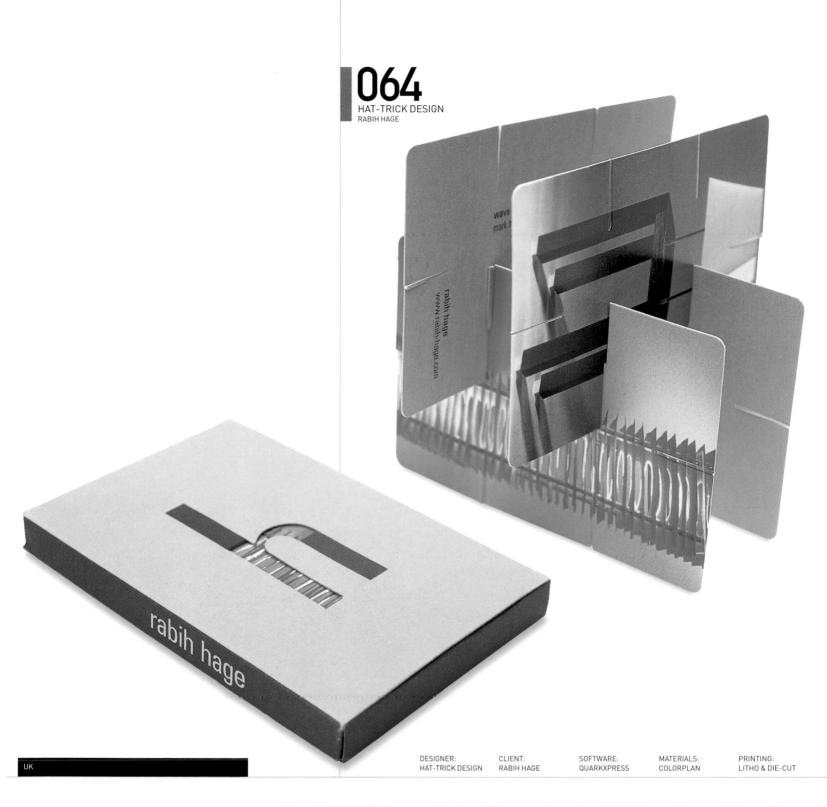

rabih hage
www.rabih-hage.com

rabih hage

DESIGNER:	CLIENT:	SOFTWARE:	MATERIALS:	PRINTING:
HAT-TRICK DESIGN	RABIH HAGE	QUARKXPRESS	COLORPLAN	LITHO & DIE-CUT

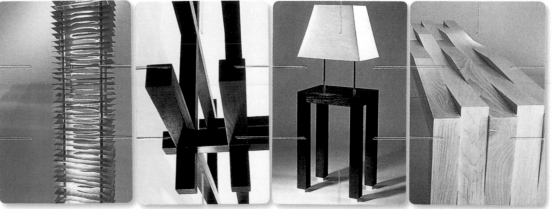

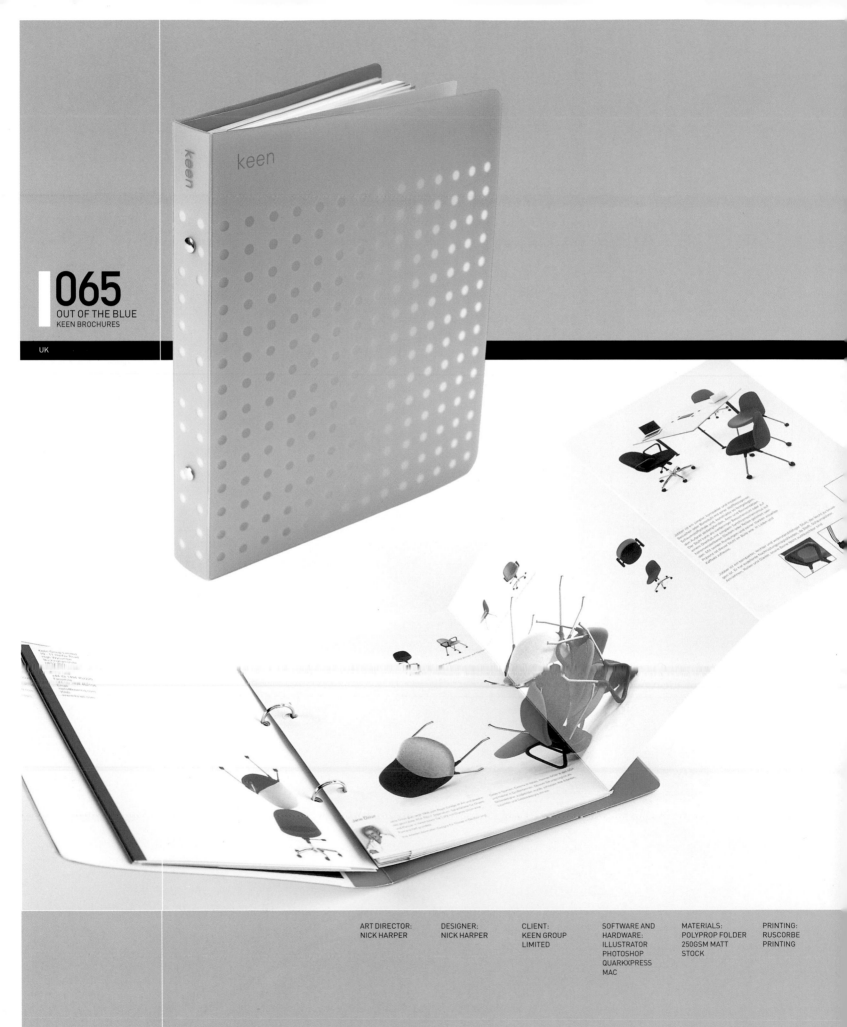

065
OUT OF THE BLUE
KEEN BROCHURES

UK

keen

ART DIRECTOR:	DESIGNER:	CLIENT:	SOFTWARE AND	MATERIALS:	PRINTING:
NICK HARPER	NICK HARPER	KEEN GROUP	HARDWARE:	POLYPROP FOLDER	RUSCORBE
		LIMITED	ILLUSTRATOR	250GSM MATT	PRINTING
			PHOTOSHOP	STOCK	
			QUARKXPRESS		
			MAC		

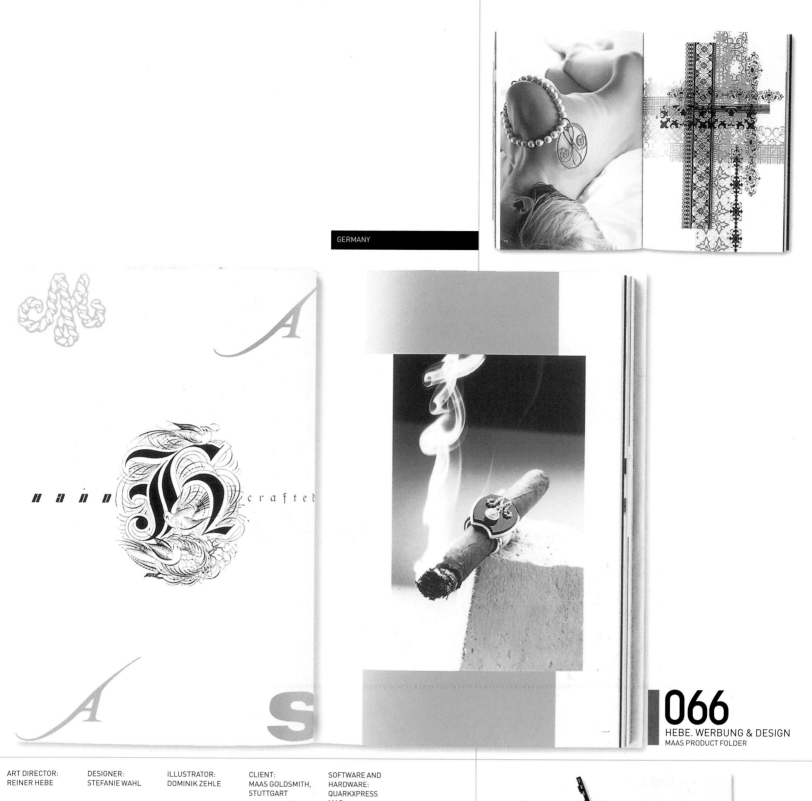

066
HEBE. WERBUNG & DESIGN
MAAS PRODUCT FOLDER

ART DIRECTOR:
REINER HEBE

DESIGNER:
STEFANIE WAHL

ILLUSTRATOR:
DOMINIK ZEHLE

CLIENT:
MAAS GOLDSMITH,
STUTTGART

SOFTWARE AND
HARDWARE:
QUARKXPRESS
MAC

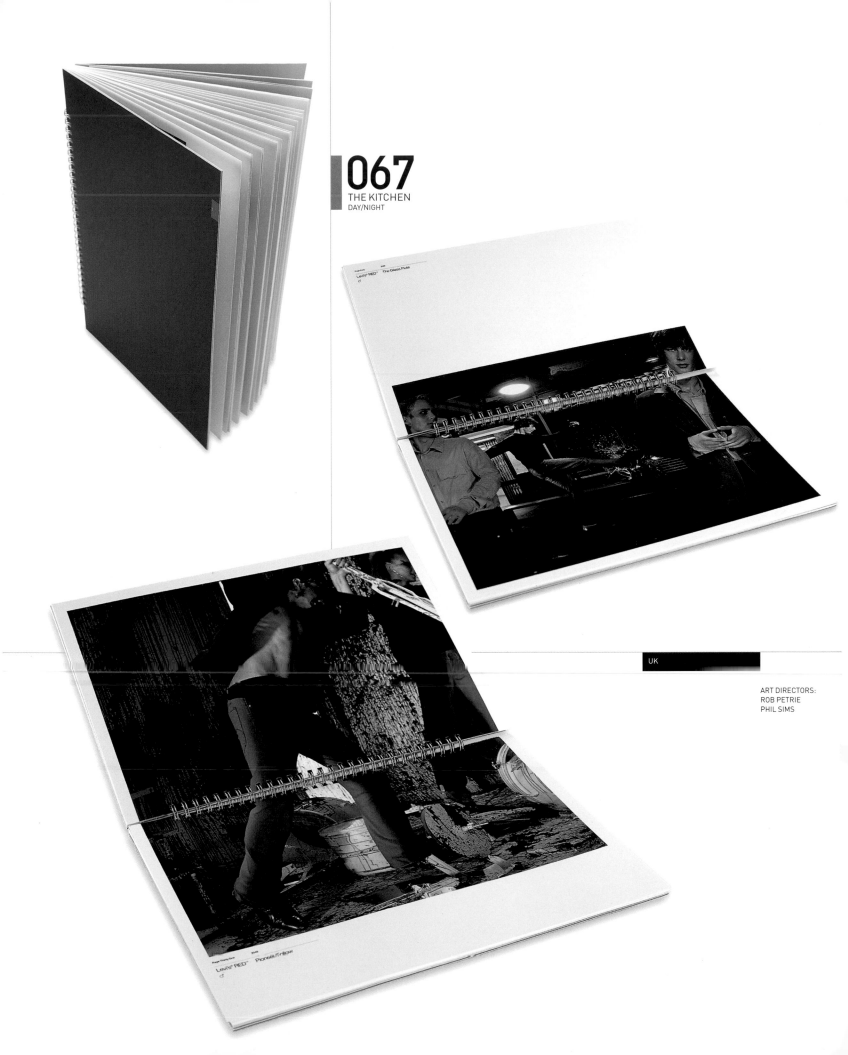

UK

ART DIRECTORS:
ROB PETRIE
PHIL SIMS

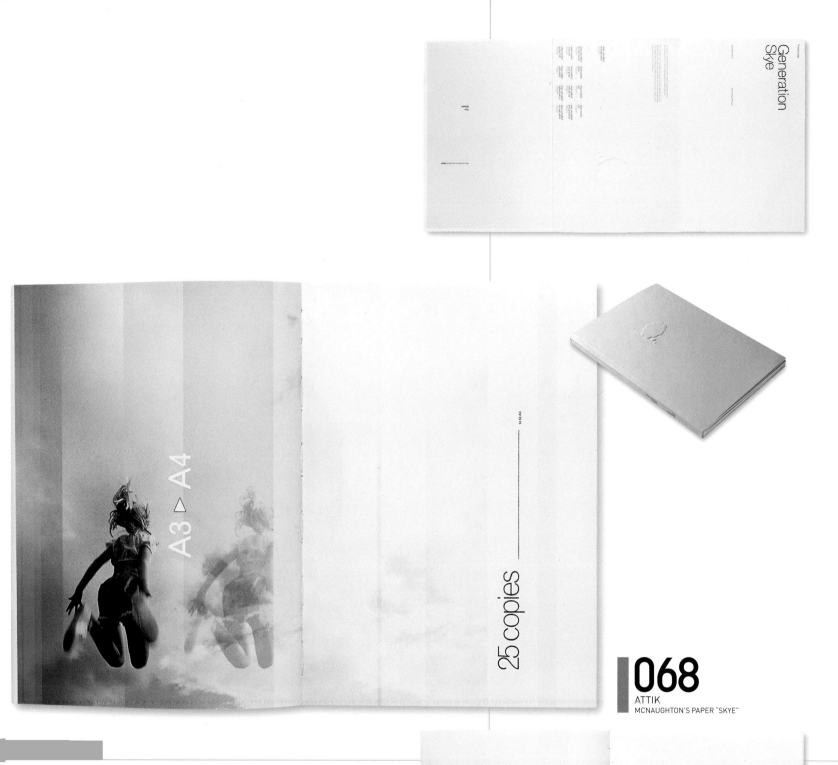

A3 ▷ A4

25 copies

Generation
Skye

068
ATTIK
MCNAUGHTON'S PAPER "SKYE"

ART DIRECTOR:
ATTIK

DESIGNER:
ATTIK

PHOTOGRAPHER:
ATTIK

CLIENT:
MCNAUGHTON'S
PAPER

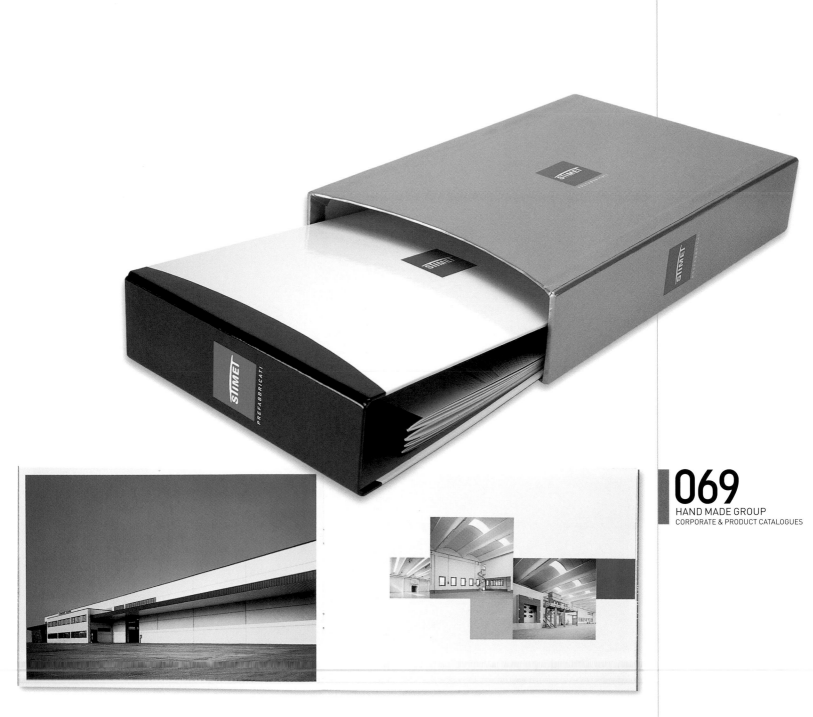

069

HAND MADE GROUP
CORPORATE & PRODUCT CATALOGUES

ART DIRECTOR:
ALESSANDRO ESTERI

DESIGNER:
GIONA MAIARELLI

PHOTOGRAPHER:
ALESSANDRO ESTERI

CLIENT:
STIMET
PREFABBRICATI

SOFTWARE AND
HARDWARE:
QUARKXPRESS
MAC

MATERIALS:
ZANDERS

PRINTING:
OFFSET

ITALY

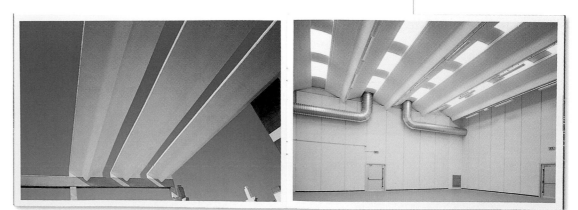

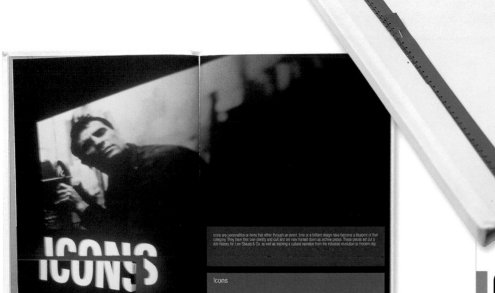

ICONS

Icons

Icons are personalities or items that either through an event, time or a brilliant design have become a blueprint of their category. They have their own identity and cult and are now hunted down as archive pieces. These pieces set out a rich history for Levi Strauss & Co. as well as tracking a cultural narration from the industrial revolution to modern day.

070
THE KITCHEN
LVC ART BOOK

ART DIRECTORS:
ROB PETRIE
PHIL SIMS

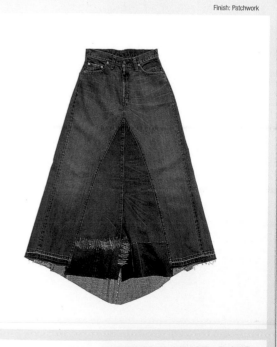

Pop & Protest 15051—0270

Finish: Patchwork

505® Skirt
(1960's)

Based around the 1967 505® jean the long A-line customised skirt was a typical girls silhouette of the early 70's. The 505® jean has a Clean Repair finish in medium blue with stone washing and scraped local abrasion. Made out of denim pieces with different finishes, the skirt is patched together using selvage fabrics, epitomising the style and customisation of garments by youth culture at that time.

1 The famous red ID line of the XX narrow width looms from Cone Mills
2 Bar tacks at pocket corners for extra strength
3 Twin needle Arcuate stitch
4 Zip fly and copper waistband button

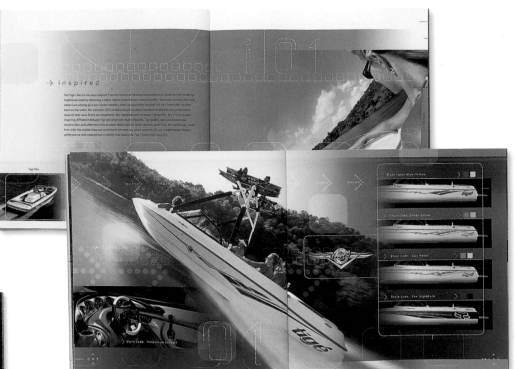

→ inspired

Form is most exquisite when it serves to enhance function.

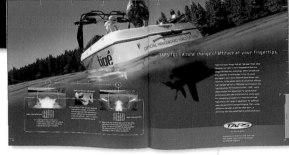

USA

ART DIRECTOR:
RON NIKKEL

DESIGNERS:
RACHEL ACTON
CHRIS DUBURG

CLIENT:
TIGÉ BOATS, INC

SOFTWARE AND
HARDWARE:
ILLUSTRATOR
PHOTOSHOP
MAC G4

PRINTING:
GRAPHIC PRESS

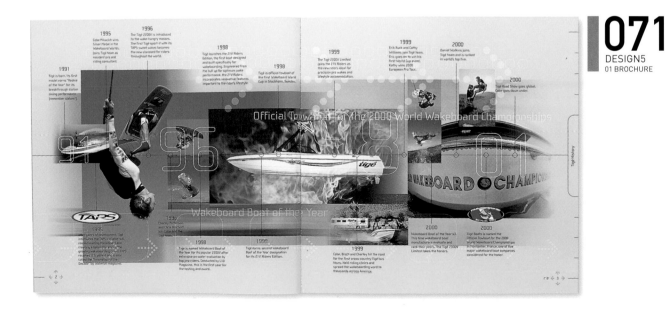

What appears to be is what I deal with.

sn

Sometimes, hum
the scene you p
take a picture of
and it's lifeless,
you can take a p
scratching his n
great picture. ■ I am a professional photogra
pher by trade and an amateur photographer by
vocation. Most of the time when I
am out of the house I carry a small
unobtrusive camera and I snap
away obsessively at things that
interest me and whatever I think
would make a good picture.

USA

museums

I certainly don't use those funny words museum people and art
critics like. Things should be left open to interpretation. If
you can take it apart, maybe it doesn't mean anything.

I go to museums to people watch.
Because everyone there has gone
to look and they are captured in a
concentrated place, it is a particularly good
thing. For a photographer, rather than fly
casting, it's like shooting fish in a barrel.
■ It is amazing how something which isn't
much of anything becomes important when
it's framed. Often the frames are
more artistic than their contents.
They are very reassuring, like the
labels. Some people spend more
time looking at the labels than at
the work itself.
In the end all museums are interesting.
Even when they're not.

ART DIRECTORS:
JUREK WAJDOWICZ
LISA LAROCHELLE

DESIGNERS:
JUREK WAJDOWICZ
LISA LAROCHELLE
MANNY MENDEZ

CLIENT:
DOMTAR

SOFTWARE:
QUARKXPRESS

MATERIALS:
BRAVO

PRINTING:
MACDONALD
PRINTING

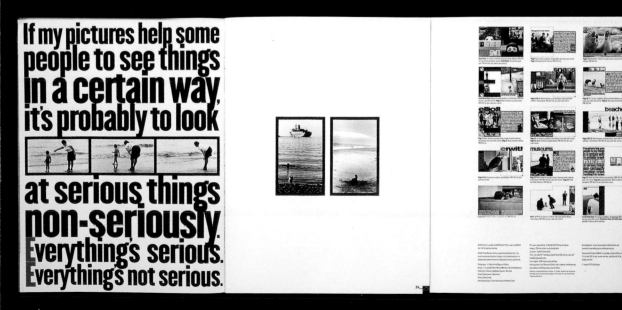

If my pictures help some
people to see things
in a certain way,
it's probably to look
at serious things
non-seriously.
Everything's serious.
Everything's not serious.

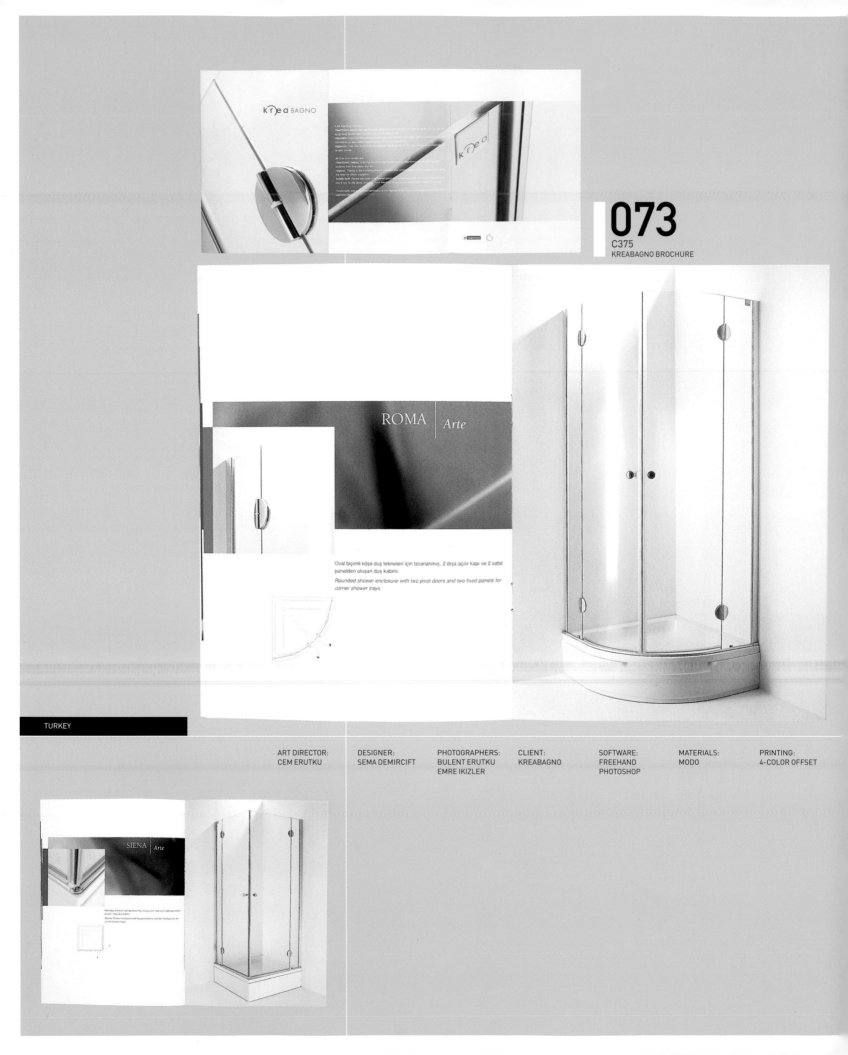

ROMA | *Arte*

Oval biçimli köşe duş tekneleri için tasarlanmış. 2 dışa açılır kapı ve 2 sabit panelden oluşan duş kabini.

Rounded shower enclosure with two pivot doors and two fixed panels for corner shower trays.

TURKEY

ART DIRECTOR:	DESIGNER:	PHOTOGRAPHERS:	CLIENT:	SOFTWARE:	MATERIALS:	PRINTING:
CEM ERUTKU	SEMA DEMIRCIFT	BULENT ERUTKU	KREABAGNO	FREEHAND	MODO	4-COLOR OFFSET
		EMRE IKIZLER		PHOTOSHOP		

SIENA | *Arte*

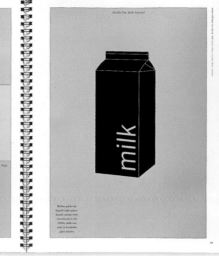

ART DIRECTOR:
KIT HINRICHS

DESIGNER:
MARIA WENZEL

CLIENT:
POTLATCH PAPER

SOFTWARE AND
HARDWARE:
ILLUSTRATOR
PHOTOSHOP
MAC

MATERIALS:
POTLATCH

PRINTING:
ANDERSON,
LOS ANGELES

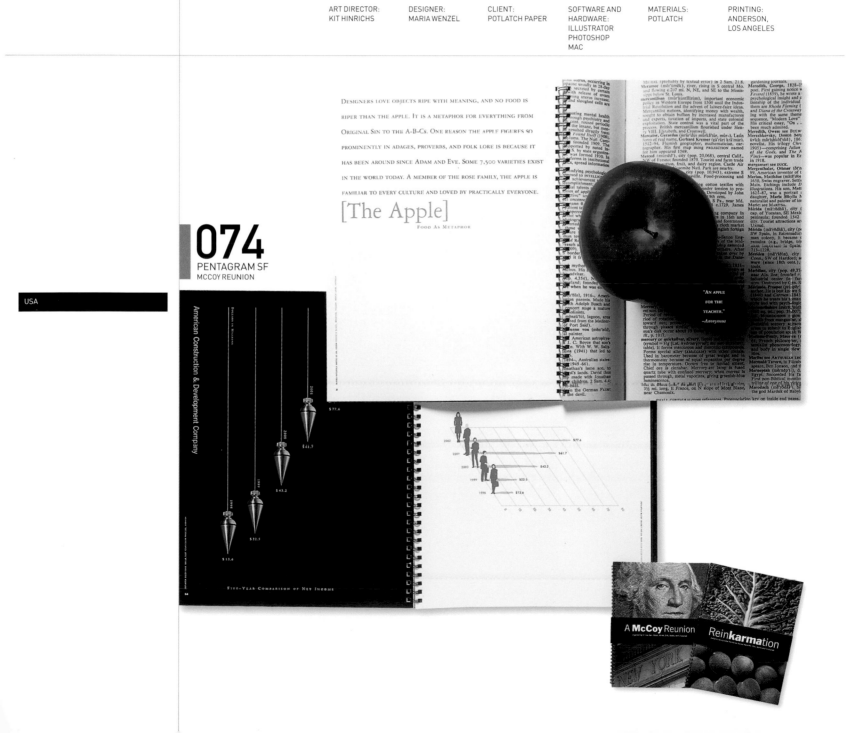

074

PENTAGRAM SF
MCCOY REUNION

USA

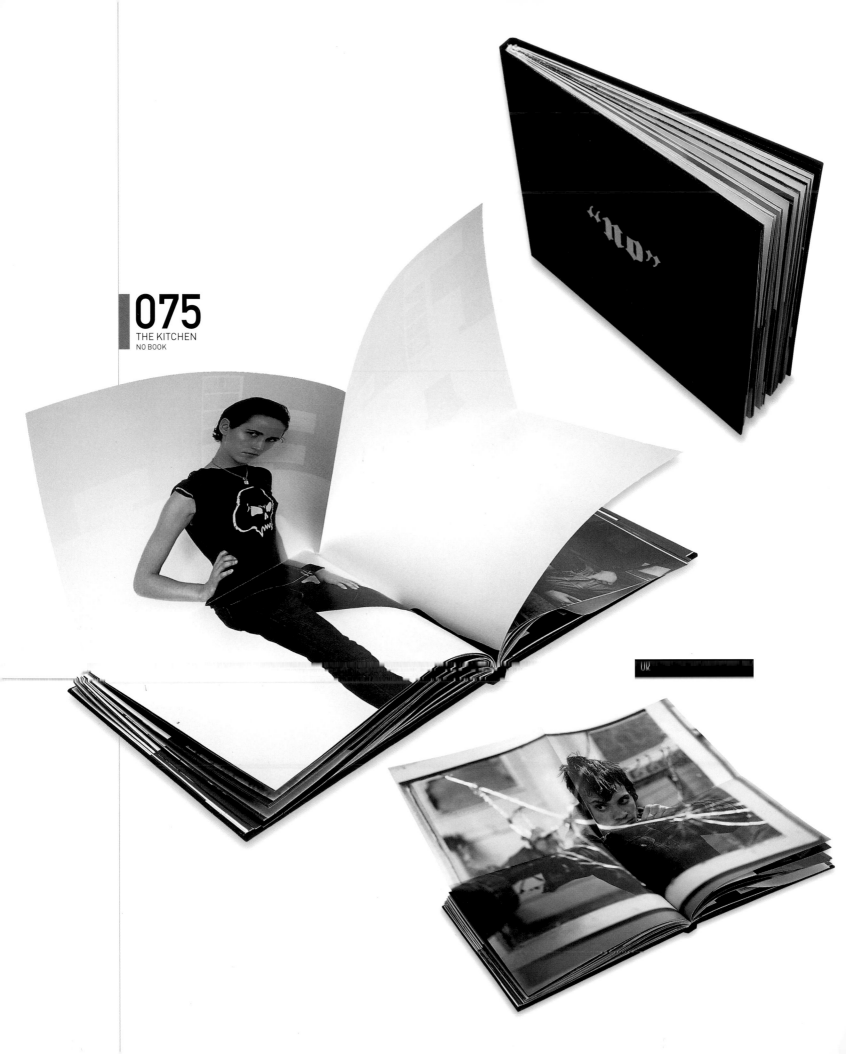

"NO"

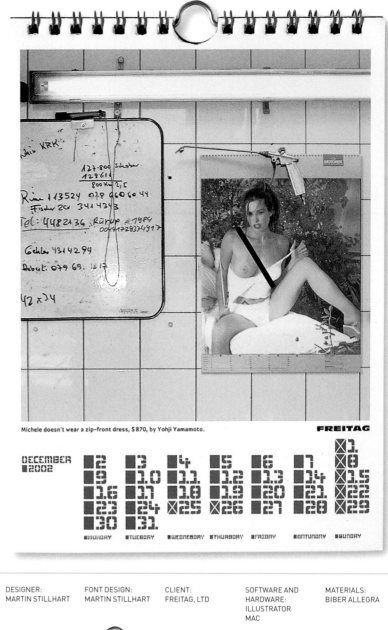

Michele doesn't wear a zip-front dress, $870, by Yohji Yamamoto.

FREITAG

DECEMBER 2002

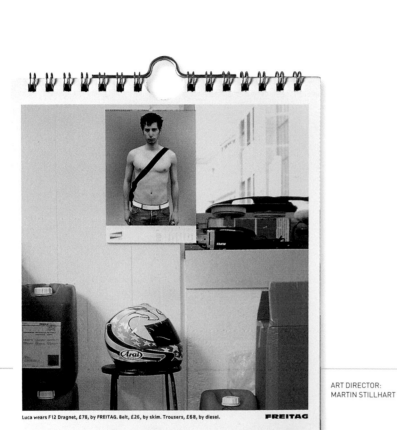

Luca wears F12 Dragnet, £78, by FREITAG. Belt, £26, by skim. Trousers, £68, by diesel.

FREITAG

JANUARY 2002

SWITZERLAND

ART DIRECTOR:
MARTIN STILLHART

DESIGNER:
MARTIN STILLHART

FONT DESIGN:
MARTIN STILLHART

CLIENT:
FREITAG, LTD

SOFTWARE AND
HARDWARE:
ILLUSTRATOR
MAC

MATERIALS:
BIBER ALLEGRA

076
FAUXPAS
FREITAG CALENDAR 2002

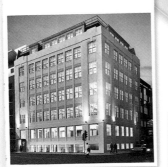

EVEN IN 1925, THE CORNER
OF FARRINGDON ROAD AND
CLERKENWELL ROAD WAS
A PRIME SPOT. TODAY IT'S
A PIVOTAL SPOT.

IT'S WHERE PUBLIC RELATIONS
MEETS PRIVATE BANKING.
WHERE ADVERTISING MEETS
ASSET FINANCE. WHERE THE
MAC MEETS THE PC.

AS SUCH, IT WOULD SUIT A
LEGAL OR FINANCIAL COMPANY
MOVING WEST. OR A CREATIVE
COMPANY MOVING EAST.

077

SEA DESIGN
THE CORNER

ART DIRECTOR:
JOHN SIMPSON

DESIGNER:
JAMIE ROBERTS

CLIENT:
PILCHER HERSHAM

SOFTWARE AND
HARDWARE:
ILLUSTRATOR
PHOTOSHOP
QUARKXPRESS
MAC G4

MATERIALS:
NATURALIS
GALLERY SILK
ARTIC WHITE
SMOOTH

PRINTING:
4 COLOR &
EMBOSSING

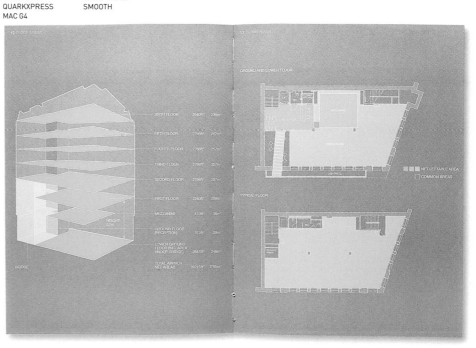

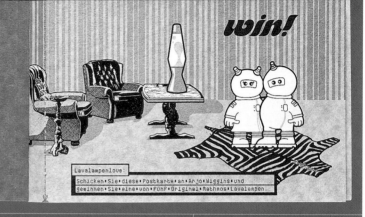

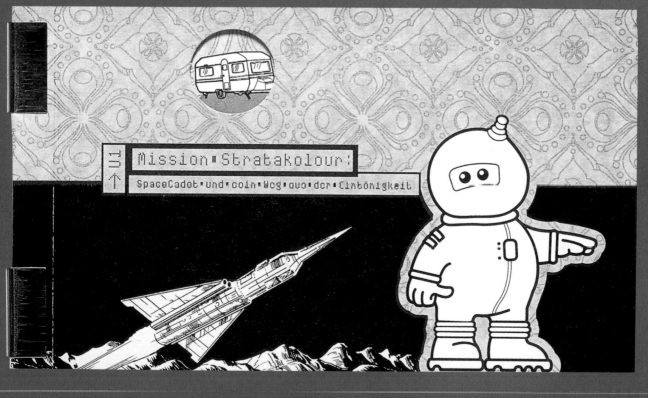

078
Q
MISSION STRATAKOLOUR

ART DIRECTOR:
THILO VON
DEBSCHITZ

DESIGNER:
MATTHIAS FREY

PHOTOGRAPHER:
MATTHIAS FREY

CLIENT:
ARJO WIGGINS
GERMANY

SOFTWARE AND
HARDWARE:
ILLUSTRATOR
QUARKXPRESS
MAC

MATERIALS:
STRATAKOLOUR

PRINTING:
GORIUS DRUCK &
SERVICE

ART DIRECTOR:
ANN WILLOUGHBY

DESIGNER:
TRENTON KENAGY

CLIENT:
EL DORADO INC

SOFTWARE AND
HARDWARE:
QUARKXPRESS
MAC

MATERIALS:
UNCOATED
CHIPBOARD

PRINTING:
IN-HOUSE

USA

079
WILLOUGHBY DESIGN GROUP
BARN BOOK

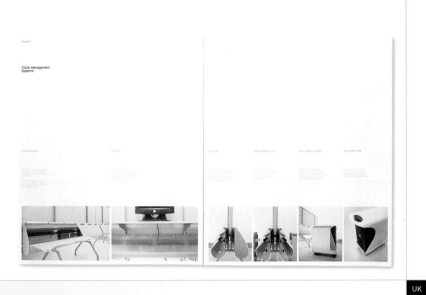

Cable Management
Systems

080
SEA DESIGN
BEYON

ART DIRECTOR:
BRYAN EDMONDSON

CLIENT:
RICHMOND
SOLUTIONS

SOFTWARE AND
HARDWARE:
ILLUSTRATOR
PHOTOSHOP
QUARKXPRESS
MAC G4

MATERIALS:
GALLERY ART SILK
170GSM

PRINTING:
CASE BOUND +
EMBOSS + 4-COLOR
+ M/C VARNISH

Desks

Shelves

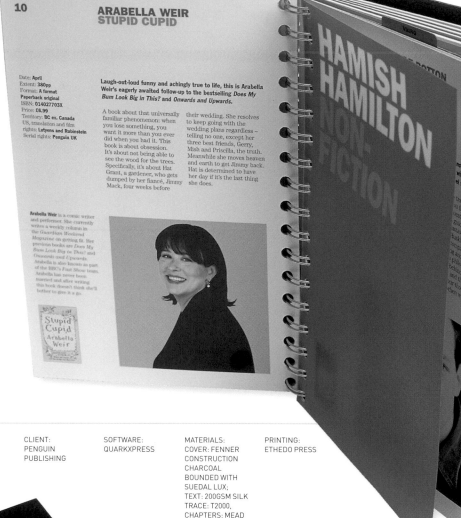

10

ARABELLA WEIR
STUPID CUPID

Date: **April**
Extent: **380pp**
Format: **A format**
Paperback original
ISBN: **014027703X**
Price: **£6.99**
Territory: **BC ex. Canada**
US, translation and film
rights: **Lutyens and Rubinstein**
Serial rights: **Penguin UK**

Laugh-out-loud funny and achingly true to life, this is Arabella Weir's eagerly awaited follow-up to the bestselling *Does My Bum Look Big in This?* and *Onwards and Upwards.*

A book about that universally familiar phenomenon: when you lose something, you want it more than you ever did when you had it. This book is about obsession. It's about not being able to see the wood for the trees. Specifically, it's about Hat Grant, a gardener, who gets dumped by her fiancé, Jimmy Mack, four weeks before their wedding. She resolves to keep going with the wedding plans regardless – telling no one, except her three best friends, Gerry, Mish and Priscilla, the truth. Meanwhile she moves heaven and earth to get Jimmy back. Hat is determined to have her day if it's the last thing she does.

Arabella Weir is a comic writer and performer. She currently writes a weekly column in the *Guardian Weekend Magazine* on getting fit. Her previous books are *Does My Bum Look Big in This?* and *Onwards and Upwards*. Arabella is also known as part of the BBC's *Fast Show* team. Arabella has never been married and after writing this book doesn't think she'll bother to give it a go.

UK

ART DIRECTORS:
ALAN DYE
NICK FINNEY
BEN STOTT

DESIGNER:
NICK VINCENT

CLIENT:
PENGUIN
PUBLISHING

SOFTWARE:
QUARKXPRESS

MATERIALS:
COVER: FENNER
CONSTRUCTION
CHARCOAL
BOUNDED WITH
SUEDAL LUX;
TEXT: 200GSM SILK
TRACE: T2000,
CHAPTERS: MEAD
CUSTOM NOTE

PRINTING:
ETHEDO PRESS

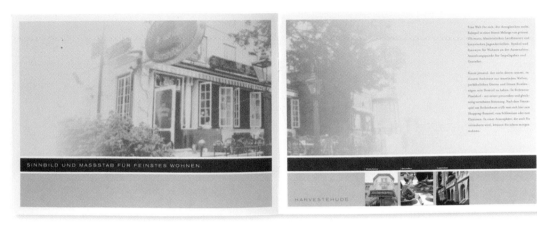

SINNBILD UND MASSSTAB FÜR FEINSTES WOHNEN.

HARVESTEHUDE

ART DIRECTORS:
MARIUS FAHRNER
UMUB ETTERLIG

DESIGNERS:
MARIUS FAHRNER
UMUB ETTERLIG

CLIENT:
DAHLER & COMPANY
PROJECT MARKETING

SOFTWARE:
FREEHAND

MATERIALS:
RÖMERTURM
CURTIS ESPARTO

PRINTING:
4-COLOR OFFSET

082
MARIUS FAHRNER DESIGN
AVANTGARDE

GERMANY

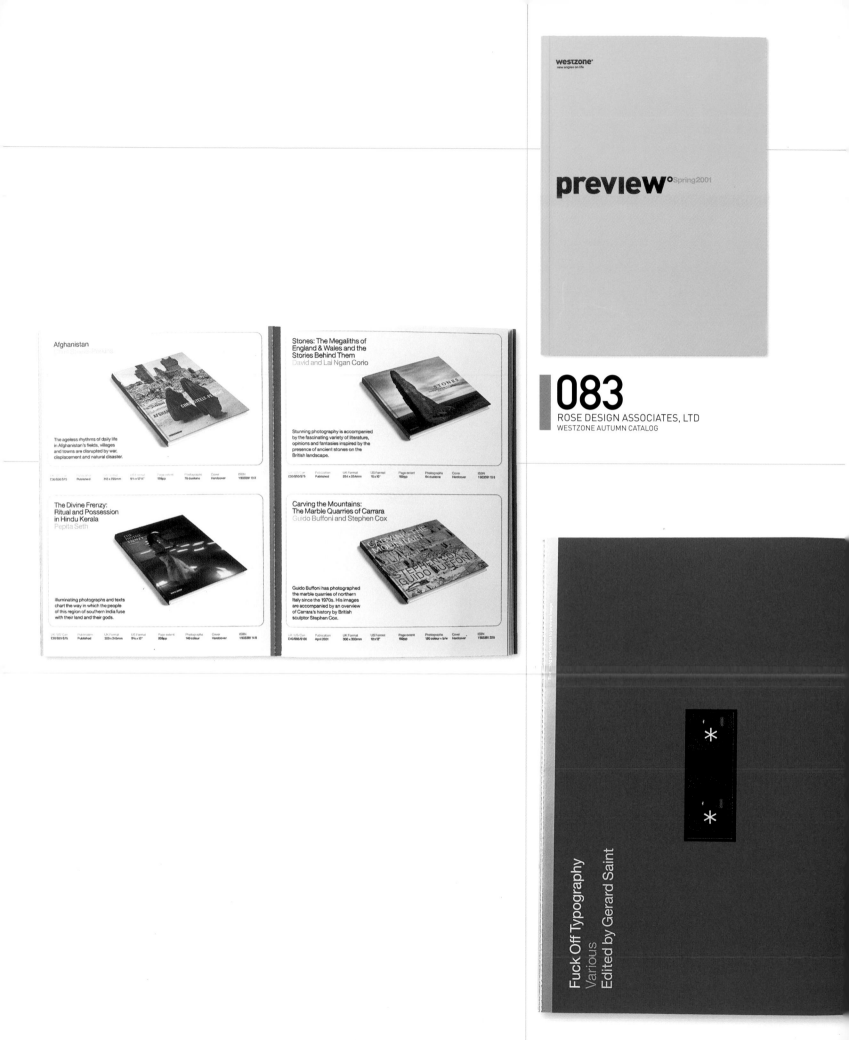

westzone°
new angles on life

preview°Spring2001

Afghanistan
Christelle Perkins

The ageless rhythms of daily life in Afghanistan's fields, villages and towns are disrupted by war, displacement and natural disaster.

UK/US/Can	Publication	UK Format	US Format	Page extent	Photographs	Cover	ISBN
£30/\$30/\$75	Published	312 x 235mm	9¼ x 17¾"	128pp	79 duotone	Hardcover	1903391 13 X

The Divine Frenzy: Ritual and Possession in Hindu Kerala
Pepita Seth

Illuminating photographs and texts chart the way in which the people of this region of southern India fuse with their land and their gods.

UK/US/Can	Publication	UK Format	US Format	Page extent	Photographs	Cover	ISBN
£30/\$35/\$75	Published	300 x 245mm	9¾ x 12"	208pp	149 colour	Hardcover	1903391 14 8

Stones: The Megaliths of England & Wales and the Stories Behind Them
David and Lai Ngan Corio

Stunning photography is accompanied by the fascinating variety of literature, opinions and fantasies inspired by the presence of ancient stones on the British landscape.

UK/US/Can	Publication	UK Format	US Format	Page extent	Photographs	Cover	ISBN
£30/\$30/\$75	Published	254 x 254mm	10 x 10"	192pp	84 duotone	Hardcover	1903391 15 6

Carving the Mountains: The Marble Quarries of Carrara
Guido Buffoni and Stephen Cox

Guido Buffoni has photographed the marble quarries of northern Italy since the 1970s. His images are accompanied by an overview of Carrara's history by British sculptor Stephen Cox.

UK/US/Can	Publication	UK Format	US Format	Page extent	Photographs	Cover	ISBN
£40/\$85/\$100	April 2001	300 x 300mm	12 x 12"	192pp	120 colour + b/w	Hardcover	1903391 22 9

Fuck Off Typography
Various
Edited by Gerard Saint

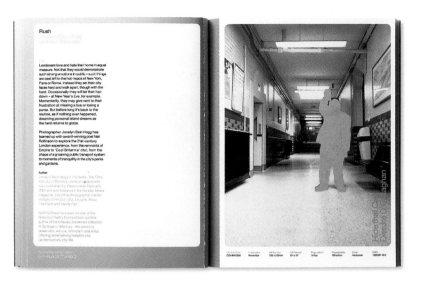

ART DIRECTOR:
SIMON ELLIOTT

DESIGNER:
SIMON ELLIOTT

CLIENT:
WESTZONE
PUBLISHING, LTD

SOFTWARE:
ILLUSTRATOR
PHOTOSHOP
QUARKXPRESS

MATERIALS:
VALLIANT SATIN ART

PRINTING:
OFFSET LITHO

Fuck Off Typography
Various
Edited by Gerard Saint

Publication
June

Cover price
£40

Format
330mm x 265mm

Page extent
176

Illustrations
124 colour +
b/w plates

Cover
Hardcover

ISBN
1 903391 21 0

Title
Fuck Off Typography invites prolific
typographers, graphic designers
and illustrators from the UK and
international scene to trade visual
insults. Peppered with expletives,
Fuck Off Typography explores and
offers insight into obscure taboo
colloquialisms, and explores the
creation of brand new, sharp-witted
profanities expressed through the
medium of typography.

Contributors include Paul Davis,
Jasper Goodall, Dave Foldvari,
Michael Gillette, Christophe
Gowans, London design companies
Form, Monster and many others,
alongside their illustrious
international contemporaries.

Author
Gerard Saint is an art director and
co-founder of the London design
group Big-Active.

ART DIRECTOR:
VANESSA ECKSTEIN

DESIGNERS:
VANESSA ECKSTEIN
FRANCES CHEN

CLIENT:
NIENKAMPER

SOFTWARE:
ILLUSTRATOR

MATERIALS:
BECKETT

PRINTING:
LITHO

CANADA

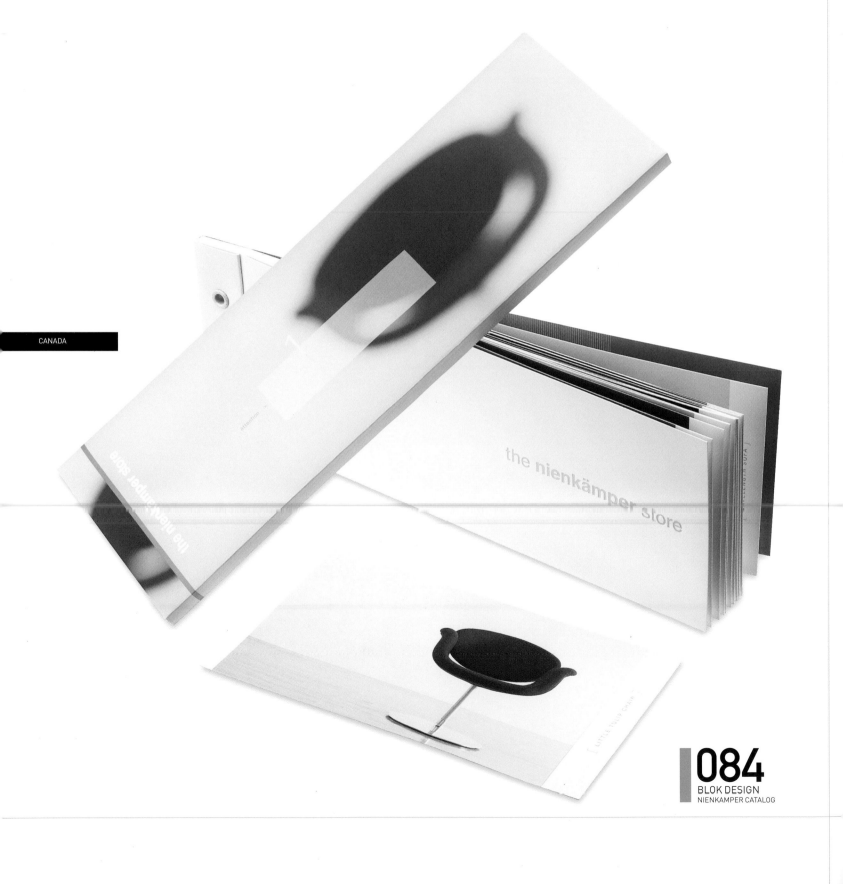

084
BLOK DESIGN
NIENKAMPER CATALOG

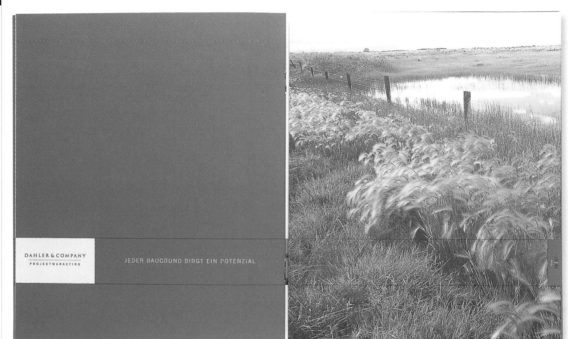

085

MARIUS FAHRNER DESIGN
DAHLER & COMPANY
MARKETING BROCHURE

ART DIRECTOR:
MARIUS FAHRNER
DESIGN

DESIGNER:
MARIUS FAHRNER
DESIGN

CLIENT:
DAHLER &
COMPANY PROJECT
MARKETING

SOFTWARE:
FREEHAND

MATERIALS:
250GSM AMBITION

PRINTING:
2-COLOR OFFSET

ART DIRECTOR:
NICK BELL

DESIGNER:
AXEL FELDMANN

CLIENT:
PETER MILNE
FURNITURE MAKERS

SOFTWARE AND
HARDWARE:
QUARKXPRESS
MAC

MATERIALS:
FEDRIGONI SAVILLE
ROW + FEDRIGONI
DALI NEVE + B&C
GALERIE ART GLOSS

PRINTING:
PAUL GREEN
PRINTING [LITHO]

086
UNA (LONDON) DESIGNERS
PETER MILNE FURNITURE MAKERS

Laurence King Publishing
Autumn 2001

UK

ART DIRECTOR:
VINCE FROST

DESIGNERS:
VINCE FROST
SONYA DYAKOVA

CLIENT:
LAURENCE KING
PUBLISHING LTD

MATERIALS:
NEW FORMATION
SUPERFINE 100GSM

PRINTING:
PRINCIPAL COLOR
(LITHO)

Laurence King Publishing
World Rights 2002

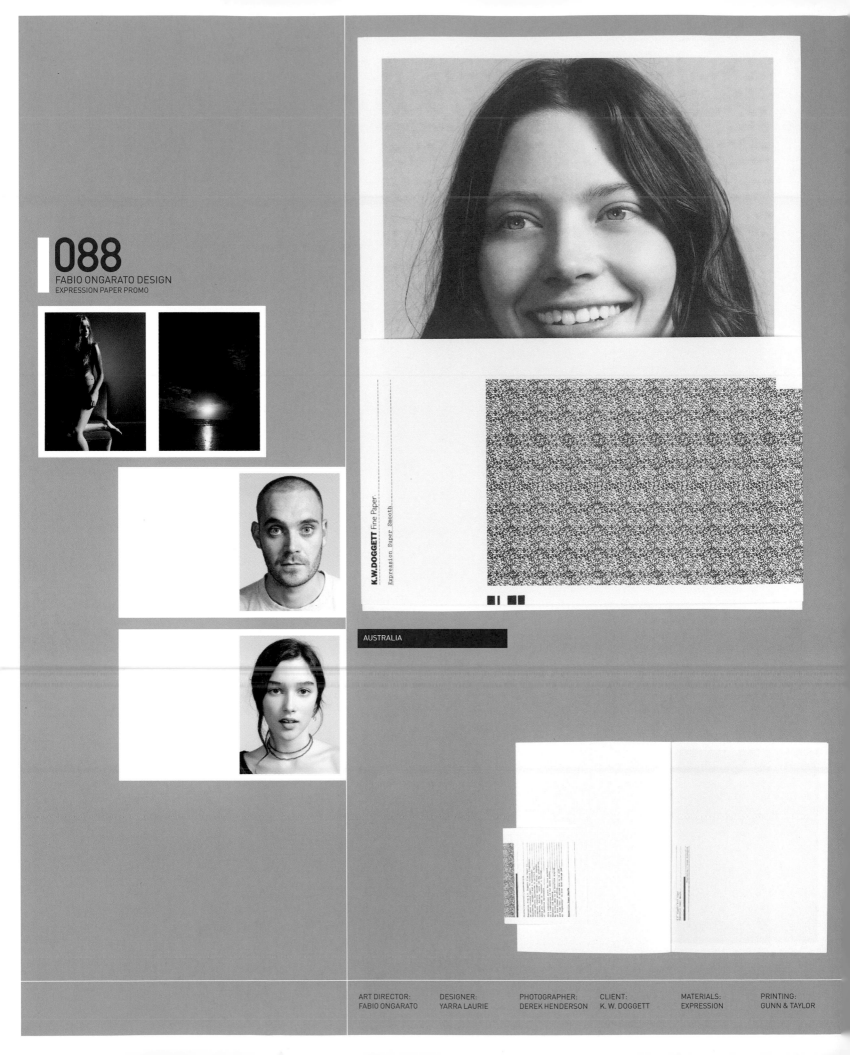

088

FABIO ONGARATO DESIGN
EXPRESSION PAPER PROMO

K.W.DOGGETT Fine Paper.

Expression Super Smooth.

AUSTRALIA

ART DIRECTOR:
FABIO ONGARATO

DESIGNER:
YARRA LAURIE

PHOTOGRAPHER:
DEREK HENDERSON

CLIENT:
K. W. DOGGETT

MATERIALS:
EXPRESSION

PRINTING:
GUNN & TAYLOR

ART DIRECTOR:
JOHANNES PLASS

DESIGNER:
KRISTINA
DULLMANN

PHOTOGRAPHER:
CARSTEN RAFFEL

CLIENT:
SINNER SCHRADER

MATERIALS:
ZANDERS MEDLEY
PURE

PRINTING:
DRUCKGEREI
BRÜNNER

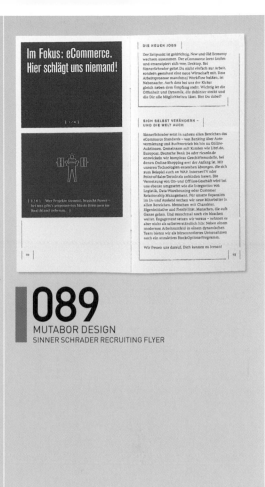

089
MUTABOR DESIGN
SINNER SCHRADER RECRUITING FLYER

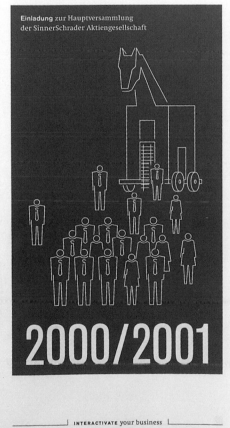

GERMANY

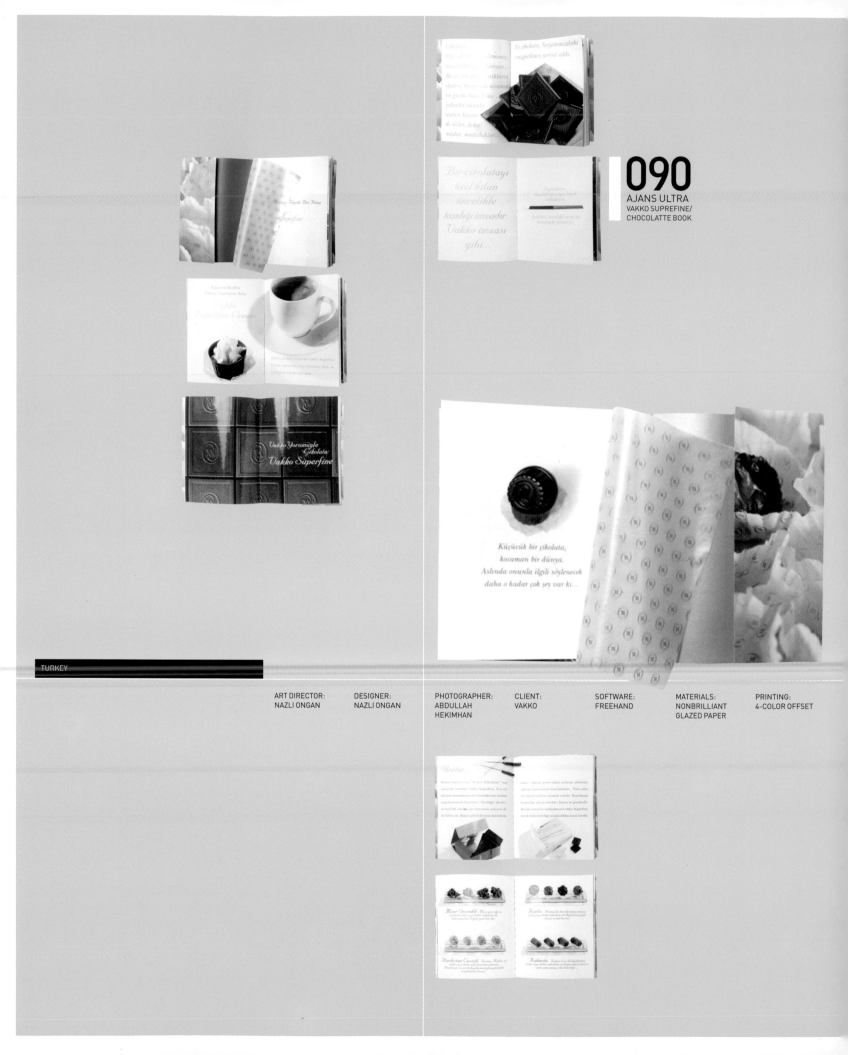

090

AJANS ULTRA
VAKKO SUPREFINE/
CHOCOLATTE BOOK

ART DIRECTOR:
NAZLI ONGAN

DESIGNER:
NAZLI ONGAN

PHOTOGRAPHER:
ABDULLAH
HEKIMHAN

CLIENT:
VAKKO

SOFTWARE:
FREEHAND

MATERIALS:
NONBRILLIANT
GLAZED PAPER

PRINTING:
4-COLOR OFFSET

Home networking:
Smarter the second time around

JACQUES DUGUEN, RENÉE FOSTER, ALAN MILES, LUIS URBINAS, MATTHIAS WINTER

091

HAMBLY & WOOLLEY INC.
FUTURE INTELLIGENCE 2

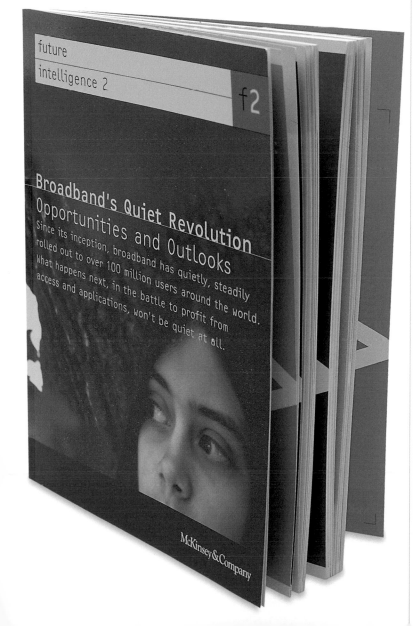

F2 Overview

100 million users can't be wrong:
Competitive insights for a broadband world

SCOTT BEARDSLEY, JOE BERGHTOLD, JEFF KARSH, WILHELM MOHN, LUIS URBINAS

ART DIRECTOR:	DESIGNER:	CLIENT:		CANADA
BARB WOOLLEY	DOMINIC AYRE	MCKINSEY & COMPANY		

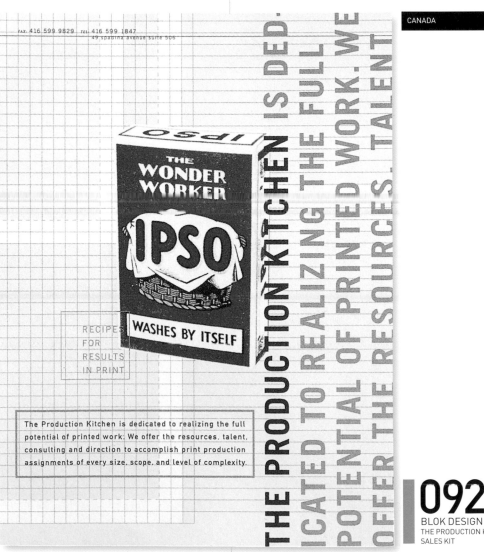

ART DIRECTOR:
VANESSA ECKSTEIN

DESIGNERS:
VANESSA ECKSTEIN
FRANCES CHEN

CLIENT:
THE PRODUCTION
KITCHEN

MATERIALS:
BENEFIT

PRINTING:
SOMERSET
GRAPHICS

FROM

IDEA GENERATION TO PROJECT AND CAMPAIGN
MANAGEMENT AND BEYOND. WE ARE A UNIQUE
PRODUCTION RESOURCE, CONSISTENTLY DE-
LIVERING THE BEST CONTACTS, PRICE LEVERAGE,
SYSTEMS, PROCEDURES, AND LIAISON SERVICES.
WE TAKE PRIDE IN OUR ABILITY TO MEET EVERY
DEADLINE, AND IN THE CREATIVITY AND KNOW-
LEDGE WE BRING TO EVERY ASSIGNMENT.

RESOURCES. KNOWLEDGE. DEADLINES.

THE WONDER WORKER
IPSO
WASHES BY ITSELF

RECIPES
FOR
RESULTS
IN PRINT

The Production Kitchen is dedicated to realizing the full
potential of printed work. We offer the resources, talent,
consulting and direction to accomplish print production
assignments of every size, scope, and level of complexity.

FAX. 416 599 9829 TEL. 416 599 1847
49 spadina avenue suite 506

092
BLOK DESIGN
THE PRODUCTION KITCHEN
SALES KIT

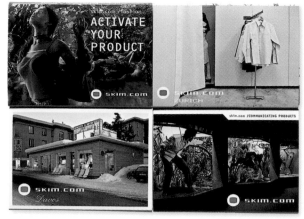

ART DIRECTOR:
MARTIN STILLHART

DESIGNER:
MARTIN STILLHART

CLIENT:
SKIM.COM

SOFTWARE:
ILLUSTRATOR
QUARKXPRESS

MATERIALS:
INVERCOAT 240GSM

PRINTING:
OFFSET

SWITZERLAND

093
FAUXPAS
LEPORELLO

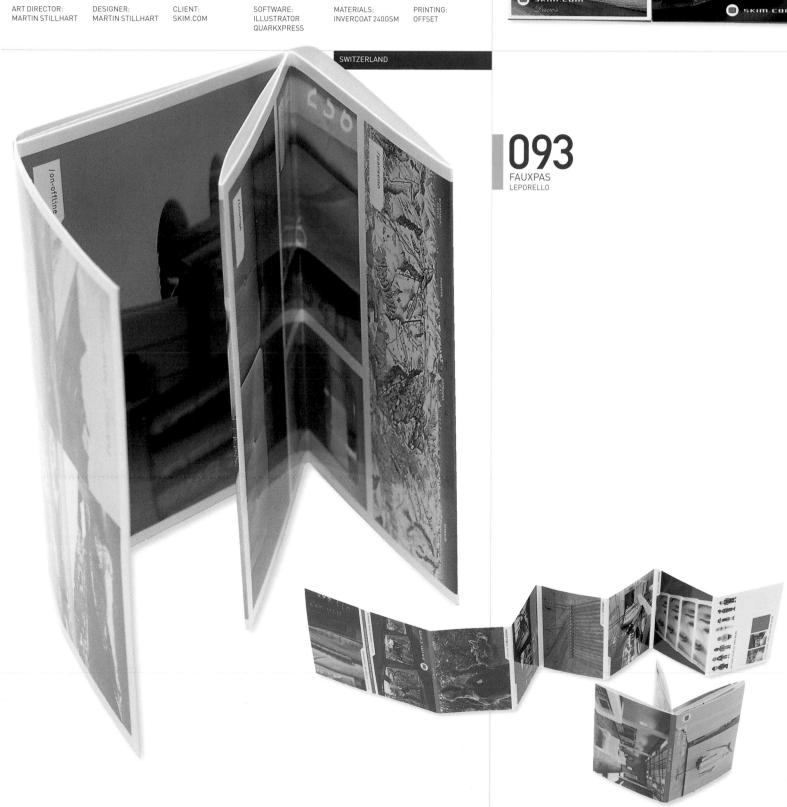

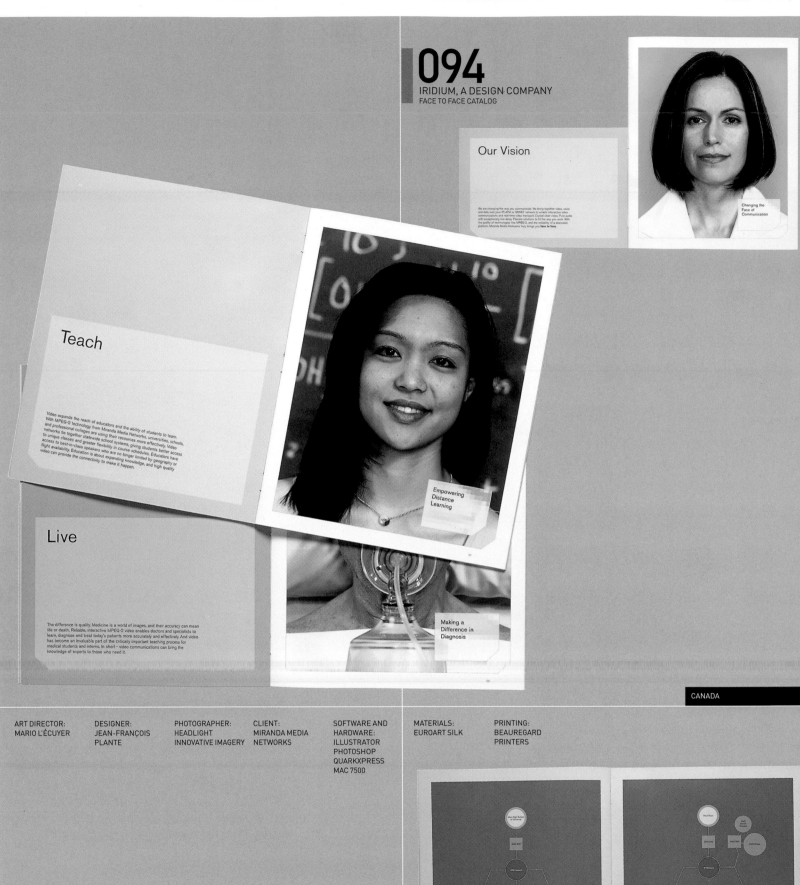

Our Vision

We are changing the way you communicate. We bring together video, voice and data over your IP, ATM or SONET network to enable interactive video communications and real-time video transport. Crystal clear video. Pure audio with exceptionally low delay. Flexible solutions to fit the way you work. With the quality of technologies like MPEG-2, and the reliability of a dedicated platform, Miranda Media Networks truly brings you **face to face**.

Changing the
Face of
Communication

Teach

Video expands the reach of educators and the ability of students to learn. With MPEG-2 technology from Miranda Media Networks, universities, schools, and professional colleges are using their resources more effectively. Video networks tie together statewide school systems, giving students better access to unique classes and greater flexibility in course schedules. Educators have access to best-in-class speakers who are no longer limited by geography or flight availability. Education is about expanding knowledge, and high quality video can provide the connectivity to make it happen.

Empowering
Distance
Learning

Live

The difference is quality. Medicine is a world of images, and their accuracy can mean life or death. Reliable, interactive MPEG-2 video enables doctors and specialists to learn, diagnose and treat today's patients more accurately and effectively. And video has become an invaluable part of the critically important teaching process for medical students and interns. In short – video communications can bring the knowledge of experts to those who need it.

Making a
Difference in
Diagnosis

CANADA

ART DIRECTOR:
MARIO L'ÉCUYER

DESIGNER:
JEAN-FRANÇOIS
PLANTE

PHOTOGRAPHER:
HEADLIGHT
INNOVATIVE IMAGERY

CLIENT:
MIRANDA MEDIA
NETWORKS

SOFTWARE AND
HARDWARE:
ILLUSTRATOR
PHOTOSHOP
QUARKXPRESS
MAC 7500

MATERIALS:
EUROART SILK

PRINTING:
BEAUREGARD
PRINTERS

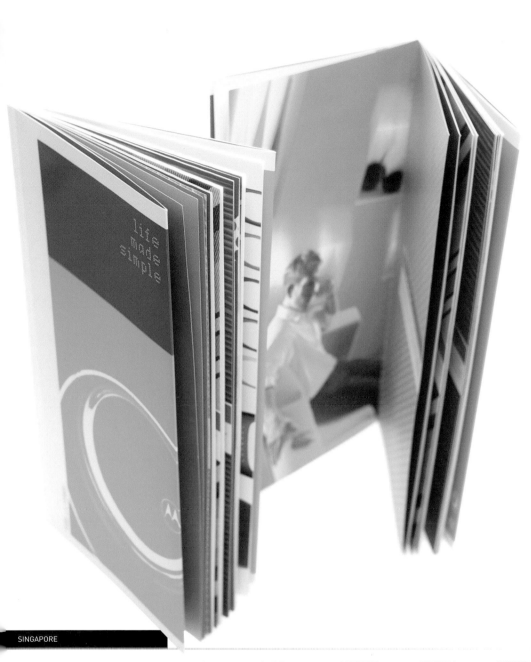

SINGAPORE

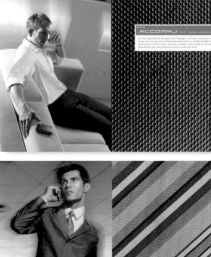

ART DIRECTOR:	DESIGNERS:	CLIENT:	SOFTWARE:	MATERIALS:	PRINTING:
CHRISTOPHER LEE	CHRISTOPHER LEE CARA ANG	MOTOROLA ELECTRONICS PTE LTD	FREEHAND	MATT ARTPAPER	4C X 4C

Think business lunches. Rubbing shoulders with corporate powers. Think glamorous parties, and mingling with the chic and well-heeled. Think Silicon Valley at the altars of worshipping technophiles. Think family and loved ones. Whatever your needs may be, Motorola has a world of wireless communications devices to simplify your life.

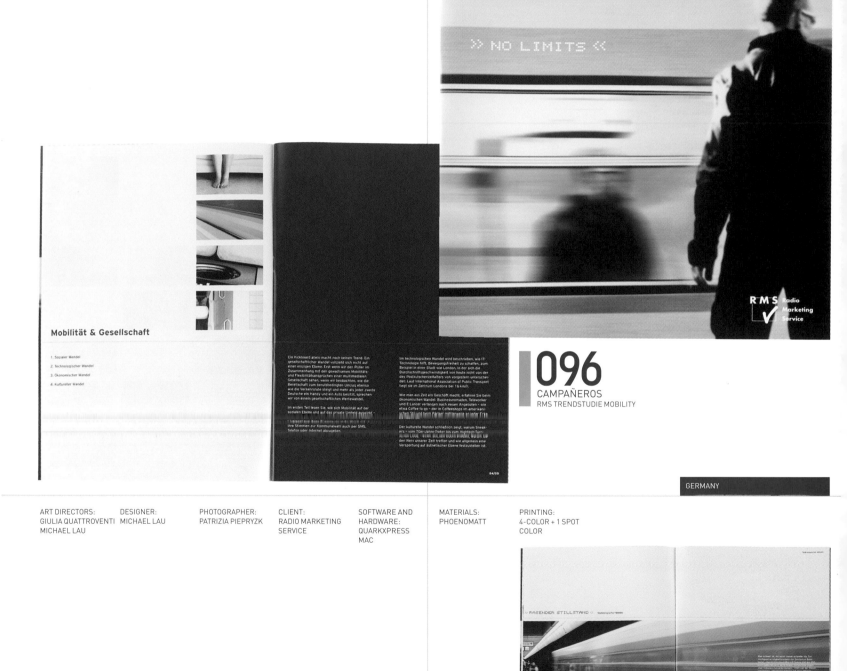

096
CAMPAÑEROS
RMS TRENDSTUDIE MOBILITY

GERMANY

ART DIRECTORS:
GIULIA QUATTROVENTI
MICHAEL LAU

DESIGNER: MICHAEL LAU

PHOTOGRAPHER:
PATRIZIA PIEPRYZK

CLIENT:
RADIO MARKETING
SERVICE

SOFTWARE AND
HARDWARE:
QUARKXPRESS
MAC

MATERIALS:
PHOENOMATT

PRINTING:
4-COLOR + 1 SPOT
COLOR

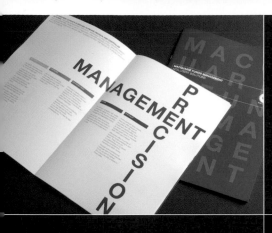

ART DIRECTOR:
EMERY VINCENT
DESIGN

DESIGNER:
EMERY VINCENT
DESIGN

CLIENT:
MACQUARIE FUNDS
MANAGEMENT

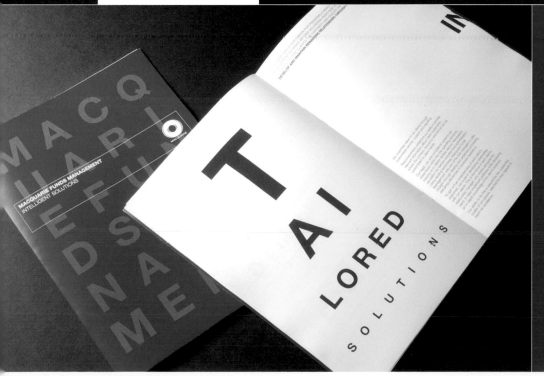

AUSTRALIA

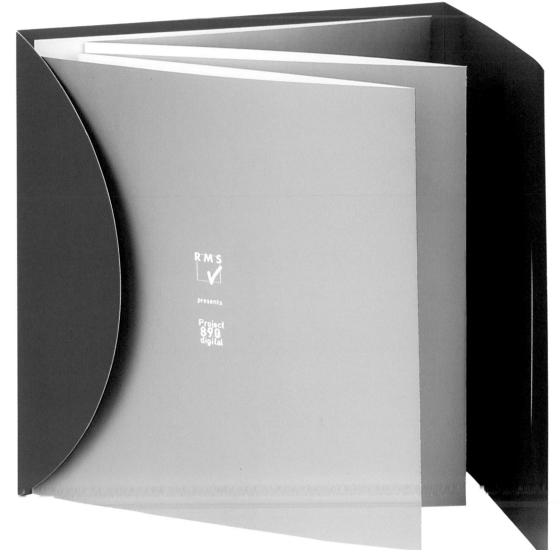

GERMANY

ART DIRECTOR:	DESIGNER:	CLIENT:	SOFTWARE AND	MATERIALS:	PRINTING:
PATRIZIA PIEPRYZK	PATRIZIA PIEPRYZK	RADIO MARKETING SERVICE	HARDWARE: QUARKXPRESS MAC	DUOCARD PROFISTAR	4-COLOR + 1 SPOT COLOR

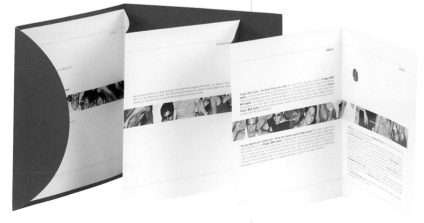

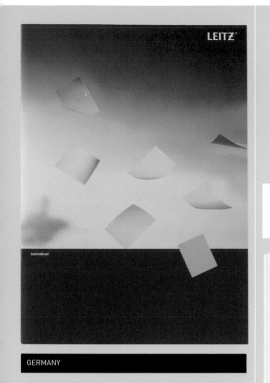

Individual

GERMANY

099
CAMPAÑEROS
LEITZ IMAGE BROCHURE

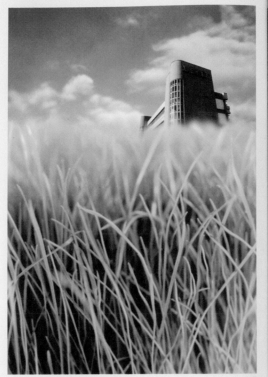

22

Das sind ja schöne Aussichten.
+49 (0)180/3 22 33 50
A bright prospect!

ART DIRECTOR:
MARTIN KAHRMANN

DESIGNER:
MARTIN KAHRMANN

PHOTOGRAPHER:
MARTIN KAHRMANN

CLIENT:
ESSELTE LEITZ
INDIVIDUAL

SOFTWARE AND
HARDWARE:
QUARKXPRESS
MAC

MATERIALS:
PHOENOMATT

PRINTING:
4-COLOR + 2 SPOT
COLOR

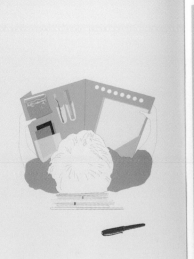

Bei uns können Sie sich einige Freiheiten erlauben.
Your individuality is okay with us.

NON-PROFIT, EDUCATIONAL, INSTITUTIONAL AND HEALTHCARE BROCHURES

ATTIK // ORIGIN // RADLEY YELDAR // POULIN + MORRIS // CLARK CREATIVE GROUP // CHENG DESIGN // WILLIAM HOMAN DESIGN // UNA (LONDON) DESIGNERS // EMERY VINCENT DESIGN // IRIDIUM, A DESIGN AGENCY // ENERGY ENERGY DESIGN // 2D3D // NBBJ GRAPHIC DESIGN // CHEN DESIGN ASSOCIATES // MARIUS FAHRNER DESIGN // FORM // USINE DE BOUTONS // THIRTEEN DESIGN // BOSTOCK & POLLITT // MADE THOUGHT

IONAL,

:04

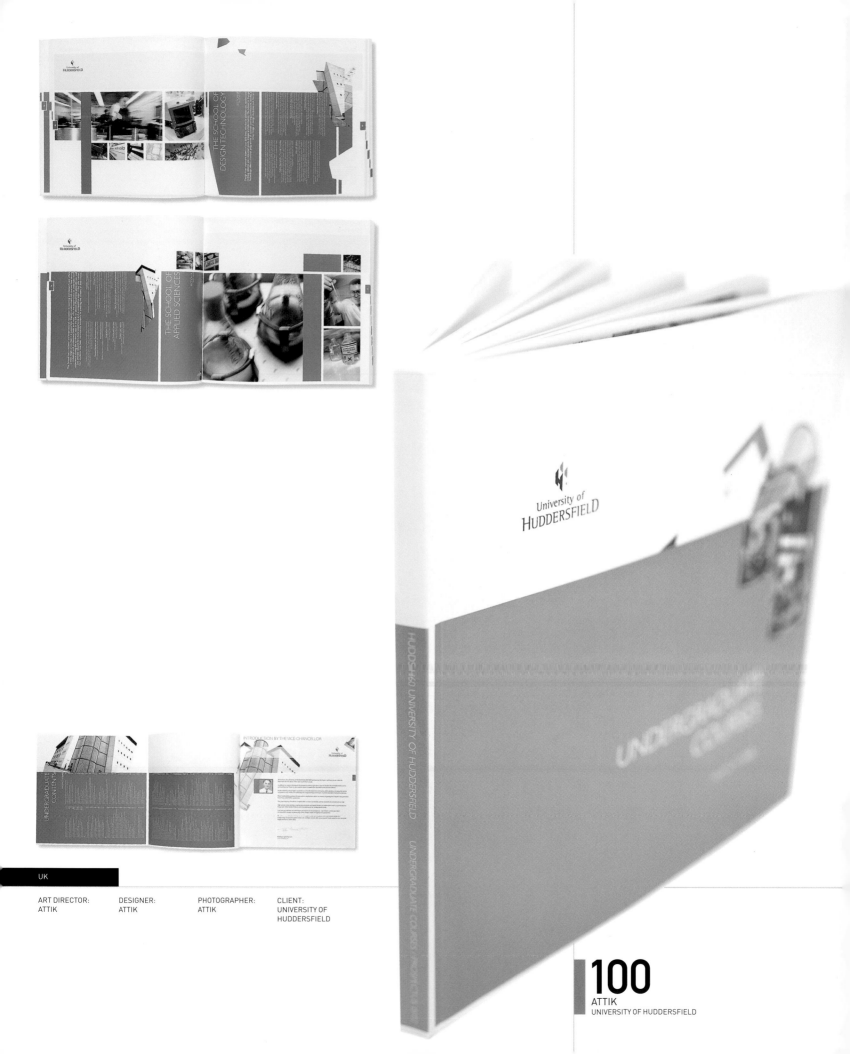

ART DIRECTOR:
ATTIK

DESIGNER:
ATTIK

PHOTOGRAPHER:
ATTIK

CLIENT:
UNIVERSITY OF
HUDDERSFIELD

100
ATTIK
UNIVERSITY OF HUDDERSFIELD

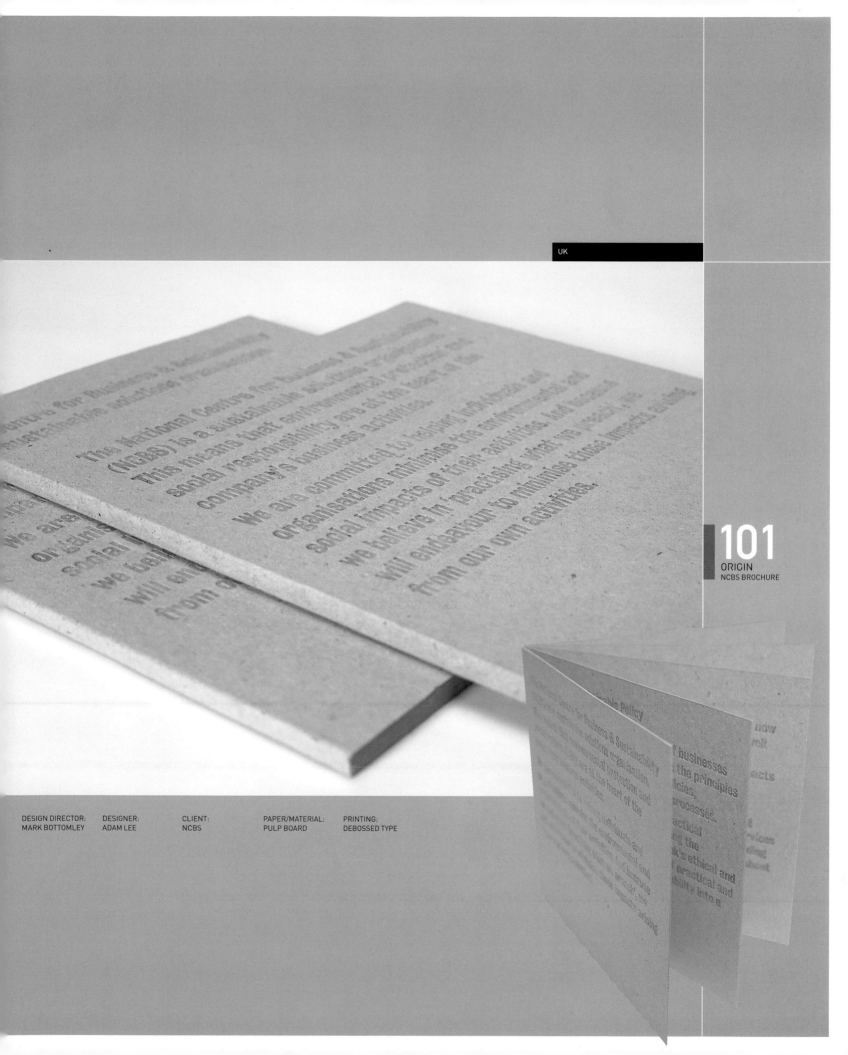

The National Centre for Business & Sustainability (NCBS) is a sustainable solutions organisation. This means that environmental protection and social responsibility are at the heart of the company's business activities. We are committed to helping individuals and organisations minimise the environmental and social impacts of their activities, but because we believe in 'practising what we preach', we will endeavour to minimise these impacts arising from our own activities.

101
ORIGIN
NCBS BROCHURE

DESIGN DIRECTOR:
MARK BOTTOMLEY

DESIGNER:
ADAM LEE

CLIENT:
NCBS

PAPER/MATERIAL:
PULP BOARD

PRINTING:
DEBOSSED TYPE

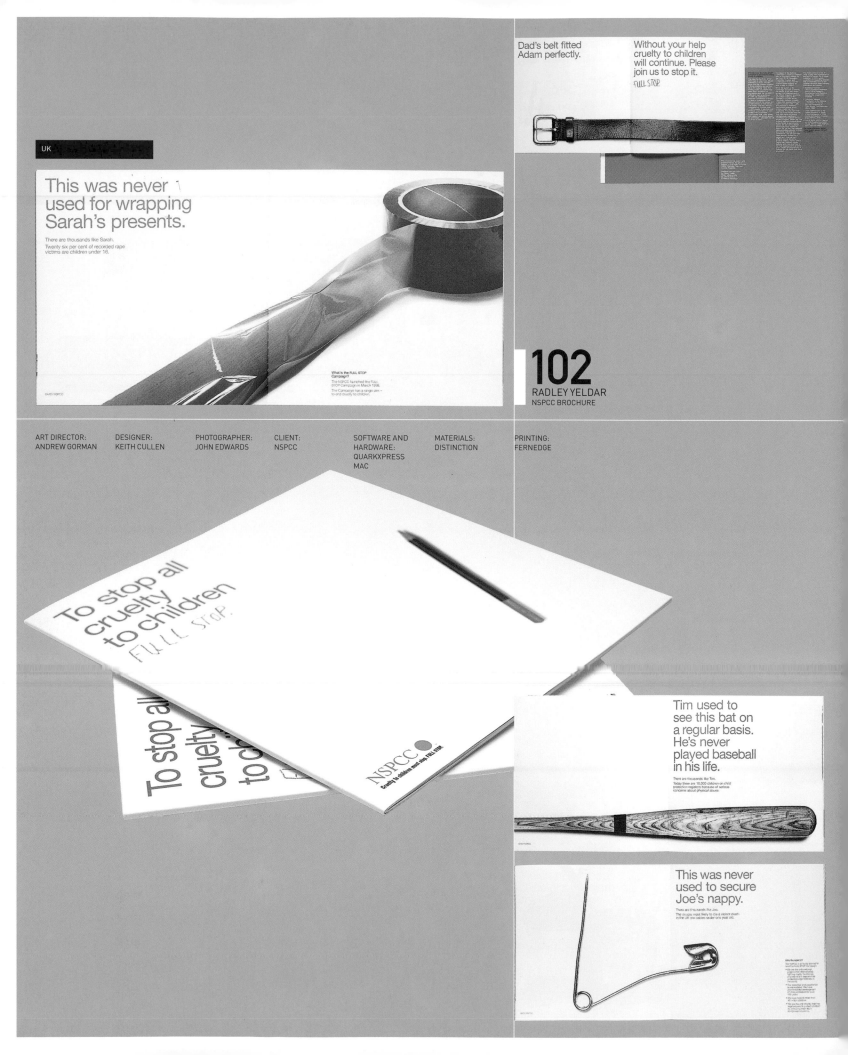

UK

This was never used for wrapping Sarah's presents.

There are thousands like Sarah.
Twenty six per cent of recorded rape victims are children under 16.

What is the FULL STOP Campaign?
The NSPCC launched the FULL STOP Campaign in March 1999.
The Campaign has a single aim – to end cruelty to children.

Dad's belt fitted Adam perfectly.

Without your help cruelty to children will continue. Please join us to stop it.
FULL STOP.

102
RADLEY YELDAR
NSPCC BROCHURE

ART DIRECTOR:
ANDREW GORMAN

DESIGNER:
KEITH CULLEN

PHOTOGRAPHER:
JOHN EDWARDS

CLIENT:
NSPCC

SOFTWARE AND
HARDWARE:
QUARKXPRESS
MAC

MATERIALS:
DISTINCTION

PRINTING:
FERNEDGE

To stop all cruelty to children FULL STOP.

NSPCC
Cruelty to children must stop. FULL STOP.

Tim used to see this bat on a regular basis. He's never played baseball in his life.

There are thousands like Tim.
Today there are 10,000 children on child protection registers because of serious concerns about physical abuse.

This was never used to secure Joe's nappy.

There are thousands like Joe.
The couple most likely to die a violent death in the UK are babies under one year old.

Although the appropriate development of open space and building sites varies by planning precinct, Yale's linear and dispersed campus can be better integrated by judicious attention to campus-wide—uses, built form, landscape and open space, circulation, parking, lighting, signage and neighborhood interface.

FRAMEWORK PLAN

Photographs showing existing character
of the Green/George area
1 High-rise housing
2 Shared City and University retail area

the Route 34/Oak Street Connector to Chapel Street. A joint effort by the City and Yale could significantly enhance the area by improving the streetscape and expanding arts-related uses, medical uses (both office and clinical), restaurants, retail stores, shops and studios that support the performing and visual arts. Development and improvements should focus on the York and College Street corridors. Yale already has an important presence in this area. It owns several parcels on York Street between Chapel and High Streets. University Towers houses many Yale-related tenants and the Medical Center leases space north of the Route 34/Oak Street Connector. The retail space between George Street and the Air Rights Garage has a high turnover rate that might decrease if quality stores moved in. The University should propose to the City that it convert York and College Streets to two-way traffic, and that it undertake landscaping and lighting programs to improve vehicular access and the pedestrian experience for everyone in the area. Physical improvements and building development along these corridors would reinforce connections between the Central Campus and Medical Center.

These two opportunities, especially when undertaken through joint planning projects by the City of New Haven and the University, would enhance the City and move each significantly closer to the common goal of more fully blending Yale's environment with that of its neighbors.

CAMPUS FRAMEWORK SYSTEMS

Uses
Built Form
Landscape and Open Space
Circulation
 Pedestrian
 Vehicular
 Bicycles
Parking
Signage
Lighting
Neighborhood Interface

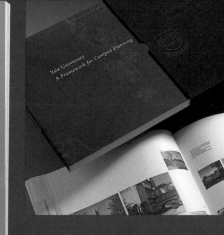

103
POULIN + MORRIS
YALE UNIVERSITY: A FRAMEWORK
FOR CAMPUS

ART DIRECTOR:
L RICHARD POULIN

DESIGNER:
AMY KWON

CLIENT:
COOPER,
ROBERTSON &
PARTNERS

SOFTWARE:
QUARKXPRESS

MATERIALS:
MOHAWK
SUPERFINE

PRINTING:
UNIVERSAL
PRINTING

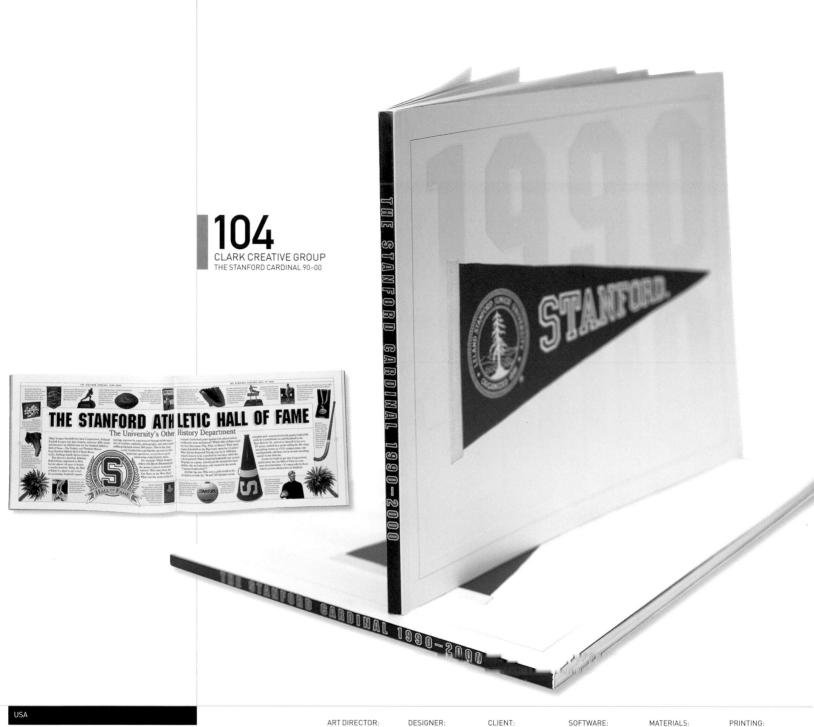

104
CLARK CREATIVE GROUP
THE STANFORD CARDINAL 90–00

ART DIRECTOR:
ANNEMARIE CLARK

DESIGNER:
NOREEN REI
FUKUMORI

CLIENT:
STANFORD
ATHLETIC DEPT

SOFTWARE:
ILLUSTRATOR
PHOTOSHOP
QUARKXPRESS

MATERIALS:
CENTURA

PRINTING:
HEMLOCK PRINTERS

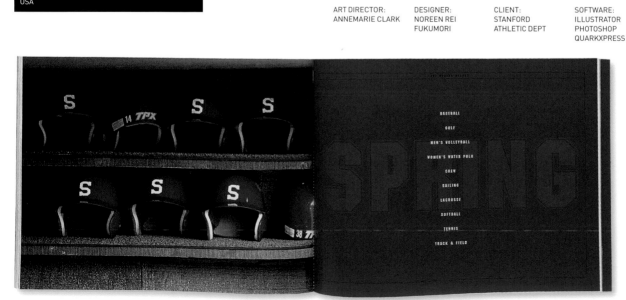

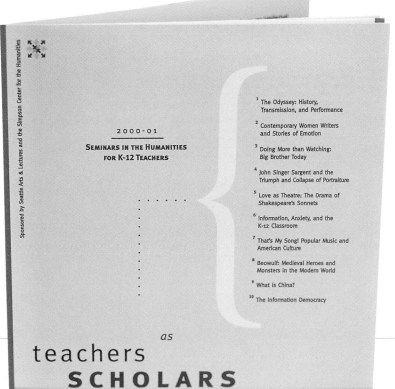

Sponsored by Seattle Arts & Lectures and the Simpson Center for the Humanities

2000-01

SEMINARS IN THE HUMANITIES FOR K-12 TEACHERS

1 The Odyssey: History, Transmission, and Performance

2 Contemporary Women Writers and Stories of Emotion

3 Doing More than Watching: Big Brother Today

4 John Singer Sargent and the Triumph and Collapse of Portraiture

5 Love as Theatre: The Drama of Shakespeare's Sonnets

6 Information, Anxiety, and the K-12 Classroom

7 That's My Song! Popular Music and American Culture

8 Beowulf: Medieval Heroes and Monsters in the Modern World

9 What is China?

10 The Information Democracy

as
teachers
SCHOLARS

Sponsored by Seattle Arts & Lectures and the Simpson Center for the Humanities

2001-2002

wednesday university

literature · culture · history

M Tu **W**✳ Th F

DESIGNER:
KAREN CHENG

CLIENT:
SEATTLE ARTS
AND LECTURES

SOFTWARE:
ILLUSTRATOR
PHOTOSHOP
QUARKXPRESS

MATERIALS:
FINCH FINE
COVER + TEXT

PRINTING:
2 PMS COLORS

USA

Education is not the filling of a pail but the lighting of a fire.
W. B. YEATS

SEMINARS IN THE HUMANITIES FOR K-12 TEACHERS

teachers *as*
SCHOLARS

2001-02

Mission Guadalupe Alternative Programs fosters learning, personal growth and skill development in those individuals who are not well served by mainstream educational institutions.

Imagine attending high school while you are pregnant or getting yourself and your child ready for school every morning. Imagine arriving in this country as a teenager and having to learn a second language while taking academic courses required for graduation. Imagine getting a year or more behind your classmates in school, but persevering and graduating anyway. Imagine the pressure and honor of being the first person in your family to graduate. The 23 students who made up the GAP graduating class of 2000 have lived through situations that some of us can only imagine. They are a group of survivors and left high school just a few weeks ago as seasoned, confident young adults ready to seize their futures. To a person, they know how to set and achieve goals, use their resources, help one another. They are ready. In their words, GAP has been a small place where they got individual attention, where teachers were cool, and where students got along well together. It is a nice thing to think about now that they are gone and we look forward to the beginning of another school year.

Survivors CLASS OF 2000

ART DIRECTOR:
WILLIAM HOMAN

DESIGNER:
WILLIAM HOMAN

CLIENT:
GUADALUPE
ALTERNATIVE
PROGRAM

MATERIALS:
CLASSIC CREST

PRINTING:
CUSTOM COLOR
PRINTING

106
WILLIAM HOMAN DESIGN
GUADALUPE ALTERNATIVE PROGRAM

Milestones of the millennium As we move forward into the next century, our goal is to be prepared to meet the needs of all current and future GAP students. We have grown from a one-room house to a building with programs that provide multiple educational opportunities for youth and adults. **We** have reached many milestones this year. On an academic level, our students' scores improved substantially over last year. Continually, through collaborations and partnerships, students have learned about the richness and diversity of others, the importance of tradition and the need to respect each other. They continue to prepare for the technological advances of the future and the need for communication and computer skills. **We** can achieve these goals because of the commitment and dedication of the staff. Congratulations to Sister Anna Louise Wilson, who will be celebrating her fiftieth anniversary as a School Sister of Notre Dame. She has worked at GAP for 25 years. Her contributions to GAP have been legendary. She has received numerous awards, but what is more important to her is the contact she makes with students in her art classes. **The** board has diligently worked this year to provide the resources for staff members to create an environment that allows each student to reach his or her potential. A new strategic plan has been adopted to position us for the future. We remain committed to the mission of GAP. Karen Thompson, Chair, GAP Board of Directors

Sister Ann

This annual report reviews the year 1999 and, we hope, shows that this agency is secure financially and solid as an educational institution–as it always has been. It also celebrates the graduating class of 2000 and the teachers and support staff who had so much to do with the success of our new-century graduates. We appreciate them and their talents and we also, and in the same breath, appreciate you and your support of GAP. In a unique way, your dedication to our mission is felt here every day, helping us create a place where learning and opportunity are realities.

Thanks

UK

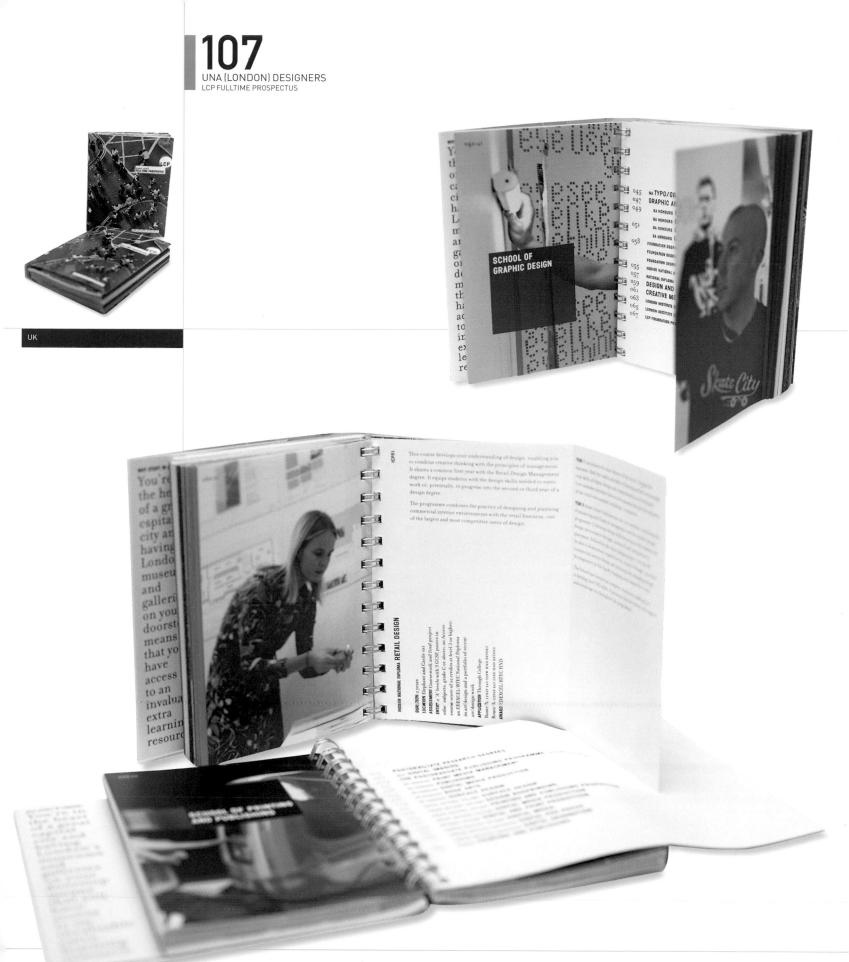

ART DIRECTOR:
NICK BELL

DESIGNER:
AXEL FELDMANN

PHOTOGRAPHER:
JANERIK POSTH

CLIENT:
LONDON COLLEGE
OF PRINTING

SOFTWARE AND
HARDWARE:
QUARKXPRESS
MAC

MATERIALS:
TUCKY WOODFREE
MATT ART

PRINTING:
SOUTH SEA
INTERNATIONAL
PRESS LTD

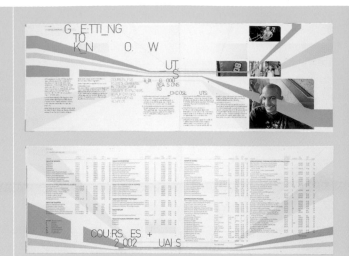

AUSTRALIA

ART DIRECTOR:
EMERY VINCENT
DESIGN

DESIGNER:
EMERY VINCENT
DESIGN

CLIENT:
UTS

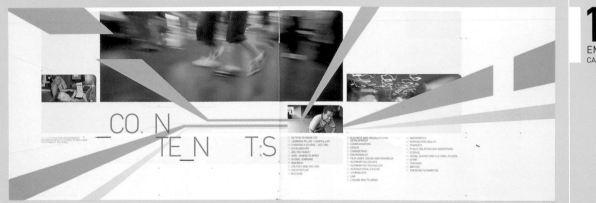

108
EMERY VINCENT DESIGN
CAREERS & COURSES GUIDE 2003

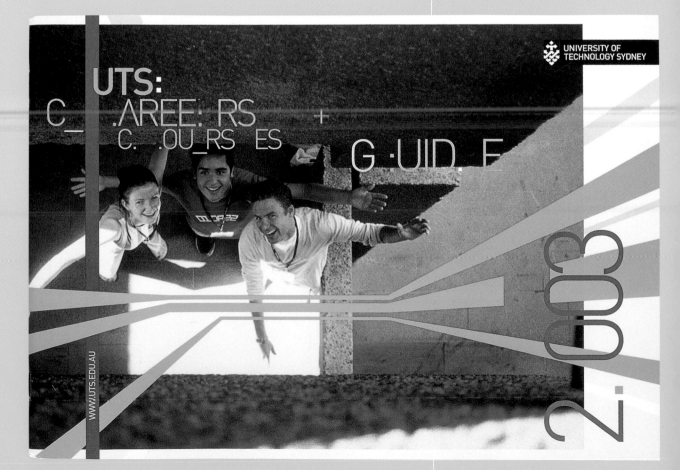

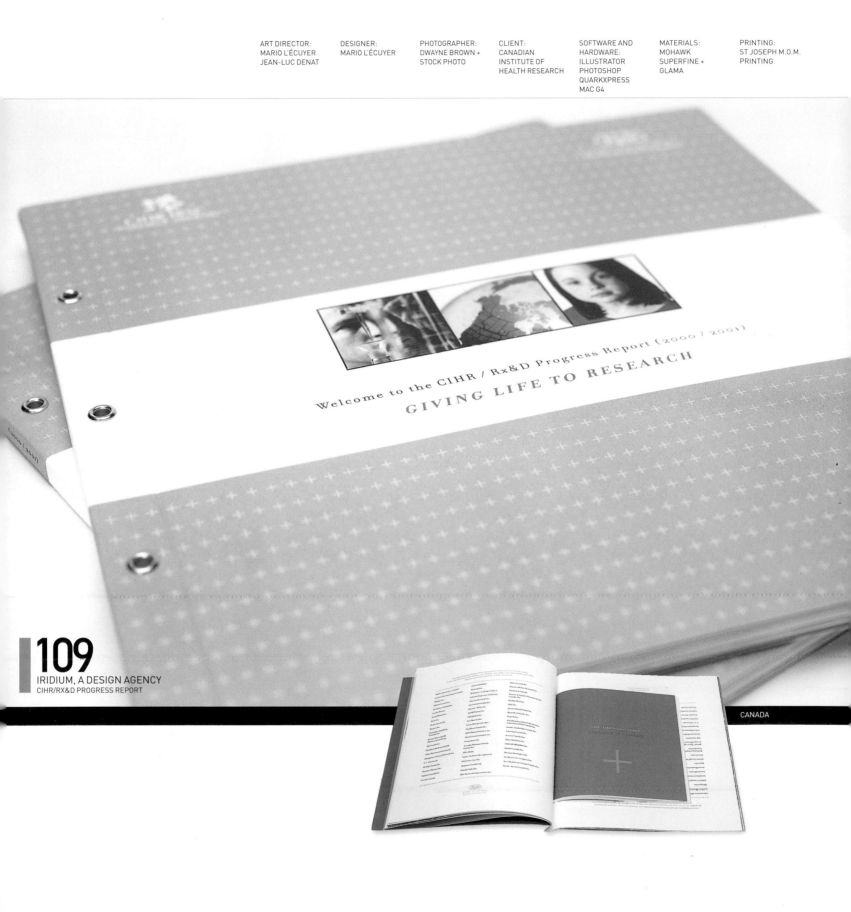

ART DIRECTOR:
MARIO L'ÉCUYER
JEAN-LUC DENAT

DESIGNER:
MARIO L'ÉCUYER

PHOTOGRAPHER:
DWAYNE BROWN +
STOCK PHOTO

CLIENT:
CANADIAN
INSTITUTE OF
HEALTH RESEARCH

SOFTWARE AND
HARDWARE:
ILLUSTRATOR
PHOTOSHOP
QUARKXPRESS
MAC G4

MATERIALS:
MOHAWK
SUPERFINE +
GLAMA

PRINTING:
ST JOSEPH M.O.M.
PRINTING

109
IRIDIUM, A DESIGN AGENCY
CIHR/RX&D PROGRESS REPORT

CANADA

ProTrials

Experienced Professionals, Trusted Partners

ART DIRECTOR:
LESLIE GUIDICE

DESIGNER:
STACY GUIDICE

CLIENT:
PROTRIALS
RESEARCH INC

SOFTWARE AND
HARDWARE:
ILLUSTRATOR
PHOTOSHOP
MAC G4

MATERIALS:
CURIOUS ICE BOLD
TEXT

PRINTING:
4/4

USA

Efficient clinical operations are the cornerstone of successful pharmaceutical, biotechnology, and medical device development.

Keeping clinical operations on schedule—and within budget—requires people who are as committed to your goals as you are. That's why pharmaceutical, biotechnology, and medical device companies rely on ProTrials.

PEOPLE

Skilled people make the difference between projects that go well and those that don't. ProTrials professionals are some of the most experienced professionals in the industry. And while skills are important, so are character, responsiveness, and integrity. ProTrials professionals deliver projects that start and finish on time, stay within budget, and yield quality results.

The results speak for themselves. More than 90% of our clients engage us multiple times, and they return to us with larger projects and more responsibility. Our people and hands-on approach make us trusted partners in clinical operations.

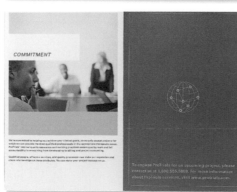

COMMITMENT

110
ENERGY ENERGY DESIGN
PROTRIALS BROCHURE

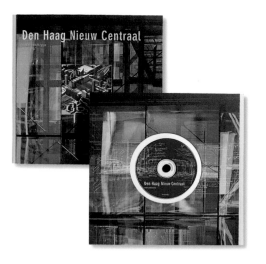

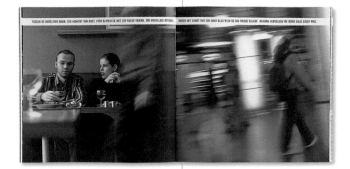

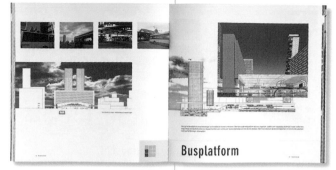

Busplatform

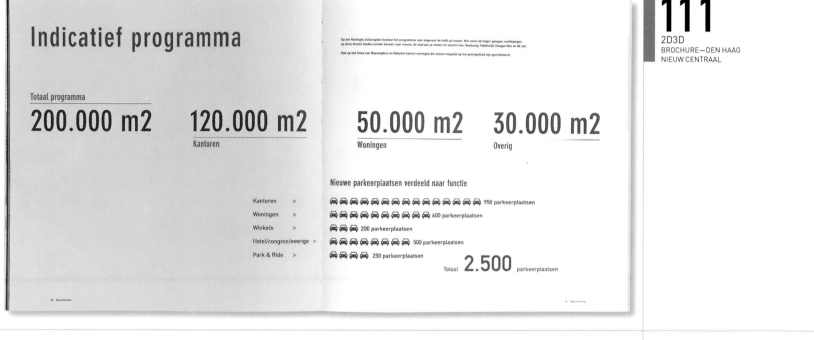

Indicatief programma

Op het Koningin Julianaplein bestaat het programma voor ongeveer de helft uit wonen. Met name de hoger gelegen verdiepingen op deze locatie bieden unieke kansen voor wonen; de stad aan je voeten en uitzicht over Kootkamp, Malieveld, Haagse Bos en de zee.

Ook op het Anna van Buerenplein en Babylon komen woningen die zoveel mogelijk op het groengebied zijn georiënteerd.

Totaal programma

200.000 m2	120.000 m2	50.000 m2	30.000 m2
	Kantoren	Woningen	Overig

Nieuwe parkeerplaatsen verdeeld naar functie

Kantoren	>	950 parkeerplaatsen
Woningen	>	600 parkeerplaatsen
Winkels	>	200 parkeerplaatsen
Hotel/congres/overige	>	500 parkeerplaatsen
Park & Ride	>	250 parkeerplaatsen

Totaal **2.500** parkeerplaatsen

ART DIRECTORS:
GEA ZIEVERINK
YEW-KEE CHUNG
MICHAEL
BUCHENAUER

DESIGNERS:
GEA ZIEVERINK
YEW-KEE CHUNG
MICHAEL
BUCHENAUER

PHOTOGRAPHERS:
ERIC DE VRIES
PAUL LUNENBERG
PETER LEURINK
ARJAN BENNING
NEDERLANDSE
SPOORWEGEN
MULTI VASTGOED
GEMEENTE DEN
HAAG

CLIENT:
GEMEENTE DEN
HAAG

SOFTWARE AND
HARDWARE:
ILLUSTRATOR
PHOTOSHOP
QUARKXPRESS
MAC

MATERIALS:
GREY CARTON
2000GSM + OXFORD
160GSM

PRINTING:
OFFSET 4-PROCESS
COLORS

Anna van Buerenplein

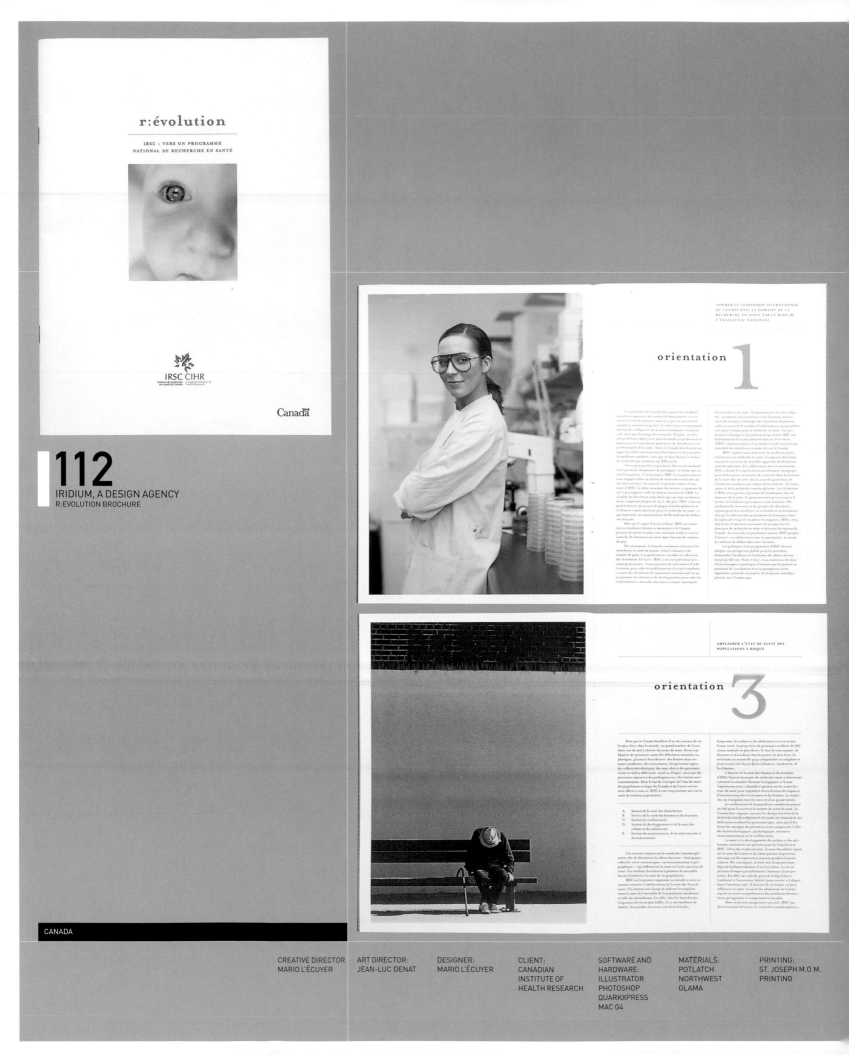

r:évolution

IRSC : VERS UN PROGRAMME
NATIONAL DE RECHERCHE EN SANTÉ

IRSC CIHR
Instituts de recherche Canadian Institutes of
en santé du Canada Health Research

Canada

112

IRIDIUM, A DESIGN AGENCY
R:EVOLUTION BROCHURE

CANADA

CREATIVE DIRECTOR
MARIO L'ÉCUYER

ART DIRECTOR:
JEAN-LUC DENAT

DESIGNER:
MARIO L'ÉCUYER

CLIENT:
CANADIAN
INSTITUTE OF
HEALTH RESEARCH

SOFTWARE AND
HARDWARE:
ILLUSTRATOR
PHOTOSHOP
QUARKXPRESS
MAC G4

MATERIALS:
POTLATCH
NORTHWEST
GLAMA

PRINTING:
ST. JOSEPH M.O.M.
PRINTING

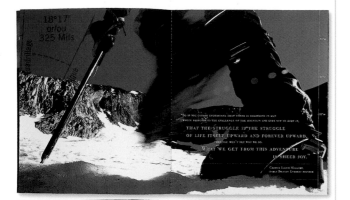

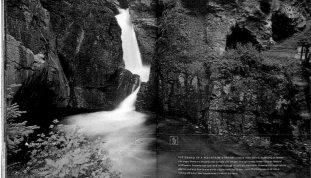

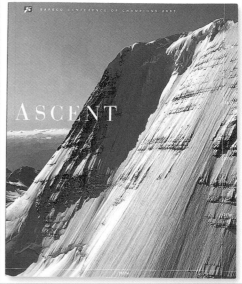

ASCENT

USA

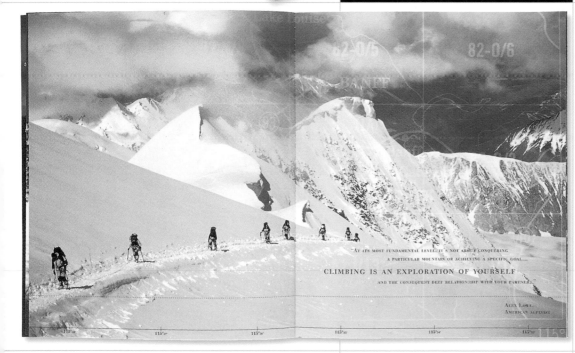

"AT ITS MOST FUNDAMENTAL LEVEL, IT'S NOT ABOUT CONQUERING
A PARTICULAR MOUNTAIN OR ACHIEVING A SPECIFIC GOAL...
CLIMBING IS AN EXPLORATION OF YOURSELF
AND THE CONSEQUENT DEEP RELATIONSHIP WITH YOUR PARTNERS."

ALEX LOWE,
AMERICAN ALPINIST

ART DIRECTOR:
YACHUN PENG

DESIGNERS:
YACHUN PENG
LEO RAYMUNDO

CLIENT:
SAFECO

SOFTWARE AND
HARDWARE:
FREEHAND
MAC G4

MATERIALS:
MOHAWK NAVAJO

PRINTING:
SAFECO PRINTING
PRESS

THE REDF APPROACH

REDF assists its portfolio organizations in a variety of ways, most notably by providing financing for organizational infrastructure, access to additional funds for capital expenses, strategic business assistance, organizational development support, and access to business networking opportunities, social outcome measurement and technological tools and training.

114

CHEN DESIGN ASSOCIATES
REDF CORPORATE BROCHURE

USA

ART DIRECTOR:
JOSHUA C. CHEN

DESIGNERS:
MAX SPECTOR
LEON YU

PHOTOGRAPHER:
JENNY THOMAS

CLIENT:
ROBERTS
ENTERPRISE
DEVELOPMENT
FUND

SOFTWARE AND
HARDWARE:
ILLUSTRATOR
PHOTOSHOP
QUARKXPRESS
MAC

MATERIALS:
CENTURA DULL

PRINTING:
LITHOGRAPHIX

DESIGNER:
KAREN CHENG

CLIENT:
UNIVERSITY OF
WASHINGTON
SCHOOL OF ART

SOFTWARE:
ILLUSTRATOR
PHOTOSHOP
QUARKXPRESS

MATERIALS:
LUSTRO ARCHIVAL
DULL

PRINTING:
PROCESS COLOR +
AQUEOUS COATING

USA

2000

F
(master of the fine arts)
M
A
university of washington
school of art

joline
ABBADESSA

thomas
ALBRECHT

roger
BOGERS

john
BYRD

maya
CHACHAVA

alan
CORKERY HAHN

mariko
DAIBO

wing
FONG

karen
GUTOWSKY

ayumi
HORIE

michelle
JACK

kamla
KAKARIA

james
LaCHANCE

robert
McCRORY

vaughn
RANDALL

phil
ROACH

lynn
SHEN

heather
SINCAVAGE

leslie
STRAKA

victoria
TCHETCHET

115
CHENG DESIGN
MASTER OF FINE ARTS EXHIBIT 2000

"Architecture . . . is the attempt to make what is originally a strange and alien environment more of our own, to transform space into place, so that instead of being cast into a strange and alien world we are allowed to dwell."

Karsten Harries
Professor of Philosophy, Yale University

116
POULIN + MORRIS
UNC AT CHARLOTTE CAMPUS
MASTER PLAN

The plan is primarily a fresh look at the making of sites and places on the campus

THE NEXT STEP

30

31

3.0

ANALYSIS

The campus today has a mix of quadrangles, lawns, and pedestrian streets that form a system which could be extended to serve a larger campus. The campus gives extent like "fingers" into the developed portions of campus and offer the possibility of maintaining natural settings within the more urban areas of campus. The surrounding woodlands provide a substantial buffer between academic life and the burgeoning commercial development surrounding the campus.

The campus today has a mix of quadrangles, lawns, and pedestrian street that form a system which could be extended to serve

The 1995 Plan proposed that a portion of Toby Creek be used to create a formal open space amenity and a storm drainage control feature (like Boston's Muddy River or Westchester New York's Bronx River). Toby Creek would then provide an ongoing environmental education opportunity at UNC Charlotte.

UNC Charlotte is characterized by steep, dramatic topography with over 100 feet of elevation change from the high point at Atkins Library to the low point along Toby Creek. Most of the level, high ground of the campus has been developed, resulting in the "V" shaped configuration of the campus core. The 1995 Plan proposed a new north-south axle for buildings and pedestrian paths. Carefully studying this axis reveals grading issues with this approach which would require bridging and significant retaining walls

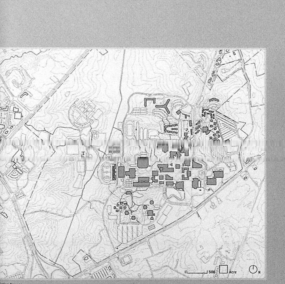

Existing Campus

USA

Phase Two: Years 6 - 10

5.0

THE NEXT STEP

ART DIRECTOR:
L RICHARD POULIN

DESIGNER:
BRIAN BRINDISI

CLIENT:
COOPER,
ROBERTSON &
PARTNERS

SOFTWARE:
QUARKXPRESS

MATERIALS:
MOHAWK 50/10
PLUS

PRINTING:
QUALITY PRINTING

AUTHORED BY
Kay Sweerky

BTW Consultants – reframing change

WITH INPUT AND CONTRIBUTIONS FROM

Rick Aubry, Rubicon Programs

Tom Danner, CompuMentor

Jane Fischberg, Rubicon Programs

Danny Feng, Dayspring Technologies

Laura Lanzerotti, BTW Consultants

Wes Rand, Third Strand

Melinda Tuan, The Roberts Enterprise Development Fund

An Information OASIS:
The Design and Implementation of
Comprehensive and Customized Client
Information and Tracking Systems

OASIS is a planning process and project that has been generously supported by: The Roberts Enterprise Development Fund, the Charles and Helen Schwab Foundation, The William and Flora Hewlett Foundation, the Surdna Foundation, the Flachsuge Foundation, and the Peavey Family Fund.

This publication is made possible by a generous contribution from The William and Flora Hewlett Foundation.

ART DIRECTOR:	DESIGNERS:	PHOTOGRAPHER:	CLIENT:	SOFTWARE AND HARDWARE:	MATERIALS:	PRINTING:
JOSHUA C. CHEN	MAX SPECTOR JOSHUA C. CHEN	JENNY THOMAS	ROBERTS ENTERPRISE DEVELOPMENT FUND	ILLUSTRATOR PHOTOSHOP QUARKXPRESS MAC	STORA ENSO CENTURA DULL 100# T, 100# C. GLAMA NATURAL 21.25# T CLEAR	LITHOGRAPHIX

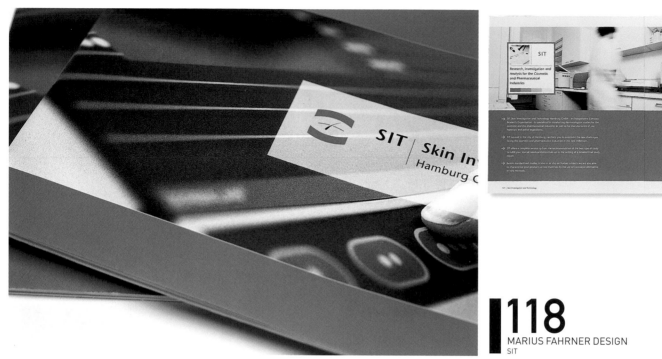

118
MARIUS FAHRNER DESIGN
SIT

ART DIRECTOR:
MARIUS FAHRNER

DESIGNER:
MARIUS FAHRNER

CLIENT:
SIT

SOFTWARE:
FREEHAND

PRINTING:
2-COLOR OFFSET

BRENG HET BELANG VAN VEILIGHEID AAN HET LICHT

OPEN →

VEILIGHEID IS EEN ESSENTIEEL ELEMENT DAT VANAF HET BEGIN THUISHOORT IN HET ONTWIKKELINGSPROCES VAN TUNNELS. NIET IN HET MINST VANWEGE HAAR HOGE KOSTEN. HET KOSTENBATEN PERSPECTIEF VOORAF IN DE

BESLUITVORMING BETREKKEN, VOORKOMT DAT HET PRIJSKAARTJE VOOR TUNNELVEILIGHEID PAS 'NÁ DE KOOP' WORDT OPGESPELD.

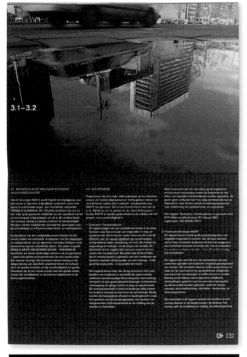

*DIEP GAAN VOOR TUNNELVEILIGHEID

3.1–3.2

THE NETHERLANDS

ART DIRECTOR:	DESIGNER:	PHOTOGRAPHER:	CLIENT:	SOFTWARE AND	MATERIALS:	PRINTING:
YEW-KEE CHUNG	YEW-KEE CHUNG	ERIC DE VRIES	PROJECTGROEP	HARDWARE:	COVER: CURIOUS	4-COLOR OFFSET
			TUNNELVEILIGHEID	PHOTOSHOP	METALLICS 300GSM	
				QUARKXPRESS	INSIDE: MUNKEN	
				MAC	LYNX 150GSM	

119

2D3D
TUNNELVEILIGHEID

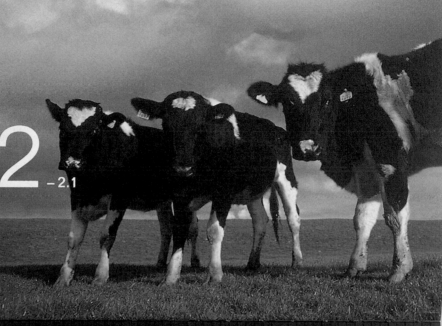

2
–2.1

2 TUNNELVEILIGHEID IN NEDERLAND

In een tunnel loopt men andere risico's dan in de open ruimte. Alhoewel de kans klein is kunnen incidenten of ongevallen in de besloten ruimte van een tunnel in korte tijd ernstige gevolgen hebben. Met name brand, ontsnapping van rook en van giftige of explosieve stoffen zijn gevaren die in enkele minuten tijd kans lopen om uit te groeien tot levensgevaarlijke rampen met dreiging van veel slachtoffers. Voor mensen die moeten vluchten is het in een tunnel nu eenmaal lastiger om een goed heenkomen te zoeken dan in de open ruimte. En voor hulpdiensten zijn de kansen om er snel en effectief levensreddend op te treden beduidend minder, zoals de laatste jaren maar al te zeer bleek bij calamiteiten in Alpentunnels (Gotthard, Mont Blanc, Tauern, Kaprun).

Gezien de ernst van deze risico's heeft tunnelveiligheid in Nederland de laatste twintig jaar zonder twijfel de aandacht gekregen die ze verdient. Ook in Nederland droeg een tunnelbrand daaraan het nodige bij. Deze calamiteit in de Velsertunnel (1978, 4 doden) leidde enkele jaren later tot nieuwe richtlijnen voor de uitrusting van wegtunnels. Mede hierdoor hebben de meeste daarvan in ons land thans gescheiden buizen voor beide rijrichtingen, zijn ze goed verlicht en worden ze terdege onderhouden. Verder is er vrijwel altijd een ventilatiesysteem dat rook en dampen kan wegblazen en beschikken grote tunnels – ook die van spoor en metro – doorgaans over beheerders din getraind zijn om adequaat om te gaan met incidenten.

De richtlijnen, in 1991 vastgesteld door de Werkgroep Uitrusting Tunnels (WUT) worden door opdrachtgevers, ontwerpers en beheerders gebruikt om een basisniveau van tunnelveiligheid te realiseren. Tien jaar geleden waren ze een duidelijke uitbreiding, tegenwoordig zijn ze veeleer synoniem met een standaardbenadering.

De groei van het aantal tunnels en hun grotere diversiteit vereisen derhalve een nieuwe fase in het veiligheidsbeleid voor tunnels; een fase niet enkel met nieuwe en aangescherpte richtlijnen maar ook met een andere benaderingswijze. De Tweede Kamer en maatschappelijke organisaties dringen hierop aan, maar – niet in de laatste plaats – ook ontwerpers vragen erom.

2.1 TUNNELVEILIGHEID. WIE IS VERANTWOORDELIJK?

Het plan om een tunnel aan te leggen kan afkomstig zijn van allerlei verschillende partijen. Naast gemeenten en provincies zijn tegenwoordig steeds vaker publiekprivate organisaties en particuliere ondernemingen initiatiefnemer op dit gebied. De motieven tot tunnelaanleg zijn velerlei. Ze variëren van een verbeterde regionale ontsluiting (Westerscheldetunnel) en de bescherming van milieu en landschap (HSL-tunnel door het Groene Hart) tot meervoudig ruimtegebruik in stedelijke gebieden (Overkluizing Zuid-as Amsterdam). Momenteel zijn diverse nieuwe en grote tunnels in aanbouw. Plannen voor tientallen grote tunnels en overkappingen staan op stapel. De verantwoordelijkheid voor de veiligheid van de tunnels wordt gedeeld. Het rijk stelt de algemene wettelijke eisen aan de veiligheid van bouwwerken en aan de uitrusting van tunnels in het bijzonder. Gemeenten moeten toezien op de navolging daarvan door het beoordelen en afgeven van bouwvergunningen. Daarnaast behoort de rampenbestrijding tot hun wettelijke taak. Lokale overheden moeten kiezen voor welke risicovolle objecten, waaronder tunnels, een rampbestrijdingsplan geboden is. De eerste en directe verantwoordelijkheid voor veiligheid in tunnels ligt echter bij de eigenaren en beheerders van een bouwwerk. Zij moeten zorgen dat zo'n bouwwerk veilig is en blijft.

ART DIRECTORS:
PAUL WEST
PAULA BENSON

DESIGNERS:
PAUL WEST
PAULA BENSON

CLIENT:
THE HOSPITAL

SOFTWARE:
FREEHAND
PHOTOSHOP

MATERIALS:
CONSORT ROYAL

PRINTING:
LITHO

Who are we?
The Hospital Group is owned by Paul G. Allen, who co-founded Microsoft, and run in collaboration with Dave Stewart, film maker, musician and Covent Garden resident.

In the USA, Paul Allen is currently developing **Experience Music Project** in Seattle, a 140,000 square foot interactive music museum, opening in 2000, providing 100 jobs and extensive education programmes.

We have been running education programmes in Seattle since 1995, as we work with local partners to take education into the community even before our building is ready. We have run workshops on the music business, video and film production, developed music curriculum materials for 10-18 year olds and even run music workshops for toddlers.

We also have **Experience Arts Camp** for 8-14 year olds, giving local children training in music, film, the visual arts, drama and creative technologies. We arranged for 30% of the places to be funded by sponsorship for those who couldn't afford the cost.

Paul G. Allen also has a wide range of commercial interests in many new media and technology ventures and other fields related to the proposed Hospital development. We have an independent film company which has made **Inspirations**, a documentary directed by Michael Apted featuring musician David Bowie, painter Roy Lichtenstein, glass artist Dale Chihuly, architect Tadao Ando, dancer Louise Lecavalier, choreographer Edouard Lock and sculptor Nora Naranjo-Morse. **Inspirations II** is now in production, focusing on the creative process in science.

We are also filming **Titus** with Julie Taymor directing a version of Titus Andronicus, starring Sir Anthony Hopkins, Jessica Lange and Alan Cumming, with a behind the camera team including four Oscar® nominees.

Our wealth of experience and contacts in the international arts, entertainment and business communities will help ensure the success of The Hospital.

Timetable.

1992	St Paul's Hospital closure.
1996	Building purchased by The Hospital Group.
1997	Cleaning up process begins.
1998	First planning application refused. Revised application to be submitted.
1999	Revised application submitted.
	· Visitor centre opens at 41 Endell Street.
	· Educational pilot programmes planned.
	· Housing gain for Camden.*
	Additional off-site educational initiatives.*
2001	The Hospital will be open and operational after an 18 month building and fitting out schedule.*

*Subject to planning approval.

...tional multi-arts facility for music, film and art, built on the ...lict St Paul's Hospital site in Covent Garden. ...facility will provide unprecedented opportunities for collaboration between world-renowned artists.

UK

120
FORM
HOSPITAL BROCHURE

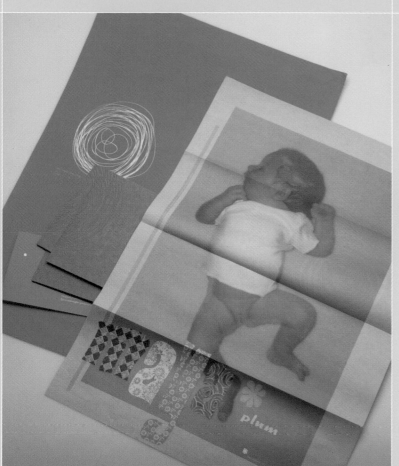

ART DIRECTORS:
CHIARA GRANDESSO
LIONELLO BOREAN

DESIGNERS:
CHIARA GRANDESSO
LIONELLO BOREAN

CLIENT:
CHIARA GRANDESSO
LIONELLO BOREAN

MATERIALS:
ENVELOPE WITH
EMBOSSED PRINT

PRINTING:
CMYK + GOLD INK
+ 1 PANTONE

121
USINE DE BOUTONS
MAYAPLUM BIRTH ANNOUCEMENT

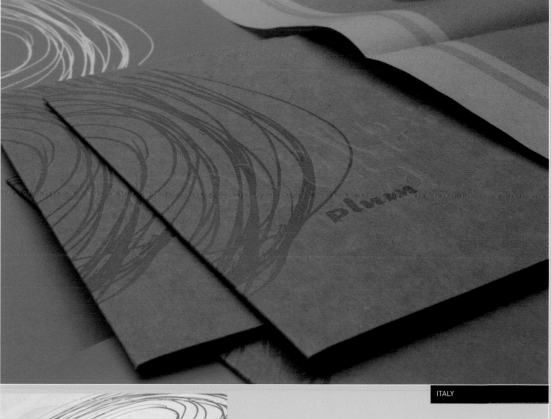

ITALY

HITEC-LOTEC IS A THREE YEAR LOTTERY-FUNDED PROJECT WHICH EXPLORE THE RELATIONSHIP BETWEEN CRAFT AND INDUSTRY THROUGH THE USE OF NEW TECHNOLOGY AND MATERIALS.

122

THIRTEEN DESIGN
HITEC-LOTEC CATALOG

ART DIRECTOR:
DANNY JENKINS

DESIGNERS:
DANNY JENKINS
RYAN WILLS

PHOTOGRAPHERS:
MARCUS GINNS
GRANTLY LYNCH
DANNY JENKINS

CLIENT:
THE CRAFT
CONSORTIUM
FOR NOW AND THE
CRAFTS COUNCIL

SOFTWARE:
ILLUSTRATOR
PHOTOSHOP
QUARKXPRESS

PAPER/MATERIAL:
ORCHARD
SUPERFINE +
FORMATION
SUPERFINE

PRINTING:
4-COLOR PROCESS
+ SEAL

UK

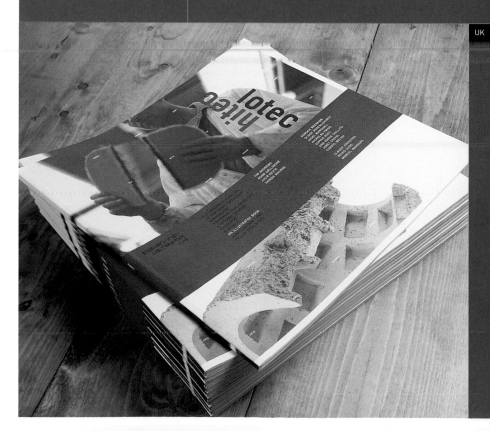

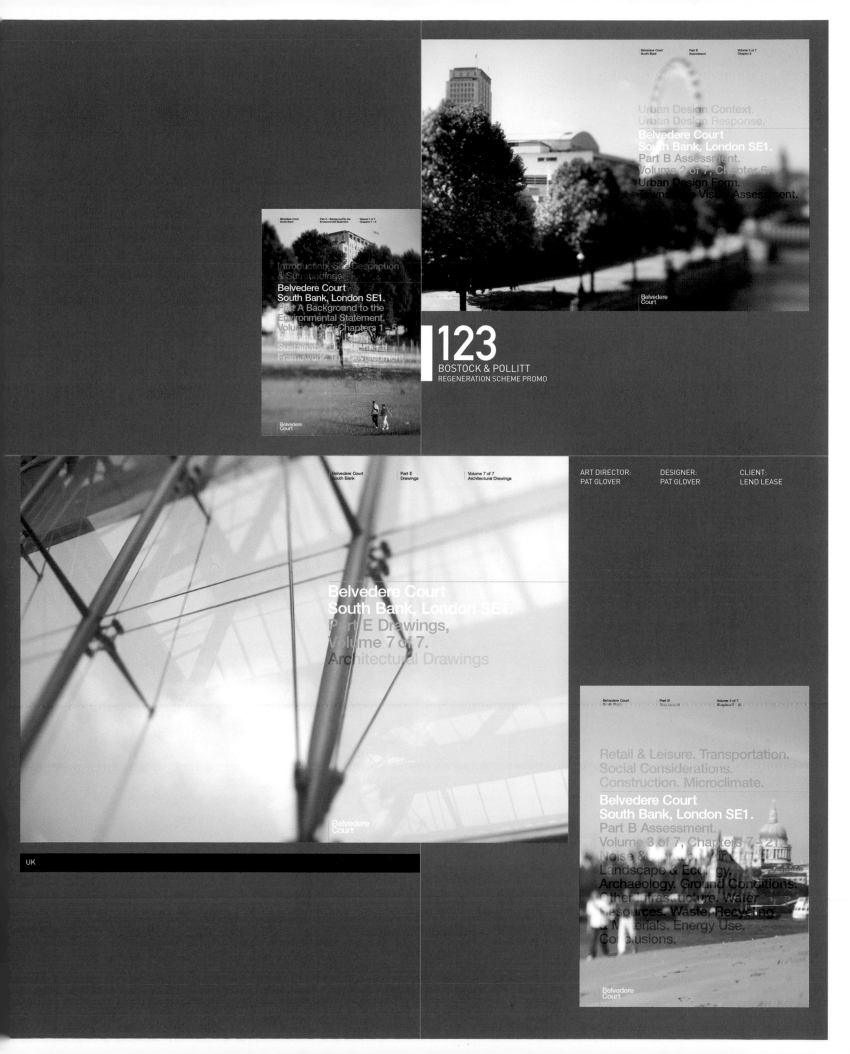

ART DIRECTOR:
PAT GLOVER

DESIGNER:
PAT GLOVER

CLIENT:
LEND LEASE

UK

ravensbourne
college of
design and communication
www.ravensbourne.ac.uk

Ravensbourne is a University Sector College with a
distinctive personality and creative tradition, focussed on
a single site campus within easy reach of central London.
Our mission is to creatively apply digital technology
to design and communication.

2002/03

ra
ens
ue.

v
bo
rn

®

ravensbourne
college of
design and communication
www.ravensbourne.ac.uk

Ravensbourne is a University Sector College with a
distinctive personality and creative tradition, focussed on
a single site campus within easy reach of central London.
Our mission is to creatively apply digital technology
to design and communication.

2002/03

®

ravensbourne
college of
design and communication
www.ravensbourne.ac.uk

Ravensbourne is a University Sector College with a
distinctive personality and creative tradition, focussed on
a single site campus within easy reach of central London.
Our mission is to creatively apply digital technology
to design and communication.

2002/03

ra
ens
ue.

v
bo
rn

Guide to courses

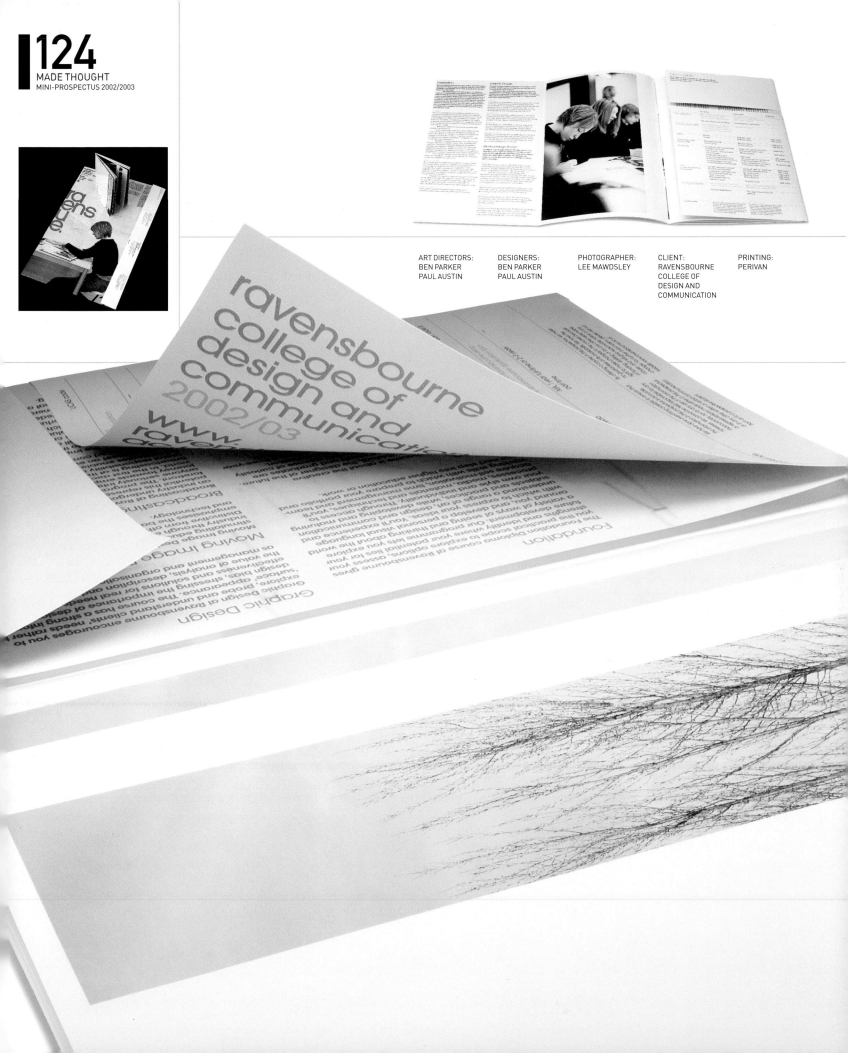

ART DIRECTORS:
BEN PARKER
PAUL AUSTIN

DESIGNERS:
BEN PARKER
PAUL AUSTIN

PHOTOGRAPHER:
LEE MAWDSLEY

CLIENT:
RAVENSBOURNE
COLLEGE OF
DESIGN AND
COMMUNICATION

PRINTING:
PERIVAN

SELF-PROMOTIONAL BROCHURES

STILRADAR // CHEN DESIGN ASSOCIATES // SAS // FROST DESIGN // IRIDIUM, A DESIGN AGENCY
IRON DESIGN // FORM // ELFEN // GRAPHICULTURE // BISQIT DESIGN // FORMAT DESIGN //
WILLOUGHBY DESIGN GROUP // I FAD DOG DIGITAL // KOLEGRAMDESIGN // KO CRÉATION //
USINE DE BOUTONS // LOEWY GROUP // HADE MADE GROUP // THIRTEEN DESIGN //

1.05

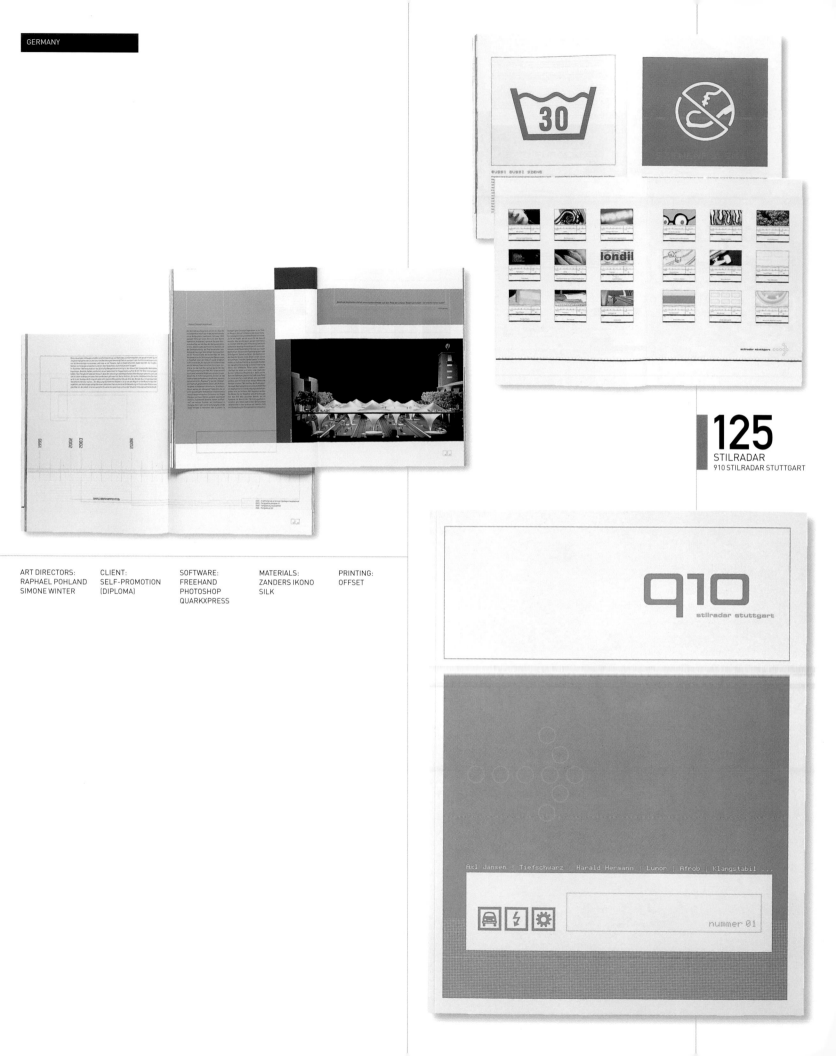

125
STILRADAR
910 STILRADAR STUTTGART

ART DIRECTORS:
RAPHAEL POHLAND
SIMONE WINTER

CLIENT:
SELF-PROMOTION
(DIPLOMA)

SOFTWARE:
FREEHAND
PHOTOSHOP
QUARKXPRESS

MATERIALS:
ZANDERS IKONO
SILK

PRINTING:
OFFSET

126

CHEN DESIGN ASSOCIATES
SUSTAINABILITY MINI-PORTFOLIO

ART DIRECTOR:
JOSHUA C. CHEN

DESIGNERS:
LEON YU
MAX SPECTOR
JUSTIN COYNE
JOSHUA C. CHEN

PHOTOGRAPHERS:
MAX SPECTOR
LEON YU
JUSTIN COYNE

CLIENT:
CHEN DESIGN
ASSOCIATES

SOFTWARE AND
HARDWARE:
ILLUSTRATOR
PHOTOSHOP
QUARKXPRESS
MAC

MATERIALS:
HAMMERMILL
REGALIA ULTRA
WHITE 80C

PRINTING:
MADISON STREET
PRESS

USA

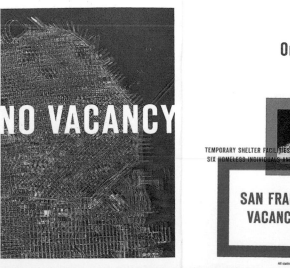

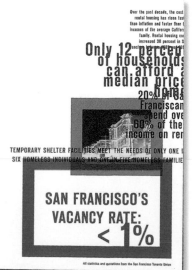

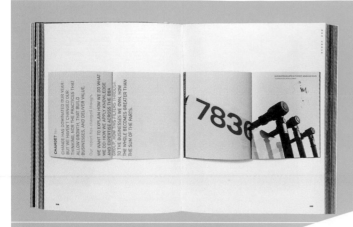

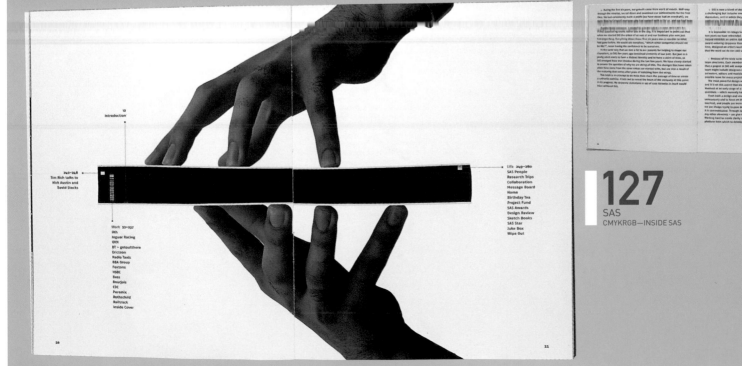

ART DIRECTOR:
GILMAR WENDT

DESIGNER:
GILMAR WENDT

CLIENT:
SAS

SOFTWARE:
INDESIGN

MATERIALS:
PHOENIXMOTION
XENON

PRINTING:
ROSBEEK

127

SAS
CMYKRGB—INSIDE SAS

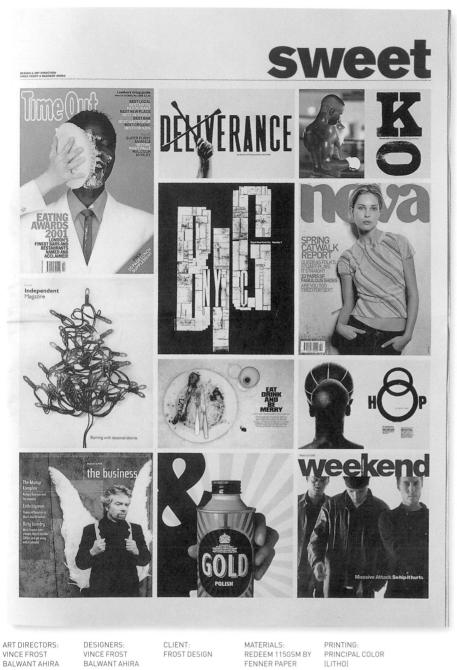

ART DIRECTORS:
VINCE FROST
BALWANT AHIRA

DESIGNERS:
VINCE FROST
BALWANT AHIRA

CLIENT:
FROST DESIGN

MATERIALS:
REDEEM 115GSM BY
FENNER PAPER

PRINTING:
PRINCIPAL COLOR
(LITHO)

UK

a mundane manifesto on:

MÉDIOCRITY

: un manif este commun

129

IRIDIUM, A DESIGN AGENCY
A MUNDANE MANIFESTO ON MEDIOCRITY

ART DIRECTORS:
JEAN-LUC DENAT
MARIO L'ÉCUYER

DESIGNER:
MARIO L'ÉCUYER

PHOTOGRAPHER:
HEADLIGHT
INNOVATIVE IMAGERY

CLIENT:
ROLLAND INC

SOFTWARE AND
HARDWARE:
ILLUSTRATOR
PHOTOSHOP
QUARKXPRESS
MAC G4

MATERIALS:
ROLLAND MOTIF

PRINTING:
LOMOR PRINTERS

CANADA

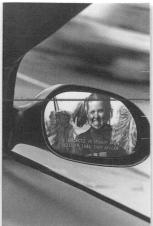

130
IRON DESIGN
IRON DESIGN BROCHURE

ART DIRECTOR:	DESIGNERS:	CLIENT:	SOFTWARE:	MATERIALS:	PRINTING:
TODD EDMUNDS	TODD EDMUNDS TANA EBAUGH	IRON DESIGN	ILLUSTRATOR PHOTOSHOP QUARKXPRESS	100LB DULL-COATED COVER	CURCIO PRINTING + JOHNSON CITY PRESS

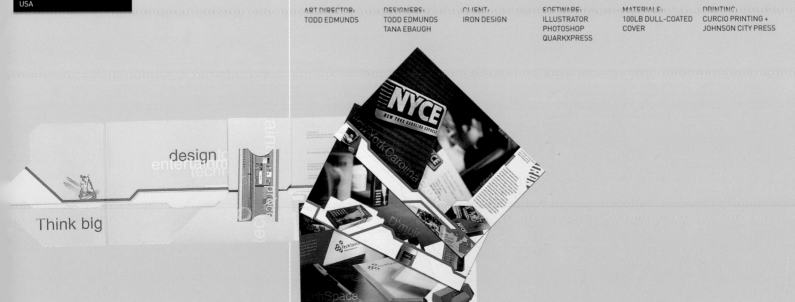

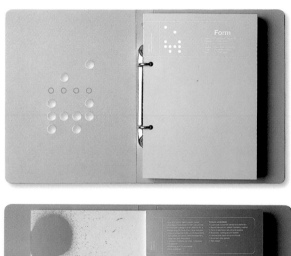

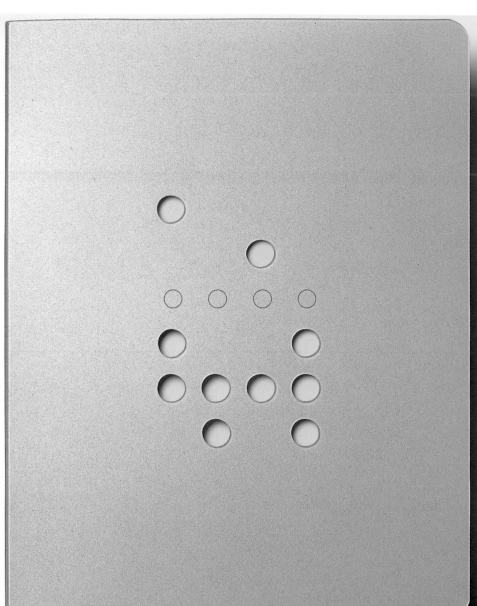

ART DIRECTORS:
PAULA BENSON
PAUL WEST

DESIGNERS:
PAULA BENSON
PAUL WEST

CLIENT:
FORM

SOFTWARE:
FREEHAND

MATERIALS:
CONSORT ROYAL
SILK +
POLYPROPELENE

PRINTING:
LITHO INSERTS +
SCREEN-PRINTED
COVER

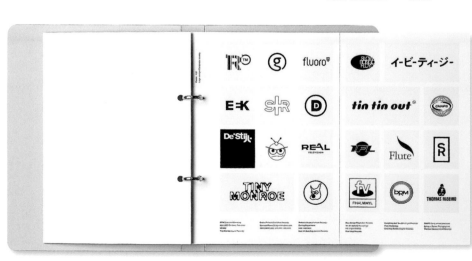

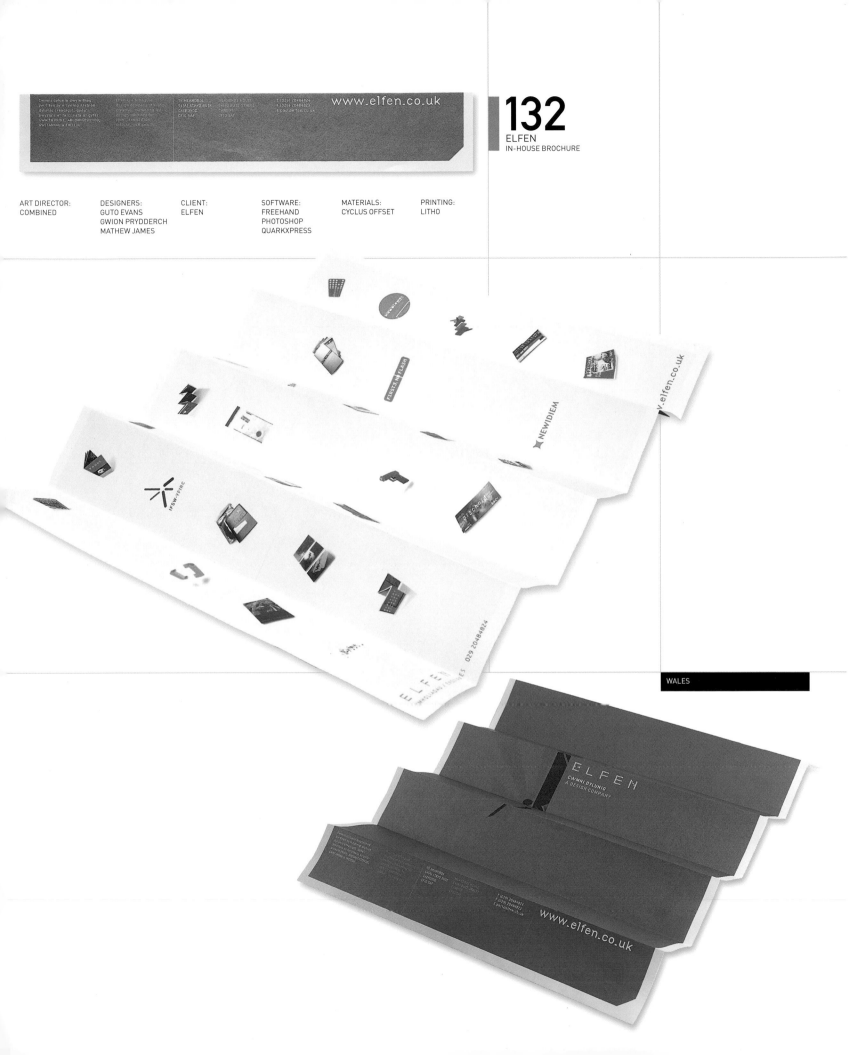

www.elfen.co.uk

ART DIRECTOR:
COMBINED

DESIGNERS:
GUTO EVANS
GWION PRYDDERCH
MATHEW JAMES

CLIENT:
ELFEN

SOFTWARE:
FREEHAND
PHOTOSHOP
QUARKXPRESS

MATERIALS:
CYCLUS OFFSET

PRINTING:
LITHO

WALES

www.elfen.co.uk

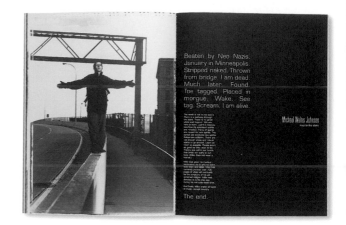

Beaten by Neo Nazis. January in Minneapolis. Stripped naked. Thrown from bridge. I am dead. Much later. Found. Toe tagged. Placed in morgue. Wake. See tag. Scream. I am alive.

The end.

Michael Walter Johnson

USA

I GET UP AT 5 IN THE MORN-ING AND I DON'T HATE IT. Twelve Chevy Suburbans and twenty five years later Steve still digs his job. Exclusive to one company, an engineering firm with clients spread across the map. He's seen many jobs inside and outside of his company, proclaiming his the best of all. Every day is different, every day is still worthy of that 5 a.m. wake-up call.

BIG HIT AND RUN. He gets the best of people. All the personal interaction he needs. Just enough, not too much. Swing in for an anniversary party, a birthday party, have a slice of cake, pizza, a handful of mixed nuts and move on.

GREEN THUMBS ON THE WHEEL. A double lot in south Minneapolis and a family history in horticulture makes Steve a favorite with the ladies. Just watch 'em beam as he slides in with a gathering of fresh flowers hand-selected from the Bachleitner Gardens.

ANTIQUE ROAD SHOWMAN. The secret life of Steve Bachleitner—arranging and running appraisal and estate sales. Tagging the remains and remnants of an existence. In dim attics and hat boxes and stubborn drawers are the letters, photographs and props of lives lived and lost. A skull possibly inherited from his father, the candy, cigarette and gum salesman, who would drag his boys to the dump and drag home assorted unmemorable finds. A collector in his own right, he warns us all to watch for the sale notice on the Steve Bachleitner estate—he guarantees it'll be a good one. (Not too soon Steve, we can wait.)

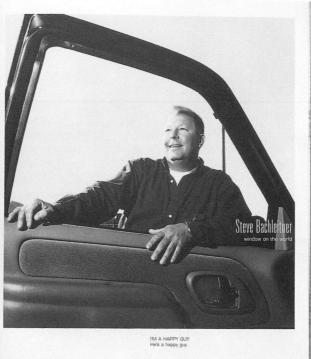

Steve Bachleitner
window on the world

I'M A HAPPY GUY
He's a happy guy.

133

GRAPHICULTURE
"DIRECT"—THE COURIER BOOK

DESIGNER:
BETH MUELLER

CLIENT:
GRAPHICULTURE

MATERIALS:
WAUSAU PAPERS

PRINTING:
LANDMARK COLOUR
COMMUNICATIONS

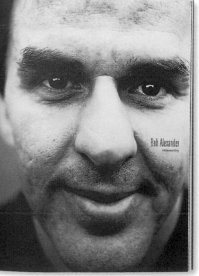

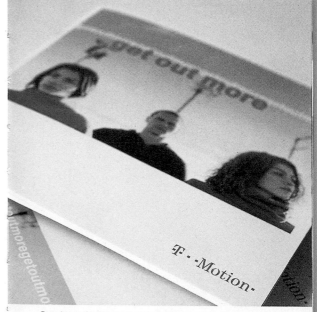

" Bisqit is a team with attitude
and a flexible approach,
that always meets deadlines.
I had a lot of fun working
with Bisqit and I'd certainly
recommend them."

Elaine Devereaux, Public Relations Department, T-Motion

Focusing on the key message 'get out more', T-Motion wanted
to promote its internet services for mobiles with a series of
communication materials that targeted the savvy mobile consumer.
Using witty photography and bold type, this campaign served to
position T-Motion as the new mobile on-line service with attitude.

BISQIT

UtNext is the independent market leader in the delivery of executive
learning, via the Internet.

This direct mail piece, with its powerful call to action, was designed
to engage their target market and provoke a response.

UK

DESIGNER:	CLIENT:	SOFTWARE AND HARDWARE:	PRINTING:
DAPHNE DIAMANT	BISQIT DESIGN	ILLUSTRATOR PHOTOSHOP QUARKXPRESS MAC	THE OAK TREE PRESS

FORMAT DESIGN

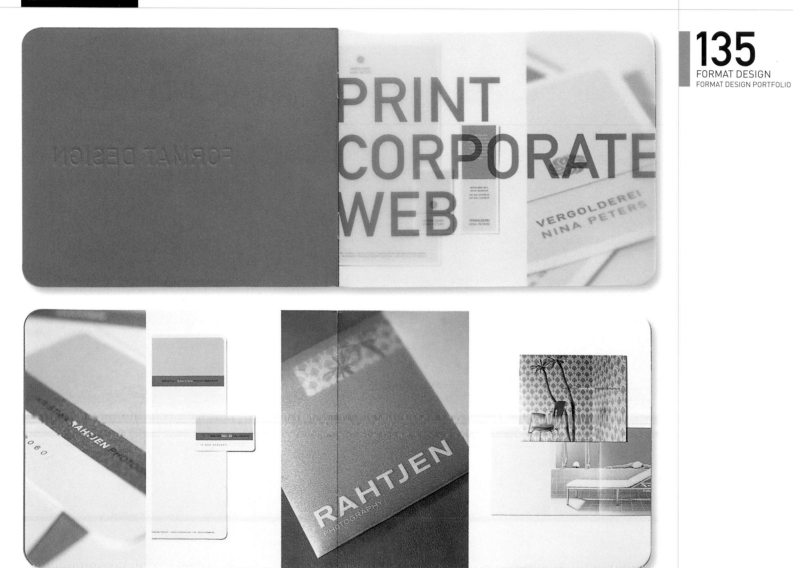

135
FORMAT DESIGN
FORMAT DESIGN PORTFOLIO

DESIGNER:	ILLUSTRATOR:	CLIENT:	SOFTWARE AND	MATERIALS:	PRINTING:
KNUT ETTLING	KNUT ETTLING	FORMAT DESIGN	HARDWARE:	300G PHOENIX	4-COLORS
			FREEHAND	MOTION	
			MAC		

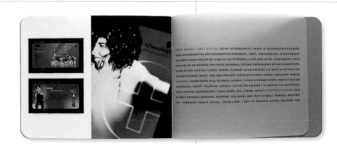

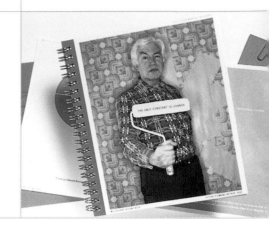

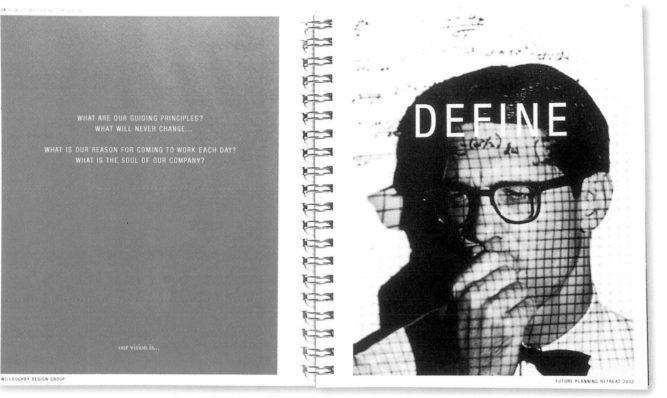

WHAT ARE OUR GUIDING PRINCIPLES?
WHAT WILL NEVER CHANGE...

WHAT IS OUR REASON FOR COMING TO WORK EACH DAY?
WHAT IS THE SOUL OF OUR COMPANY?

our vision is...

WILLOUGHBY DESIGN GROUP

DEFINE

FUTURE PLANNING RETREAT 2002

ART DIRECTOR:
ANN WILLOUGHBY

DESIGNER:
TRENTON KENAGY

CLIENT:
WILLOUGHBY
DESIGN GROUP

SOFTWARE AND
HARDWARE:
QUARKXPRESS
MAC

MATERIALS:
OFFSET

PRINTING:
IN-HOUSE

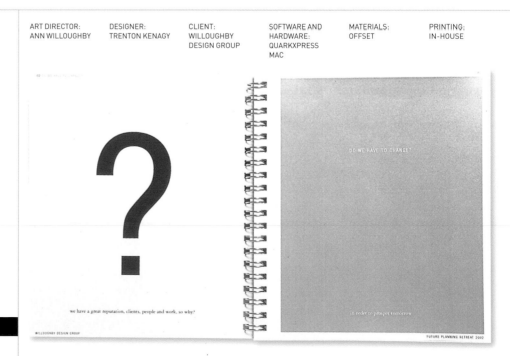

?

we have a great reputation, clients, people and work, so why?

WILLOUGHBY DESIGN GROUP

DO WE HAVE TO CHANGE?

in order to prosper tomorrow

FUTURE PLANNING RETREAT 2002

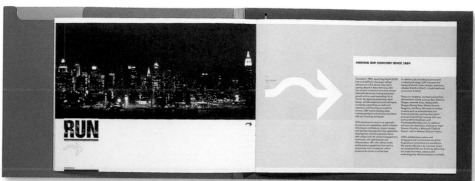

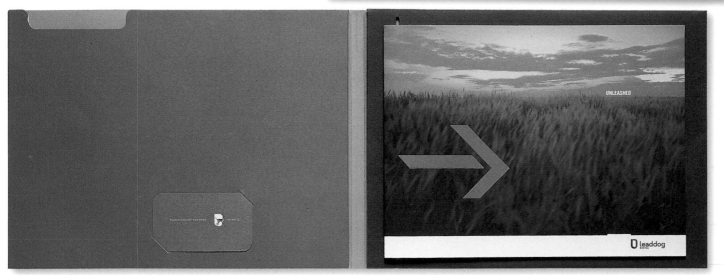

ART DIRECTOR:
NATALIE LAM

DESIGNER:
NATALIE LAM

CLIENT:
LEAD DOG DIGITAL

SOFTWARE:
ILLUSTRATOR
QUARKXPRESS

MATERIALS:
FRENCH

PRINTING:
SEIDEL

137
LEAD DOG DIGITAL
LEAD DOG DIGITAL BROCHURE

qué cho éma esi

ART DIRECTOR:
MIKE TEIXEIRA

DESIGNER:
MIKE TEIXEIRA

CLIENT:
KOLÉGRAMDESIGN

SOFTWARE AND
HARDWARE:
QUARKXPRESS
MAC

PRINTING:
DU PROGRÈS
ALBION
LOMOR PRINTING

CANADA

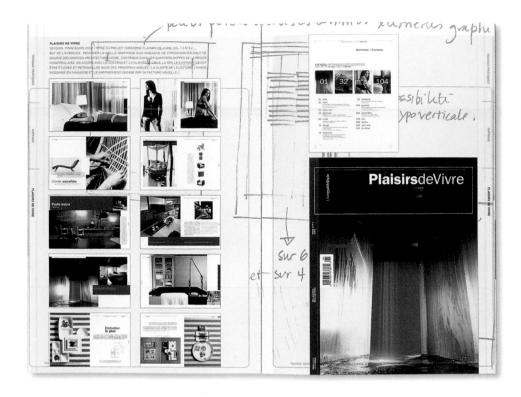

ART DIRECTORS:
POL BARIL
DENIS DULUDE
ANNIE LACHAPELLE

DESIGNERS:
POL BARIL
DENIS DULUDE
ANNIE LACHAPELLE

CLIENT:
KO CREATION

SOFTWARE AND
HARDWARE:
ILLUSTRATOR
PHOTOSHOP
QUARKXPRESS
MAC G3
MAC G4

MATERIALS:
INSIDE: SAPPI
STROBE SILK 100LB
COVER: KRAFT
CARDBOARD

PRINTING:
HEIDELBERG
SPEEDMASTER 102
SHEETFED PRESS.
LINE SCREEN: 175
LPI; 4-COLORS
PROCESS + SATIN
WATER-BASED
VARNISH, 28 X 40,
5-COLORS + WATER-
BASED UNIT

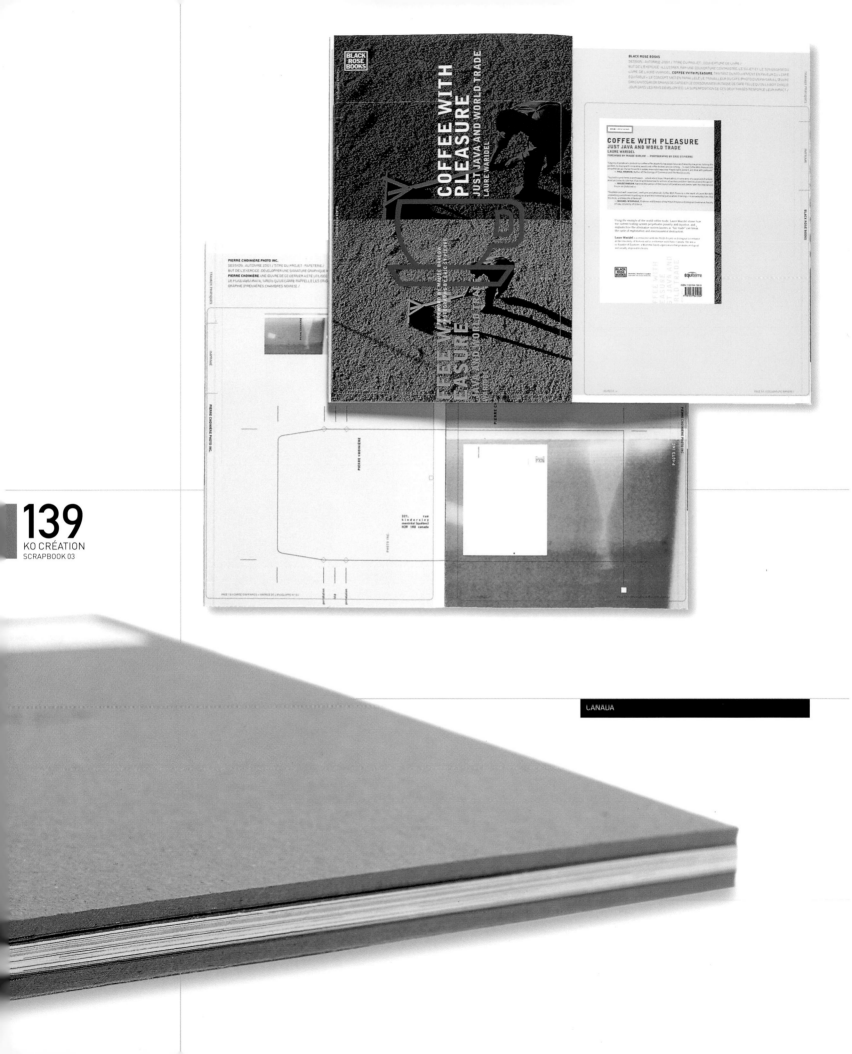

CANADA

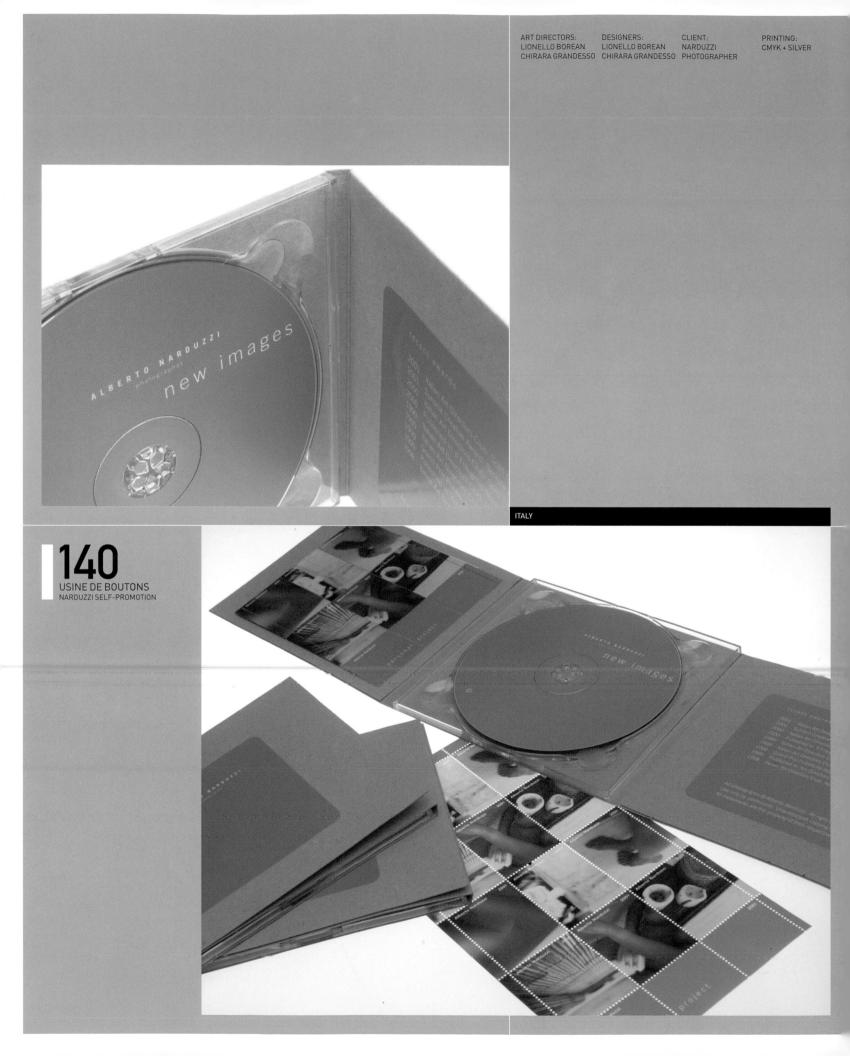

ART DIRECTORS:
LIONELLO BOREAN
CHIRARA GRANDESSO

DESIGNERS:
LIONELLO BOREAN
CHIRARA GRANDESSO

CLIENT:
NARDUZZI
PHOTOGRAPHER

PRINTING:
CMYK + SILVER

ITALY

140
USINE DE BOUTONS
NARDUZZI SELF-PROMOTION

'It must all start with an inspired, spontaneous idea'

ART DIRECTOR:
CLARE WILSON

DESIGNER:
VICKY TRAINER

PHOTOGRAPHER:
PHIL SAYER

MATERIALS:
ROBERT HORNE

PRINTING:
PERIVAN GROUP LTD

What's
going on
out there?
The year
is 2010.
Your rival's
brand is
dead.
Why?

'the main goal is not to complicate the already difficult life of the consumer'

141
LOEWY GROUP
LOEWY BROCHURE

ART DIRECTOR:
ALESSANDRO ESTERI

DESIGNERS:
DAVIDE PREMUMI
ALESSANDRO ESTERI

CLIENT:
HAND MADE GROUP

SOFTWARE AND
HARDWARE:
QUARKXPRESS
MAC

MATERIALS:
FEDRIGONI SYMBOL
PEARL

PRINTING:
OFFSET +
SILKSCREEN

142

HADE MADE GROUP
SELF-PROMO PROFILE

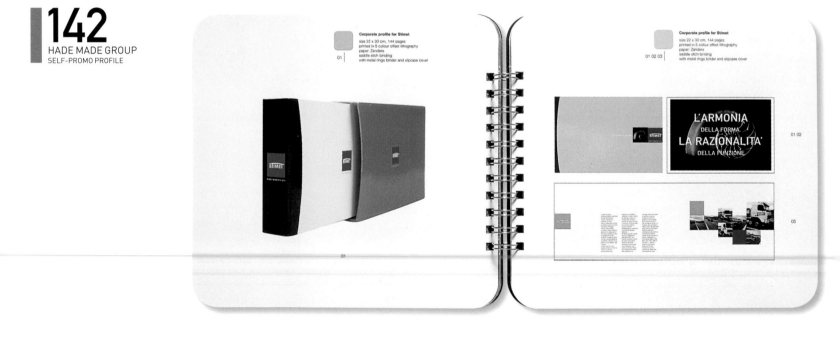

Corporate profile for Stimet
size 22 x 30 cm, 144 pages
printed in 5 colour offset lithography
paper: Zanders
saddle stich binding
with metal rings binder and slipcase cover

01

Corporate profile for Stimet
size 22 x 30 cm, 144 pages
printed in 5 colour offset lithography
paper: Zanders
saddle stich binding
with metal rings binder and slipcase cover

01 02 03

L'ARMONIA
DELLA FORMA
LA RAZIONALITA'
DELLA FUNZIONE

01 02

03

01

people

Since the very beginning at HMG we decided to work with the very best professionals in the world in order to be able to assure our clients of the highest standards for their investments and to provide us with the satisfaction which comes from knowing one has done an excellent job.

01 Alessandro Esteri
HMG
Sila

02 Simona Venentto
HMG Executive
Sila

03 Gioia Maiorelli
Designer
Long Island N.Y.

04 Davide Premuni
Designer
Bologna

05 Verdiana Maggiorelli
Writer
Milano

06 Scott Ruschkisk
Junior Designer
New York

07 Consuela Pecis
Accountant
Sila

08 Eleonora Poli
Web Designer
Firenze

ART DIRECTORS:
JOHN UNDERWOOD
DANNY JENKINS
NICK HAND

DESIGNER:
JOHN UNDERWOOD

PHOTOGRAPHERS:
PETER THORPE
MARCUS GINNS

CLIENT:
THIRTEEN DESIGN

SOFTWARE:
ILLUSTRATOR
PHOTOSHOP
QUARKXPRESS

MATERIALS:
ESSENTIAL GLOSS
DUTCHMAN

PRINTING:
4-COLOR PROCESS +
2 SPECIAL PMS
COLORS + SEALANT

UK

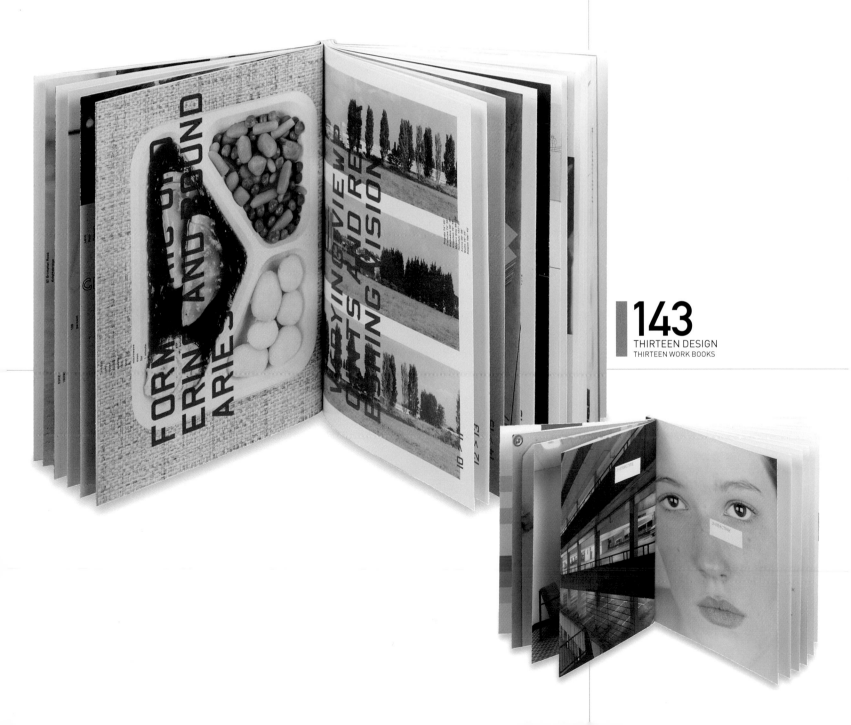

143
THIRTEEN DESIGN
THIRTEEN WORK BOOKS

ARTS, ENTERTAINMENT
AND EVENTS BROCHURES

FROST DESIGN // MARCO MOROSINI // BISQIT DESIGN // REBECCA FOSTER DESIGN // SAS //
FAUXPAS // POULIN + MORRIS // BLUE RIVER DESIGN // HAT-TRICK DESIGN // CHRISTINE FENT +
GILMAR WENDT // HAMBLY & WOOLLEY // NEW MOMENT // KO CRÉATION // KOLÉGRAMDESIGN //
NET INTEGRATORS – NET DESIGN // STEERS MCGILLAN // FABIO ONGARATO DESIGN //
NB:STUDIO // SAGMEISTER INC // CHIMERA DESIGN // CARTER WONG TOMLIN // FORM5 + BÜRO7
USINE DE BOUTONS // PING-PONG DESIGN // HATCH CREATIVE // SAYLES GRAPHIC DESIGN

ISTD 01

International
Society of
Typographic
Designers

International
TypoGraphic
Awards
2001

:06

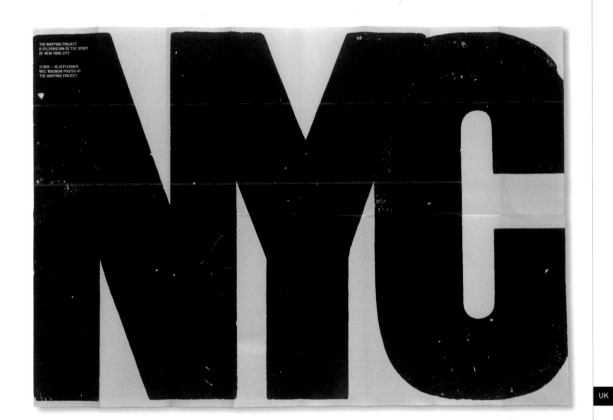

ART DIRECTOR:
VINCE FROST

DESIGNERS:
VINCE FROST
SONYA DYAKOVA

CLIENT:
THE WAPPING
PROJECT

MATERIALS:
CHROMALUX 700
90GSM (BROAD-
SHEET)

PRINTING:
PRINCIPAL COLOR
(LITHO)

UK

144

FROST DESIGN
THE WAPPING PROJECT NYC

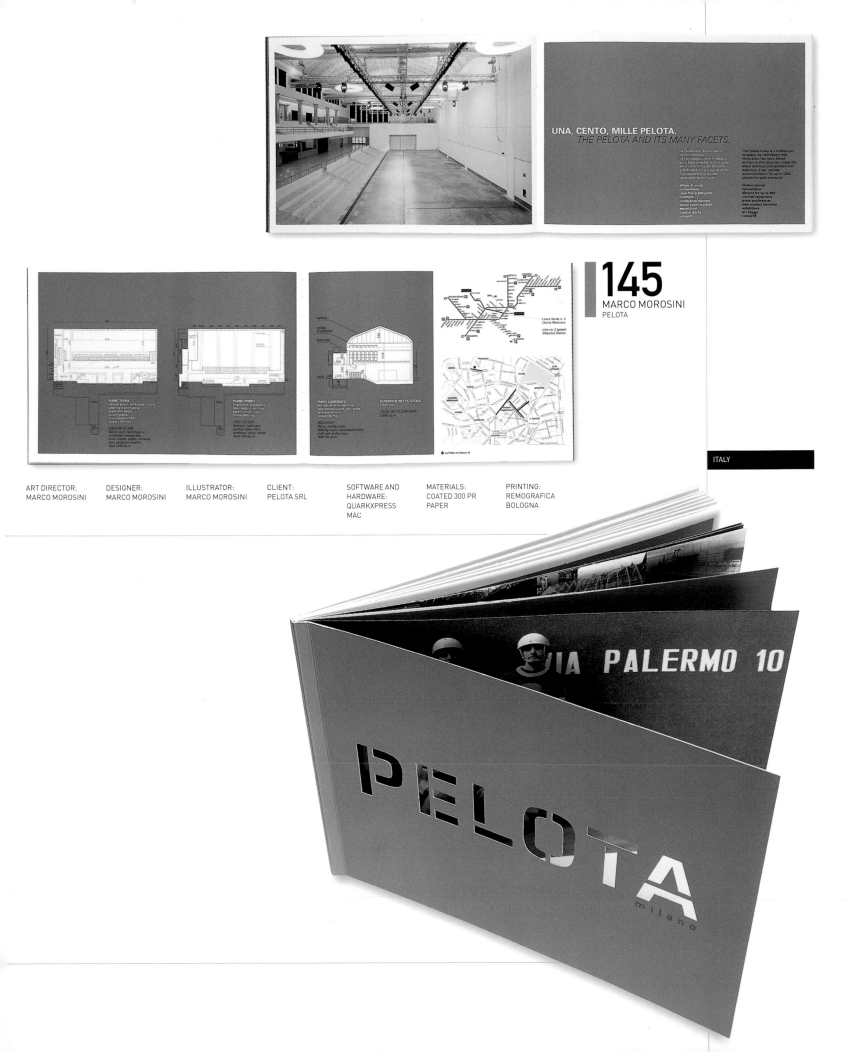

UNA, CENTO, MILLE PELOTA.
THE PELOTA AND ITS MANY FACETS.

145
MARCO MOROSINI
PELOTA

| ART DIRECTOR:
MARCO MOROSINI | DESIGNER:
MARCO MOROSINI | ILLUSTRATOR:
MARCO MOROSINI | CLIENT:
PELOTA SRL | SOFTWARE AND
HARDWARE:
QUARKXPRESS
MAC | MATERIALS:
COATED 300 PR
PAPER | PRINTING:
REMOGRAFICA
BOLOGNA |

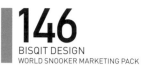

DESIGNER:
DAPHNE DIAMANT
PATRICK DEVLIN

PHOTOGRAPHER:
RANKIN

CLIENT:
WORLD SNOOKER

SOFTWARE AND
HARDWARE:
ILLUSTRATOR
PHOTOSHOP
QUARKXPRESS
MAC

MATERIALS:
MEDLEY AND PVC
PACK

PRINTING:
MIDAS

UK

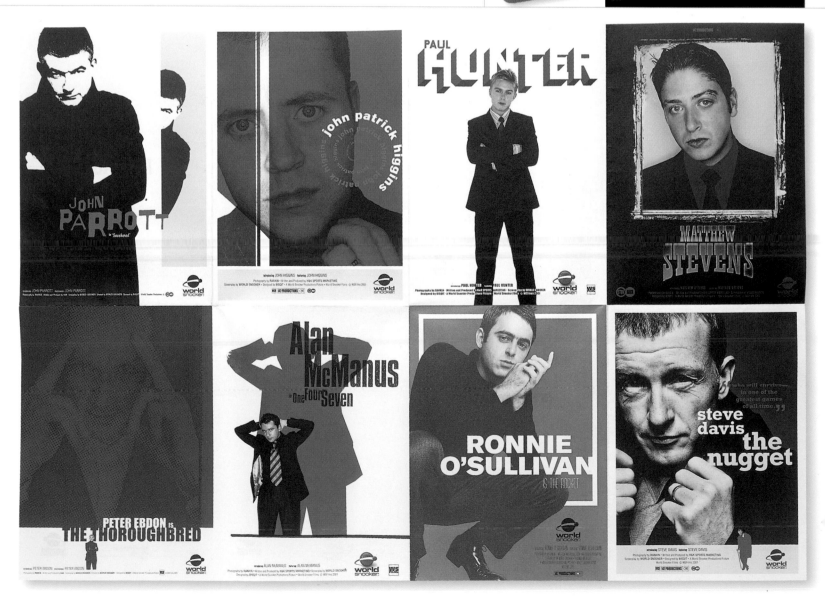

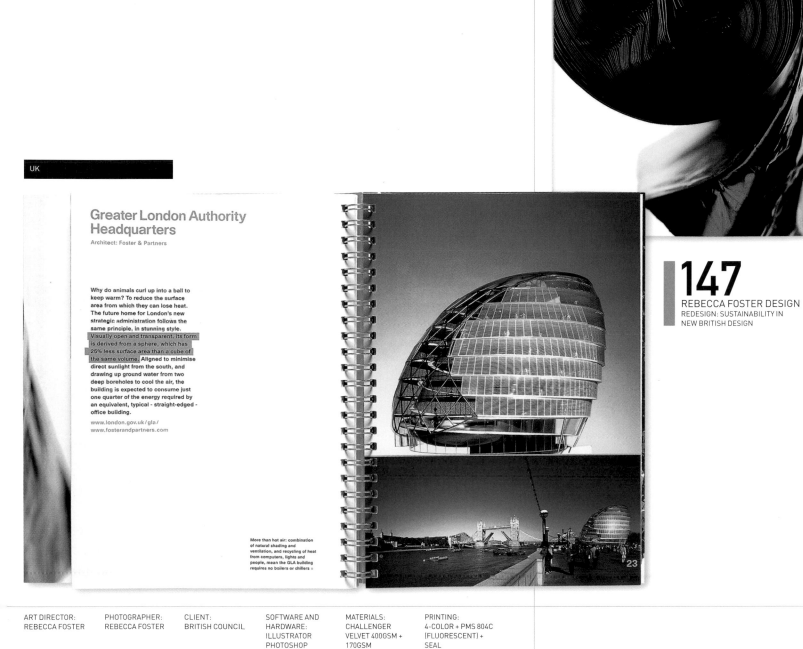

Greater London Authority Headquarters

Architect: Foster & Partners

Why do animals curl up into a ball to keep warm? To reduce the surface area from which they can lose heat. The future home for London's new strategic administration follows the same principle, in stunning style. Visually open and transparent, its form is derived from a sphere, which has 25% less surface area than a cube of the same volume. Aligned to minimise direct sunlight from the south, and drawing up ground water from two deep boreholes to cool the air, the building is expected to consume just one quarter of the energy required by an equivalent, typical - straight-edged - office building.

www.london.gov.uk/gla/
www.fosterandpartners.com

More than hot air: combination of natural shading and ventilation, and recycling of heat from computers, lights and people, mean the GLA building requires no boilers or chillers

23

ReDesign
Sustainability in New British Design

147
REBECCA FOSTER DESIGN
REDESIGN: SUSTAINABILITY IN
NEW BRITISH DESIGN

ART DIRECTOR:
REBECCA FOSTER

PHOTOGRAPHER:
REBECCA FOSTER

CLIENT:
BRITISH COUNCIL

SOFTWARE AND
HARDWARE:
ILLUSTRATOR
PHOTOSHOP
QUARKXPRESS
MAC G4

MATERIALS:
CHALLENGER
VELVET 400GSM +
170GSM

PRINTING:
4-COLOR + PMS 804C
(FLUORESCENT) +
SEAL

Supermarked på lavenergi
Sainsbury's

Supermarkedenes popularitet i Storbritannia skyldes hverken arkitektur eller energieffektivitet, men ren bekvemmelighet. Dette kan endre seg med Sainsbury's nye supermarked i Greenwich, som gjennom flott design og en mengde energibesparende tiltak har blitt et virkelig trivelig sted å handle dagligvarer. Butikken har bønnegenhetet varm et "saglannet" glasstak som slipper inn naturlig lys via canosyrte spusisle, pasom 'trikktufta'-ventilasjon, jordvarmer rundt butikken som isolasjon, oppvarming lto av kombinert varme- og kraftstasjon i selve bygningen, og et kjølesystem som sirkulerer borehullvann i gulvet. Lavere utgifter til strøm og bransel - og mer fornøyde kunder - har ført til at butikkjeden vil vurdere å gå len for fire av disse lavenergi-satsingene i alle nye butikkonsepter.

www.chollesjord-sesotalex.com

Sainsbury's supermarked i Greenwich er det første i sjelden som har blitt designet ut fra grunnleggende prinsipper, med miljøhensyn vevret på toten i

10

INDICATION
VORZEICHEN
VOORTEKEN

UWE POTH

THE OFFICE
ORCHESTRA

ANDREA CHAPPELL AND CHERRY GODDARD

PARADISE
IS ALWAYS
WHERE
YOU'VE BEEN

SANDY SYKES

148
SAS
INSIDE COVER
EXHIBITION CATALOG

A TO Z

ABRAHAMS

A TO Z

INSIDE COVER

INSIDE COVER

ART DIRECTOR:
GILMAR WENDT

DESIGNERS:
GILMAR WENDT
FRANKI GOODWIN
MATT TOMLIN

CLIENT:
MAKINGSPACE
PUBLISHERS

SOFTWARE:
QUARKXPRESS

MATERIALS:
PHOENIX MOTION
XENON

PRINTING:
PERIVAN

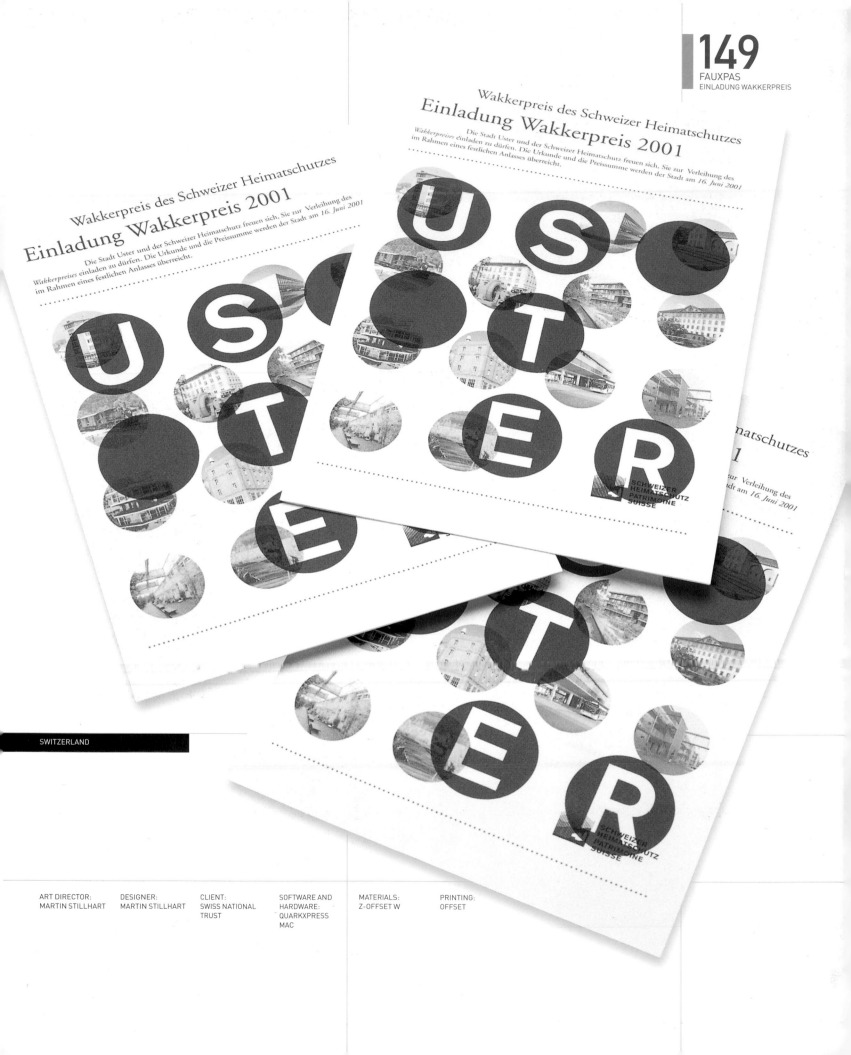

ART DIRECTOR:	DESIGNER:	CLIENT:	SOFTWARE AND	MATERIALS:	PRINTING:
MARTIN STILLHART	MARTIN STILLHART	SWISS NATIONAL	HARDWARE:	Z-OFFSET W	OFFSET
		TRUST	QUARKXPRESS		
			MAC		

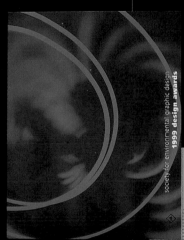

USA

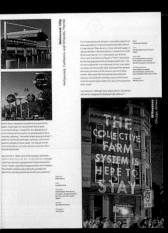

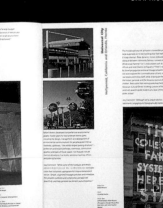

150
POULIN + MORRIS
SEGD

DESIGNERS:
L. RICHARD POULIN
DOUGLAS MORRIS

CLIENT:
SOCIETY FOR
ENVIRONMENTAL
GRAPHIC DESIGN

SOFTWARE:
QUARKXPRESS

MATERIALS:
SAPPI LUSTRO

PRINTING:
QUALITY PRINTING

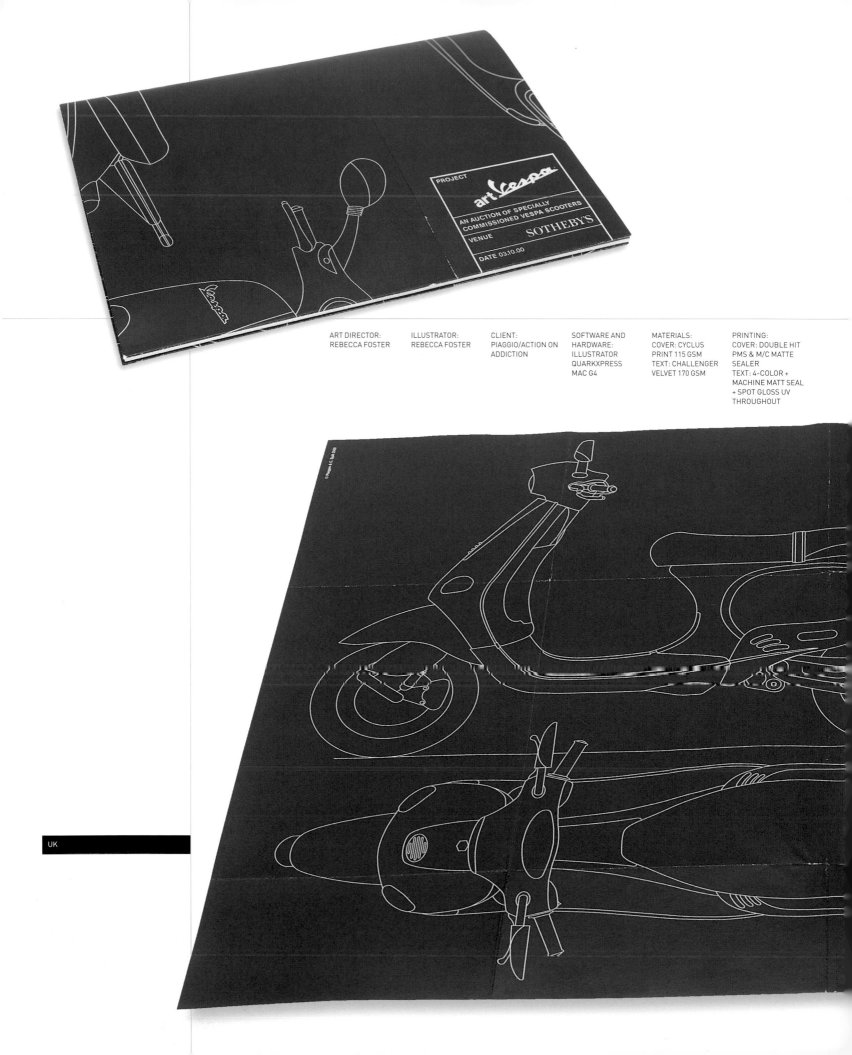

PROJECT
art Vespa
AN AUCTION OF SPECIALLY
COMMISSIONED VESPA SCOOTERS
VENUE SOTHEBY'S
DATE 03.10.00

ART DIRECTOR:
REBECCA FOSTER

ILLUSTRATOR:
REBECCA FOSTER

CLIENT:
PIAGGIO/ACTION ON
ADDICTION

SOFTWARE AND
HARDWARE:
ILLUSTRATOR
QUARKXPRESS
MAC G4

MATERIALS:
COVER: CYCLUS
PRINT 115 GSM
TEXT: CHALLENGER
VELVET 170 GSM

PRINTING:
COVER: DOUBLE HIT
PMS & M/C MATTE
SEALER
TEXT: 4-COLOR +
MACHINE MATT SEAL
+ SPOT GLOSS UV
THROUGHOUT

UK

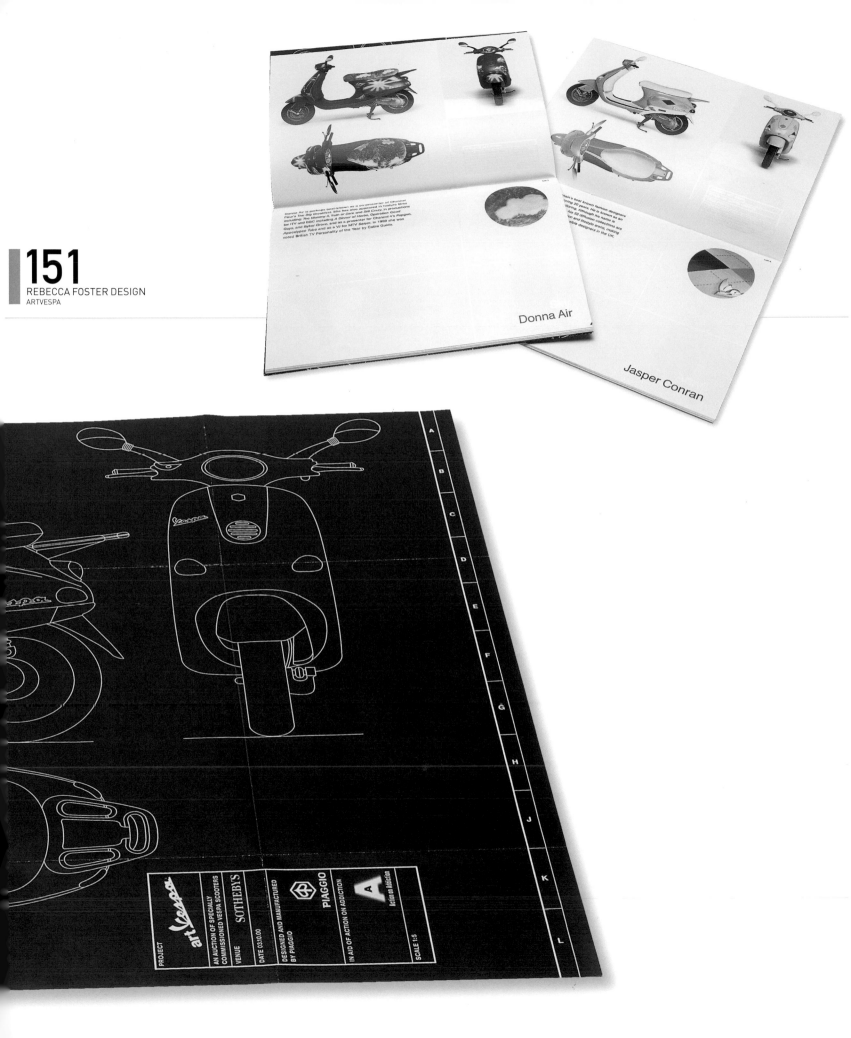

151
REBECCA FOSTER DESIGN
ARTVESPA

Donna Air

Jasper Conran

Priory Promotions present
Rab Noakes and Fraser Speirs

rupert clamp

ART DIRECTOR:	DESIGNER:	CLIENT:	SOFTWARE:	MATERIALS:	PRINTING:
LISA THUNDERCLIFFE	LISA THUNDERCLIFFE	NORTH TYNESIDE ARTS	PHOTOSHOP QUARKXPRESS	300 GSM PEREGRINA + 150 GSM HELLO MATT	2-COLOR LITHO

No-Fi present

frank bretschneider

blackbox
Arts & Media
in/side/out

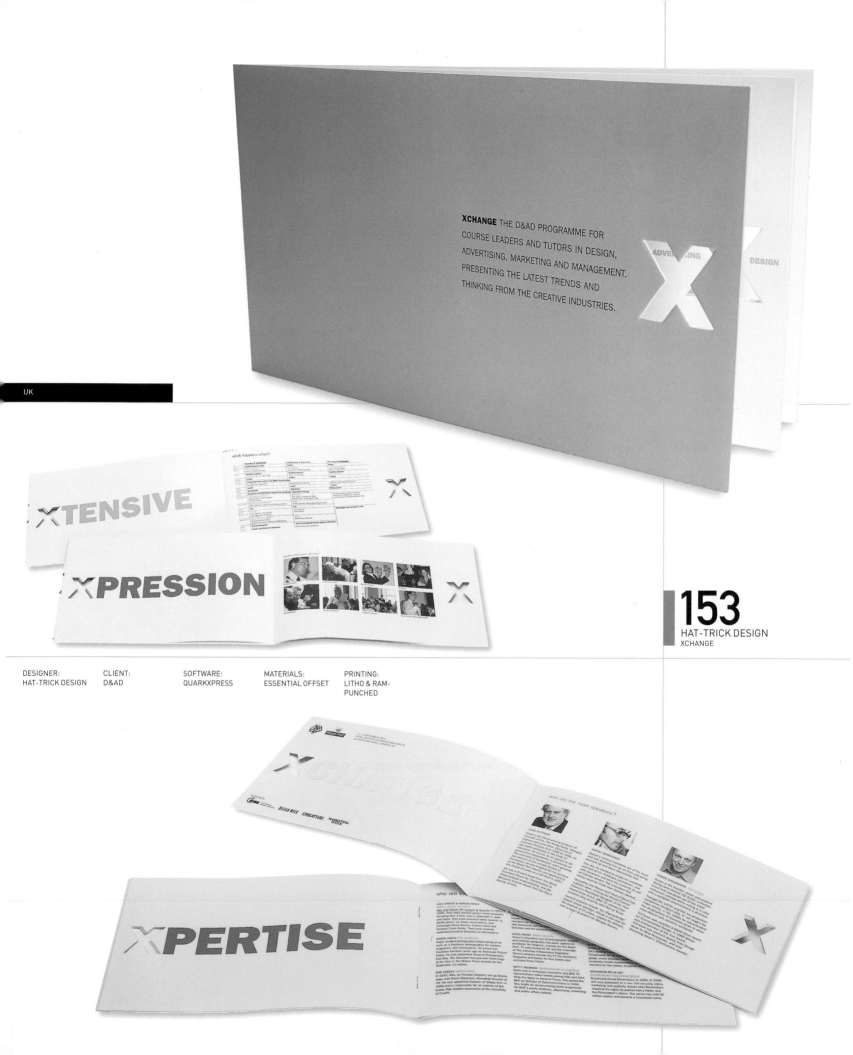

XCHANGE THE D&AD PROGRAMME FOR COURSE LEADERS AND TUTORS IN DESIGN, ADVERTISING, MARKETING AND MANAGEMENT. PRESENTING THE LATEST TRENDS AND THINKING FROM THE CREATIVE INDUSTRIES.

153
HAT-TRICK DESIGN
XCHANGE

DESIGNER:
HAT-TRICK DESIGN

CLIENT:
D&AD

SOFTWARE:
QUARKXPRESS

MATERIALS:
ESSENTIAL OFFSET

PRINTING:
LITHO & RAM-
PUNCHED

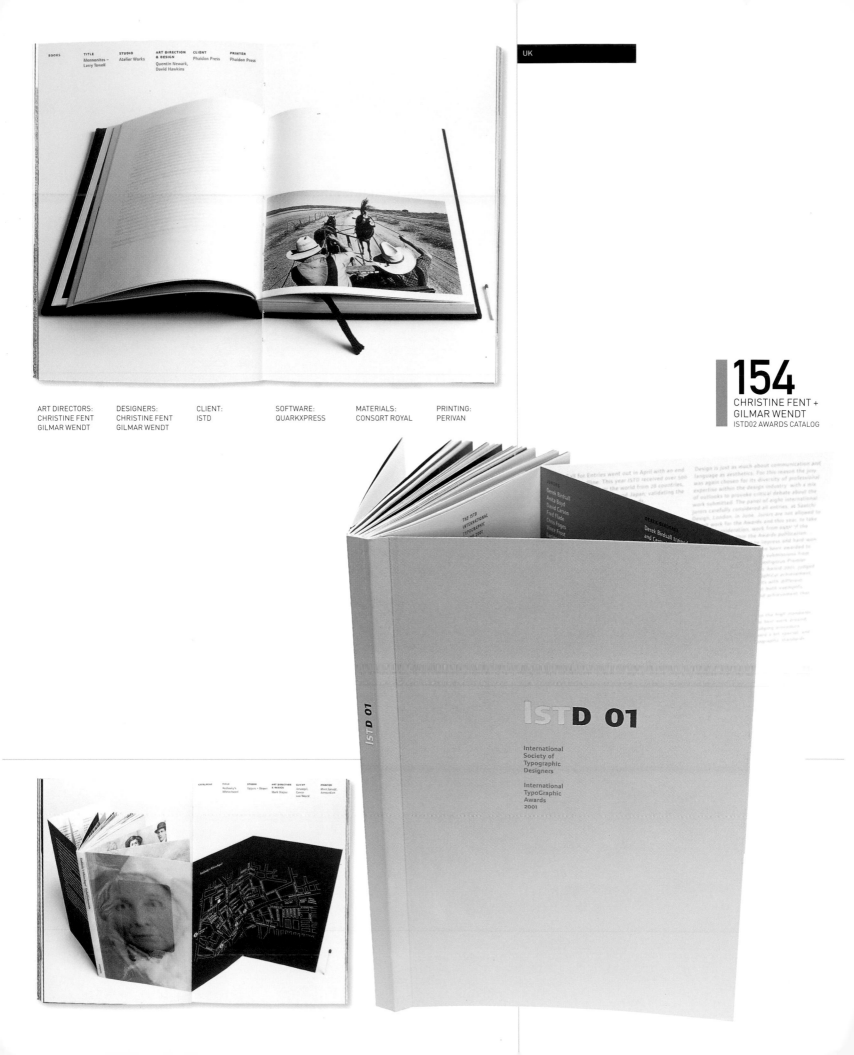

BOOKS　TITLE　STUDIO　ART DIRECTION　CLIENT　PRINTER
Mennonites –　Atelier Works　& DESIGN　Phaidon Press　Phaidon Press
Larry Towell　　Quentin Newark,
　　　David Hawkins

ART DIRECTORS:　DESIGNERS:　CLIENT:　SOFTWARE:　MATERIALS:　PRINTING:
CHRISTINE FENT　CHRISTINE FENT　ISTD　QUARKXPRESS　CONSQRT ROYAL　PERIVAN
GILMAR WENDT　GILMAR WENDT

154
CHRISTINE FENT +
GILMAR WENDT
ISTD02 AWARDS CATALOG

CATALOGUE　TITLE　STUDIO　ART DIRECTION　CLIENT　PRINTER
Redlesky's　Eggers + Diaper　& DESIGN　Artangel,　Mart Spruijt,
Whitechapel　　Mark Diaper　Cance　Amstelven
　　　van Noord

ISTD 01

ISTD 01

International
Society of
Typographic
Designers

International
TypoGraphic
Awards
2001

2000 Membership Directory
The Advertising & Design Club of Canada

A+D

155
HAMBLY & WOOLLEY INC
2000 MEMBERSHIP DIRECTORY

ART DIRECTOR:
BARB WOOLLEY

DESIGNER:
DOMINIC AYRE

PHOTOGRAPHER:
DOMINIC AYRE

CLIENT:
ADVERTISING +
DESIGN CLUB OF
CANADA

PRINTING:
ARTHURS JONES
CLARKE

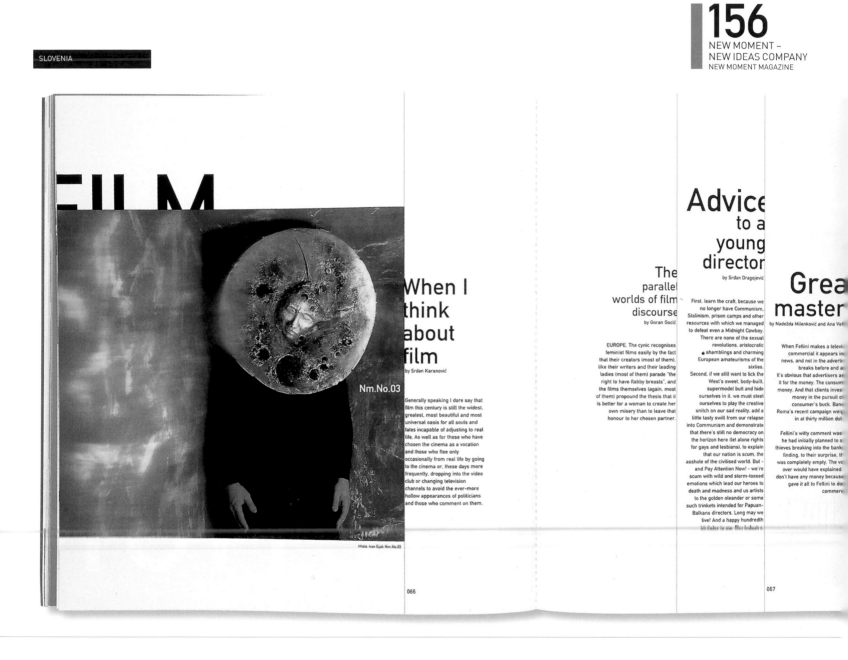

FILM

Nm.No.03

When I think about film

by Srdan Karanović

Generally speaking I dare say that film this century is still the widest, greatest, most beautiful and most universal oasis for all souls and fates incapable of adjusting to real life. As well as for those who have chosen the cinema as a vocation and those who flee only occasionally from real life by going to the cinema or, these days more frequently, dropping into the video club or changing television channels to avoid the ever-more hollow appearances of politicians and those who comment on them.

The parallel worlds of film discourse

by Goran Gocić

EUROPE. The cynic recognises feminist films easily by the fact that their creators (most of them), like their writers and their leading ladies (most of them) parade "the right to have flabby breasts", and the films themselves (again, most of them) propound the thesis that it is better for a woman to create her own misery than to leave that honour to her chosen partner.

Advice to a young director

by Srdan Dragojević

First, learn the craft, because we no longer have Communism, Stalinism, prison camps and other resources with which we managed to defeat even a Midnight Cowboy. There are none of the sexual revolutions, aristocratic shamblings and charming European amateurisms of the sixties.
Second, if we still want to lick the West's sweet, body-built, supermodel butt and hide ourselves in it, we must steel ourselves to play the creative snitch on our sad reality, add a little tasty swill from our relapse into Communism and demonstrate that there's still no democracy on the horizon here (let alone rights for gays and lesbians), to explain that our nation is scum, the asshole of the civilised world. But – and Pay Attention Now! – we're scum with wild and storm-tossed emotions which lead our heroes to death and madness and us artists to the golden oleander or some such trinkets intended for Papuan-Balkans directors. Long may we live! And a happy hundredth

Great masters

by Nadežda Milenković and Ana Vel

When Fellini makes a televi commercial it appears in news, and not in the adverti breaks before and a It's obvious that advertisers a it for the money. The consum money. And that clients inves money in the pursuit o consumer's buck. Bane Roma's recent campaign weig in thirty million dol

Fellini's witty comment was he had initially planned to s thieves breaking into the bank finding, to their surprise, th was completely empty. The vo over would have explained don't have any money because gave it all to Fellini to do commerce

Photo: Ivan Sijak Nm.No.03

FILMSKI LETAK
SLOBODAN ŠIJAN · FILM LEAFLET(S)

NEW MOMENT

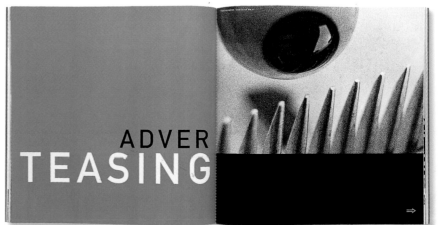

ADVER
TEASING

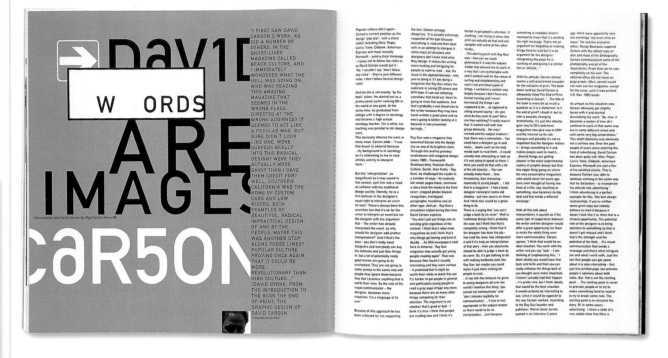

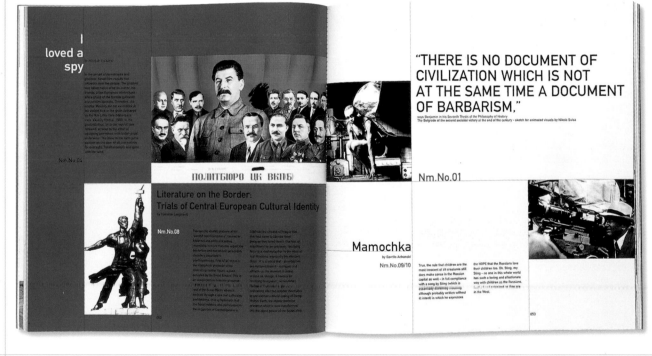

No.01

ART DIRECTORS:
EDUARD ČEHOVIN
SLAVIMIR
STODANOVIČ

DESIGNERS:
EDUARD ČEHOVIN
SLAVIMIR
STODANOVIČ

PHOTOGRAPHER:
JUGOSLAV VLAHOVIC

MATERIALS:
CHARGONET

PRINTING:
DELO PRINTING
HOUSE

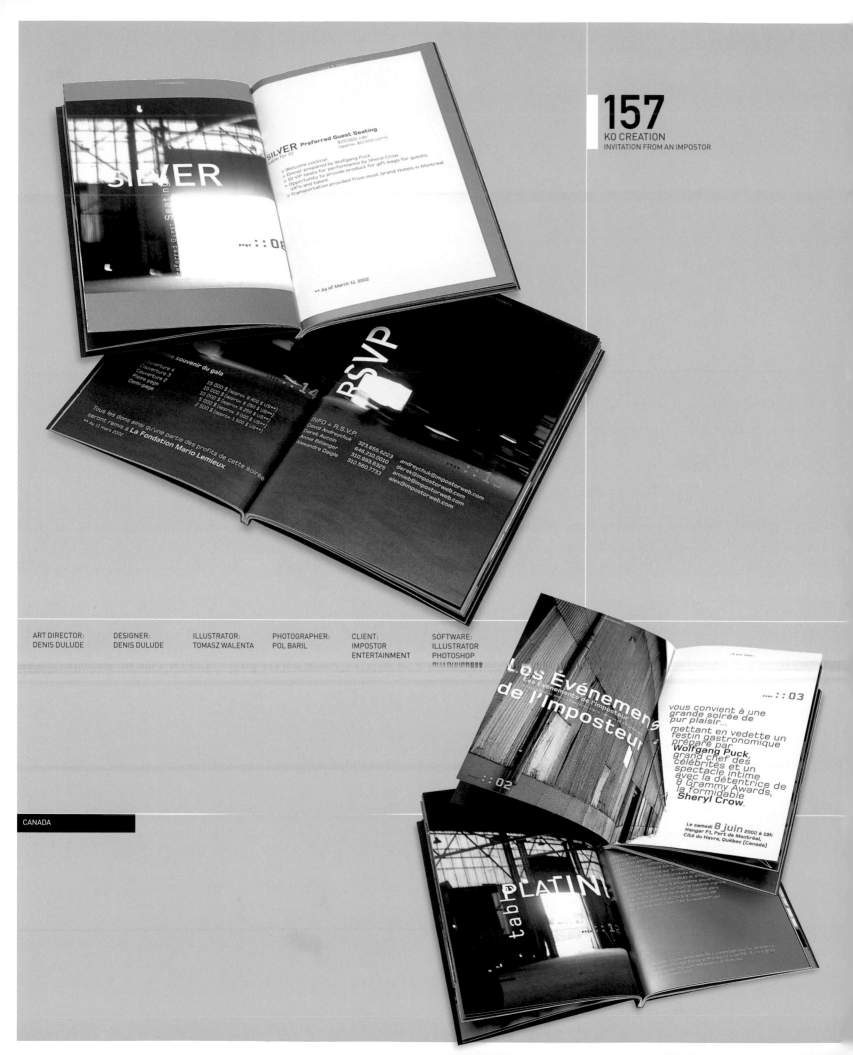

ART DIRECTOR:
DENIS DULUDE

DESIGNER:
DENIS DULUDE

ILLUSTRATOR:
TOMASZ WALENTA

PHOTOGRAPHER:
POL BARIL

CLIENT:
IMPOSTOR
ENTERTAINMENT

SOFTWARE:
ILLUSTRATOR
PHOTOSHOP
QUARKXPRESS

CANADA

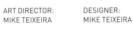

ART DIRECTOR:
MIKE TEIXEIRA

DESIGNER:
MIKE TEIXEIRA

CLIENT:
AXENÉOR/CENTRE
D'ARTISTES

PRINTING:
M.O.M. GROUP

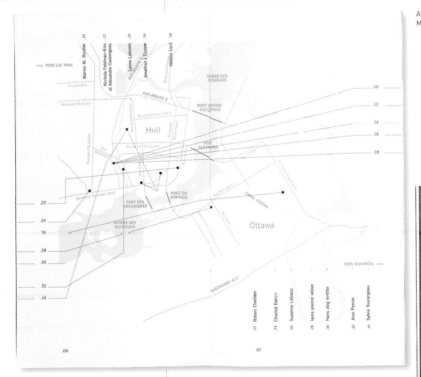

158
KOLÉGRAMDESIGN
ÉCHELLE DE LA LANGUE

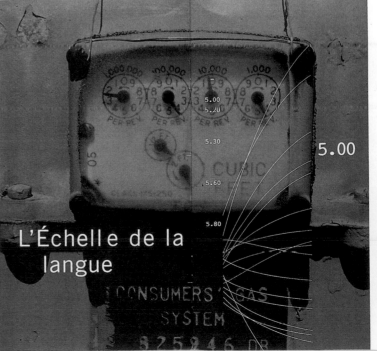

ART DIRECTOR:
JASON CHONG

DESIGNER:
JASON CHONG

CLIENT:
HUIZINGA INSTITUTE
(UNIVERSITIES OF
AMSTERDAM &
UTRECHT)

SOFTWARE AND
HARDWARE:
PHOTOSHOP
QUARKXPRESS
APPLE CUBE
PC

MATERIALS:
WOODFREE
MACHINE-COATED
170 GSM

PRINTING:
4-COLOR + VARNISH
ON A HEIDELBERG
SPEEDMASTER 72
PRESS

159
NET INTEGRATORS – NET DESIGN
CONFERENCE POSTER/FLYER/PROGRAM
(PRO BONO)

ART DIRECTOR:
ANNIE LACHAPELLE

DESIGNER:
ANNIE LACHAPELLE

CLIENT:
CINÉMATHÈQUE
QUÉBÉCOISE

SOFTWARE:
ILLUSTRATOR
PHOTOSHOP
QUARKXPRESS

68 LA REVUE DE LA CINÉMATHÈQUE

MARS-AVRIL 2002

SOMMAIRE GILLES GROULX, L'INTÉGRALE | PETER KUBELKA : AUTOPORTRAITS DE L'ARTISTE 05 | LES CHEMINS DE ROSSELLINI | ALEKSANDR PTOUCHKO | ANNE-MARIE MIÉVILLE | NOUVEAU CINÉMA TCHÈQUE | SEMAINE D'ACTIONS CONTRE LE RACISME | LA COOP VIDÉO A 25 ANS | MÉMENTO POUR HUBERT AQUIN | LARRY KENT | TOUJOURS PAGNOL | SPIRAFILM, LE 25e | PLACE AUX VARIÉTÉS | PROGRAMMES HEBDOMADAIRES DE MARS ET AVRIL 07–19 | INDEX DES CYCLES ET DES TITRES 25–27 | INFORMATIONS 28 |

64 LA REVUE DE LA CINÉMATHÈQUE

JUIN-JUILLET-AOÛT

SOMMAIRE PRÉSENTATION 03 | JAIME HUMBERTO HERMOSILLO LA PROFONDEUR DU QUOTIDIEN SELON HERMOSILLO 05 | TOTO TOTO SUR LE RUE SAINT-LAURENT | ZURLINI LE STYLE ET LES ÉMOTIONS 08–09 | SÉRIES FRANÇAISES 15 | LE CINÉMA SCIENTIFIQUE | MONTY PYTHON 21 | AUTORIOCINÉMATOGRAPHIQUE 23 | JAZZ À L'ÉCRAN 11 | PROGRAMMES HEBDOMADAIRES DE JUIN, JUILLET ET AOÛT 10–27 | INDEX DES CYCLES ET DES TITRES 31–35 | EXPOSITION ET INFORMATIONS 36 |

67 LA REVUE DE LA CINÉMATHÈQUE

JANVIER-FÉVRIER 2002

SOMMAIRE MERCI MONSIEUR SCORSESE | CARL TH. DREYER, CINÉASTE DE L'IRRÉMÉDIABLE 05 | L'AUTRE DOUBLE D'ALAIN ROBBE-GRILLET 06 | L'ACPAV / LE 30e 09 | L'ANIMATION D'AVANT-GARDE DU XXe SIÈCLE 12 | PREMIER PLAN 15 | TÉLÉTHÉÂTRE : CRÉATIONS ORIGINALES 18 | PROGRAMMES HEBDOMADAIRES DE JANVIER ET FÉVRIER 07–19 | INDEX DES CYCLES ET DES TITRES 23–27 | INFORMATIONS 28 | EXPOSITIONS 29 |

DREYER
ROBBE...
ACPAV...

66 LA REVUE DE LA CINÉMATHÈQUE

NOVEMBRE-DÉCEMBRE 2001

SOMMAIRE L'ANIMATION : UN DÉFI DE RIGUEUR 03 | ARTE DOCUMENTAIRES 05 | AGNIESZKA HOLLAND 06 | TRAJECTOIRE DE JEAN-DANIEL POLLET 06 | LE CINÉMA SCIENTIFIQUE FRANÇAIS 07 | GÉRARD BLAIN 14 | PIOTR SAGEPIN 18 | PROGRAMMES HEBDOMADAIRES DE NOVEMBRE ET DÉCEMBRE 07–19 | INDEX DES CYCLES ET DES TITRES 23–27 | INFORMATIONS 28 | EXPOSITIONS 29 |

ARTE
documentaires

CANADA

160

KO CREATION
LA REVUE

VALERIO ZURLINI :
LE STYLE ET LES ÉMOTIONS

DANS *CRONACA FAMILIARE*, VALERIO ZURLINI A SURTOUT FILMÉ UNE VOIX, LA VOIX DE MARCELLO MASTROIANNI QUI DONNE VIE À LA CONVERSATION INTIME ENTRE UN ÉCRIVAIN (ENRICO) ET SON FRÈRE DISPARU. PLUS QU'UNE ADAPTATION CINÉMATOGRAPHIQUE LITTÉRALE DE CE TEXTE TIRÉ DU ROMAN COURT ET INTENSE DE VASCO PRATOLINI, ZURLINI A RÉELLEMENT TRADUIT CES PAROLES EN IMAGES. CE SONT CES PAROLES QUI SONT LE REFLET CACHÉ DES MAISONS ÉTROITES ET DES MURS D'UNE FLORENCE DÉSERTE COMME ON PEUT LE VOIR DANS LE CADRAGE DE OTTONE ROSAI QUI LES ONT INSPIRÉS.

ANTONIO COSTA

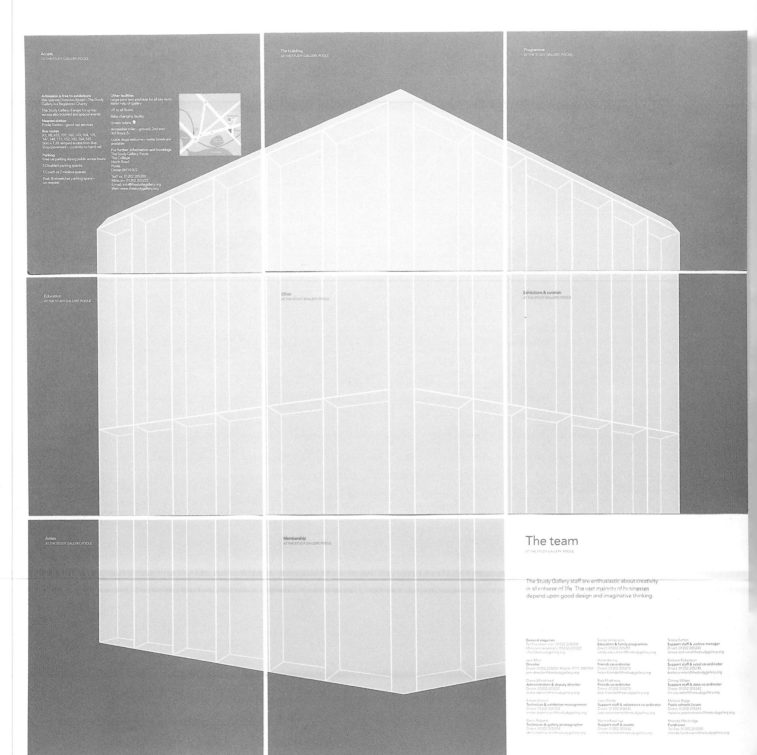

ART DIRECTORS:
RICHARD MCGILLAN
CHLOE STEERS

CLIENT:
THE STUDY GALLERY
POOLE

PRINTING:
2-COLOR LITHO

161

STEERS MCGILLAN
THE STUDY GALLERY WELCOME PACK

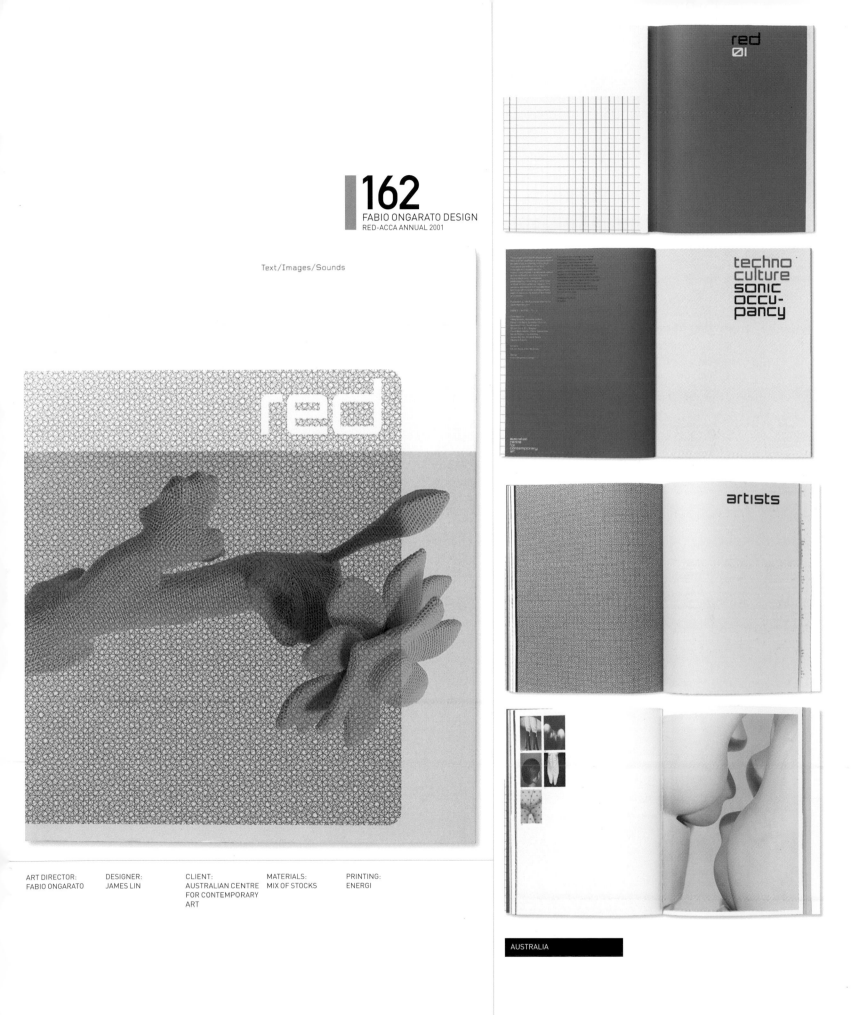

162
FABIO ONGARATO DESIGN
RED-ACCA ANNUAL 2001

Text/Images/Sounds

ART DIRECTOR:
FABIO ONGARATO

DESIGNER:
JAMES LIN

CLIENT:
AUSTRALIAN CENTRE
FOR CONTEMPORARY
ART

MATERIALS:
MIX OF STOCKS

PRINTING:
ENERGI

AUSTRALIA

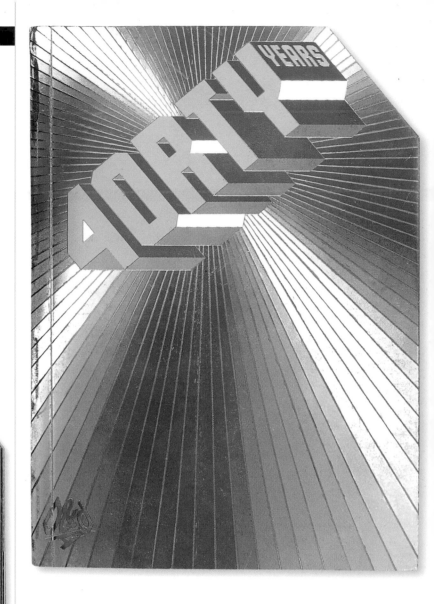

"I SHOT HIM"
REID MILES

PHOTOGRAPHER – REID MILES / ART DIRECTOR – TONY KAYE
AGENCY – CDP / CLIENT – WHITBREAD
AGENTS: TONY McAFEE ASSOCIATES LTD. 01-240 1636. TELEX 888607.

163
NB:STUDIO
D&AD BOOK OF THE NIGHT

ART DIRECTORS:
ALAN DYE
NICK FINNEY
BEN STOTT

DESIGNER:
NICK VINCENT

CLIENT:
D&AD

SOFTWARE:
ILLUSTRATOR
QUARKXPRESS

MATERIALS:
COVER: DUFLEX
ENGRAVING
TEXT: GALLERIE SILK

PRINTING:
VENTURA

life begins at 40!

happy birthday dandad
love from all @ seymourpowell
www.seymourpowell.com
020 7381 6433

ANNI KUAN

HAPPILY INVITES YOU IN THIS YEAR OF
THE HORSE TO THE FASHION COTERIE
TO PREVIEW THE FALL AND WINTER
2002 COLLECTION

FROM SUNDAY, FEB 24 2002 TO TUESDAY, FEB 26
2002, PIER 92, BOOTH #1638, NEW YORK CITY

REPRESENTED BY

CYNTHIA OCONNOR & COMPANY
141 WEST 36TH STREET, SUITE 12A
NEW YORK CITY, NY 10018
TEL 212·594 4999 FAX 212·594 0770

ANNI KUAN

ANNI KUAN STUDIO
242 WEST 38TH STREET
11TH FLOOR
NEW YORK CITY, NY 10018
TEL 212·704 4038
FAX 212·704 0651

USA

ART DIRECTOR:
STEFAN SAGMEISTER

DESIGNER:
MATHIAS
ERNSTBERGER

PHOTOGRAPHER:
MATHIAS
ERNSTBERGER

CLIENT:
ANNI KUAN DESIGN

MATERIALS:
NEWSPRINT +
PLASTIC HORSE

FABIO ONGARATO DESIGN
LINEAGE: THE ARCHITECTURE OF
DANIEL LIBESKIND

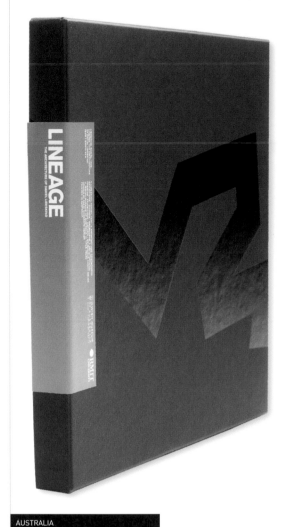

AUSTRALIA

ART DIRECTOR:
FABIO ONGARATO

DESIGNER:
JAMES LIN

CLIENT:
JEWISH MUSEUM OF
AUSTRALIA

MATERIALS:
NORDSET

PRINTING:
GUNN & TAYLOR

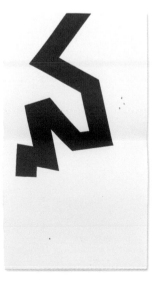

07
POINT, LIFE,
LINE

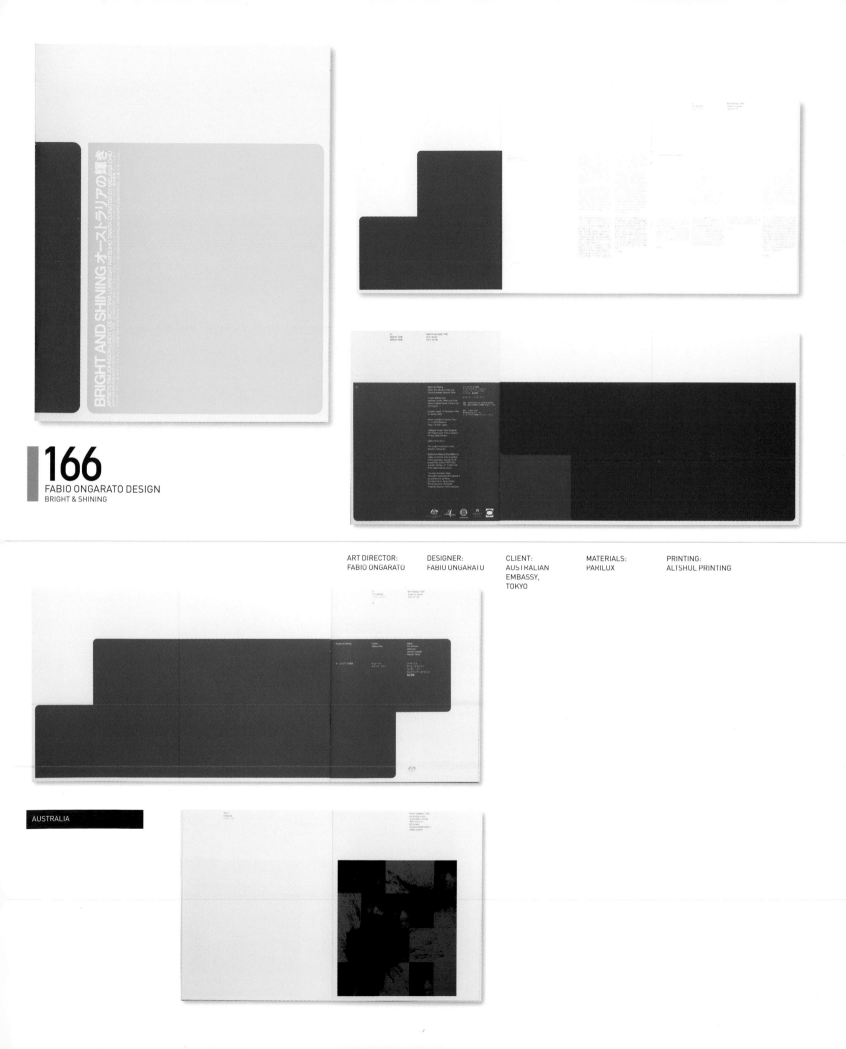

166
FABIO ONGARATO DESIGN
BRIGHT & SHINING

ART DIRECTOR:
FABIO ONGARATO

DESIGNER:
FABIO ONGARATO

CLIENT:
AUSTRALIAN
EMBASSY,
TOKYO

MATERIALS:
PARILUX

PRINTING:
ALTSHUL PRINTING

AUSTRALIA

Entertaining Benefits Exclusive use of the Serpentine Gallery in June and July + Multiple entertaining opportunities + Contemporary and elegant settings + In-house Events Organisers **Corporate Employee Benefits** Private tours and talks + Limited edition prints for company offices + Discounts at the Serpentine Bookshop + Invitations to openings + Priority booking for Serpentine Gala events **Sponsorship Opportunities** Exhibition sponsorship + Education Programme funding + Special Projects and Events sponsorship

ART DIRECTOR:
VINCE FROST

DESIGNER:
VINCE FROST

CLIENT:
THE SERPENTINE
GALLERY

PRINTING:
FARRINGDON
PRINTERS (LITHO)

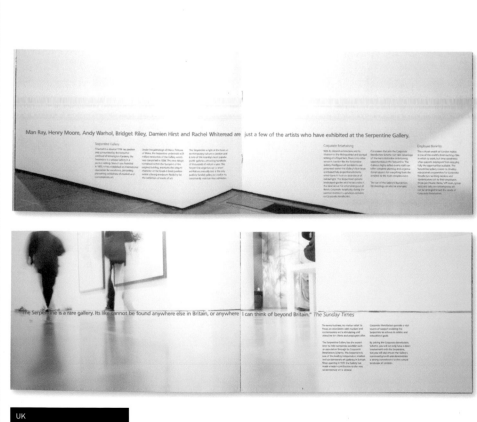

UK

168
CHIMERA DESIGN
FRUEAUF VILLAGE

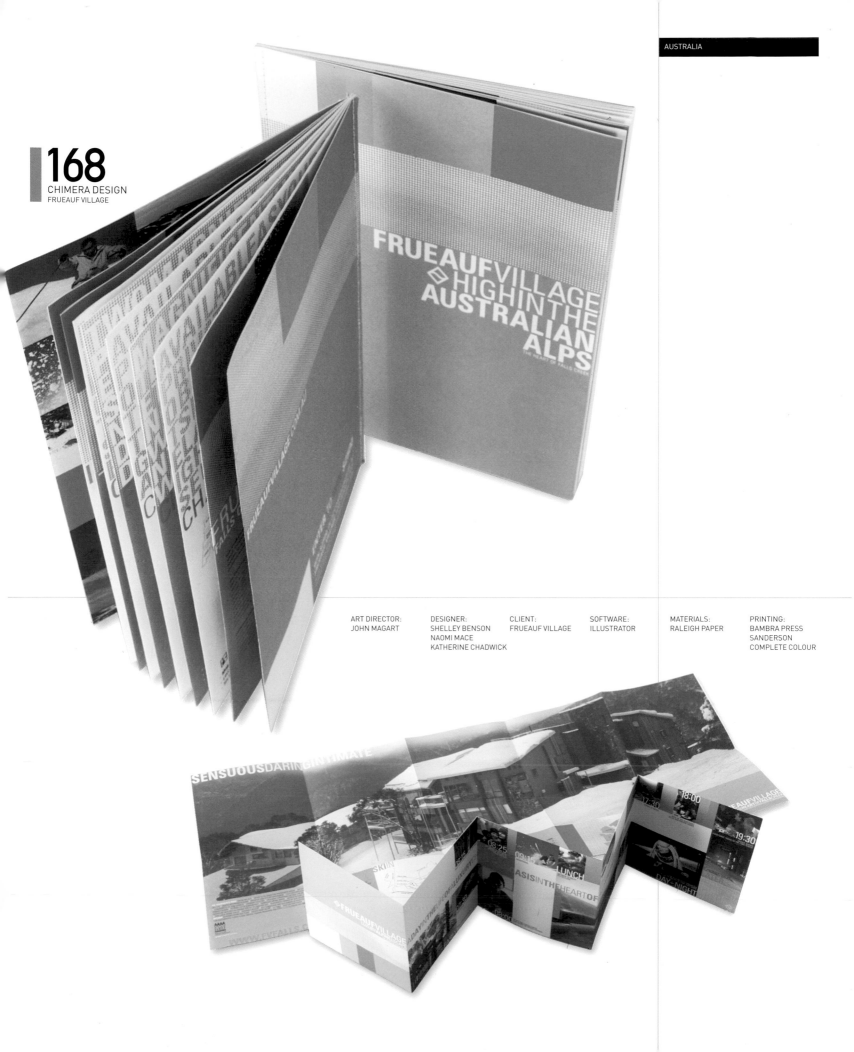

FRUEAUFVILLAGE
HIGHINTHE
AUSTRALIAN
ALPS
THE HEART OF FALLS CREEK

ART DIRECTOR:
JOHN MAGART

DESIGNER:
SHELLEY BENSON
NAOMI MACE
KATHERINE CHADWICK

CLIENT:
FRUEAUF VILLAGE

SOFTWARE:
ILLUSTRATOR

MATERIALS:
RALEIGH PAPER

PRINTING:
BAMBRA PRESS
SANDERSON
COMPLETE COLOUR

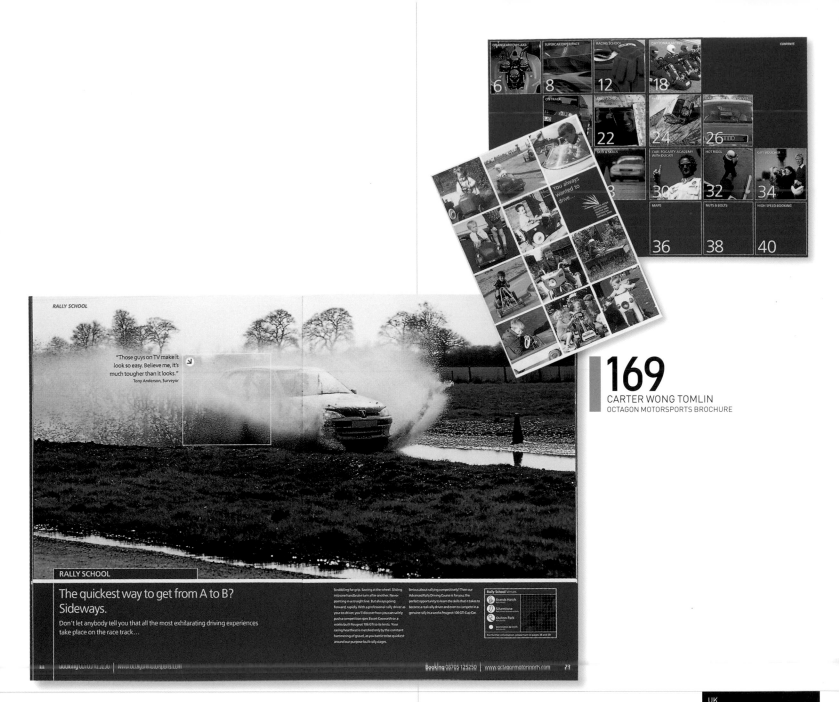

169
CARTER WONG TOMLIN
OCTAGON MOTORSPORTS BROCHURE

ART DIRECTOR:
PHIL CARTER

DESIGNER:
NEIL HEDGER

CLIENT:
OCTAGON
MOTORSPORTS

SOFTWARE AND
HARDWARE:
ILLUSTRATOR
MAC

MATERIALS:
MEGAMATT

PRINTING:
LITHO 4-COLOR +
2 SPECIALS

UK

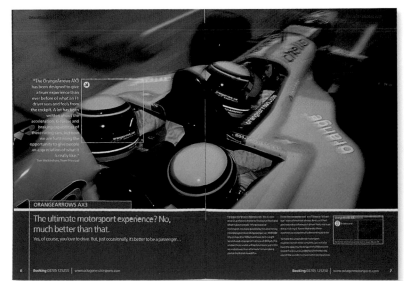

ART DIRECTOR:
DANIEL BASTIAN

DESIGNERS:
DANIEL BASTIAN
MAYA DA SILVA
JUTTA HOFFMANN

PHOTOGRAPHER:
TOM KLEINER

CLIENT:
DESIGN ZENTRUM
BREMEN

SOFTWARE:
PHOTOSHOP
QUARKXPRESS

MATERIALS:
ZANDERS MEGA
MATT 135 OFFSET

PRINTING:
FRANKE DRUCK

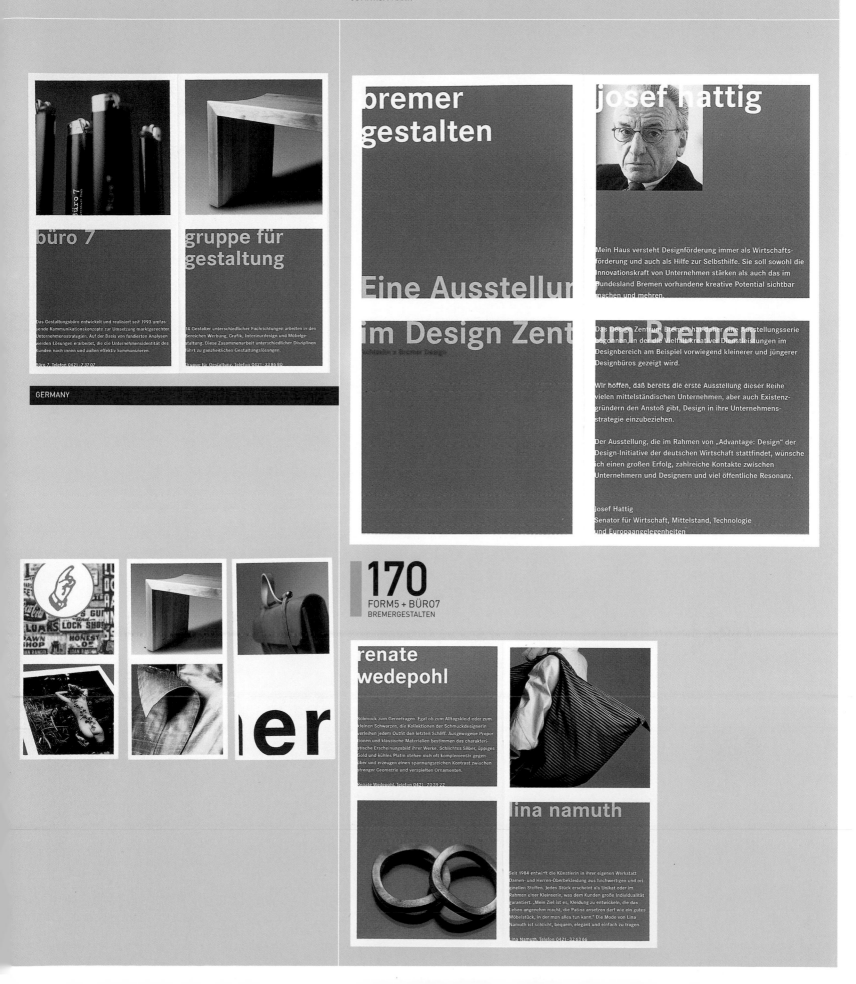

büro 7

gruppe für gestaltung

Das Gestaltungsbüro entwickelt und realisiert seit 1993 umfassende Kommunikationskonzepte zur Umsetzung marktgerechter Unternehmensstrategien. Auf der Basis von fundierten Analysen werden Lösungen erarbeitet, die die Unternehmensidentität des Kunden nach innen und außen effektiv kommunizieren.

Büro 7. Telefon 0421–7 37 07

14 Gestalter unterschiedlicher Fachrichtungen arbeiten in den Bereichen Werbung, Grafik, Interieurdesign und Möbelgestaltung. Diese Zusammenarbeit unterschiedlicher Disziplinen führt zu ganzheitlichen Gestaltungslösungen.

Gruppe für Gestaltung. Telefon 0421–33 86 80

GERMANY

bremer gestalten

josef hattig

Mein Haus versteht Designförderung immer als Wirtschaftsförderung und auch als Hilfe zur Selbsthilfe. Sie soll sowohl die Innovationskraft von Unternehmen stärken als auch das im Bundesland Bremen vorhandene kreative Potential sichtbar machen und mehren.

Eine Ausstellung im Design Zentrum Bremen

Das Design Zentrum Bremen hat daher eine Ausstellungsserie begonnen, in der die Vielfalt kreativer Dienstleistungen im Designbereich am Beispiel vorwiegend kleinerer und jüngerer Designbüros gezeigt wird.

Wir hoffen, daß bereits die erste Ausstellung dieser Reihe vielen mittelständischen Unternehmen, aber auch Existenzgründern den Anstoß gibt, Design in ihre Unternehmensstrategie einzubeziehen.

Der Ausstellung, die im Rahmen von „Advantage: Design" der Design-Initiative der deutschen Wirtschaft stattfindet, wünsche ich einen großen Erfolg, zahlreiche Kontakte zwischen Unternehmern und Designern und viel öffentliche Resonanz.

Josef Hattig
Senator für Wirtschaft, Mittelstand, Technologie und Europaangelegenheiten

170
FORM5 + BÜRO7
BREMERGESTALTEN

renate wedepohl

Schmuck zum Gernetragen. Egal ob zum Alltagskleid oder zum kleinen Schwarzen, die Kollektionen der Schmuckdesignerin verleihen jedem Outfit den letzten Schliff. Ausgewogene Proportionen und klassische Materialien bestimmen das charakteristische Erscheinungsbild ihrer Werke. Schlichtes Silber, üppiges Gold und kühles Platin stehen sich oft komplementär gegenüber und erzeugen einen spannungsreichen Kontrast zwischen strenger Geometrie und verspielten Ornamenten.

Renate Wedepohl. Telefon 0421–70 39 22

lina namuth

Seit 1984 entwirft die Künstlerin in ihrer eigenen Werkstatt Damen- und Herren-Oberbekleidung aus hochwertigen und originellen Stoffen. Jedes Stück erscheint als Unikat oder im Rahmen einer Kleinserie, was dem Kunden große Individualität garantiert. „Mein Ziel ist es, Kleidung zu entwickeln, die das Leben angenehm macht, die Patina ansetzen darf wie ein gutes Möbelstück, in dem man alles tun kann." Die Mode von Lina Namuth ist schlicht, bequem, elegant und einfach zu tragen.

Lina Namuth. Telefon 0421–32 63 66

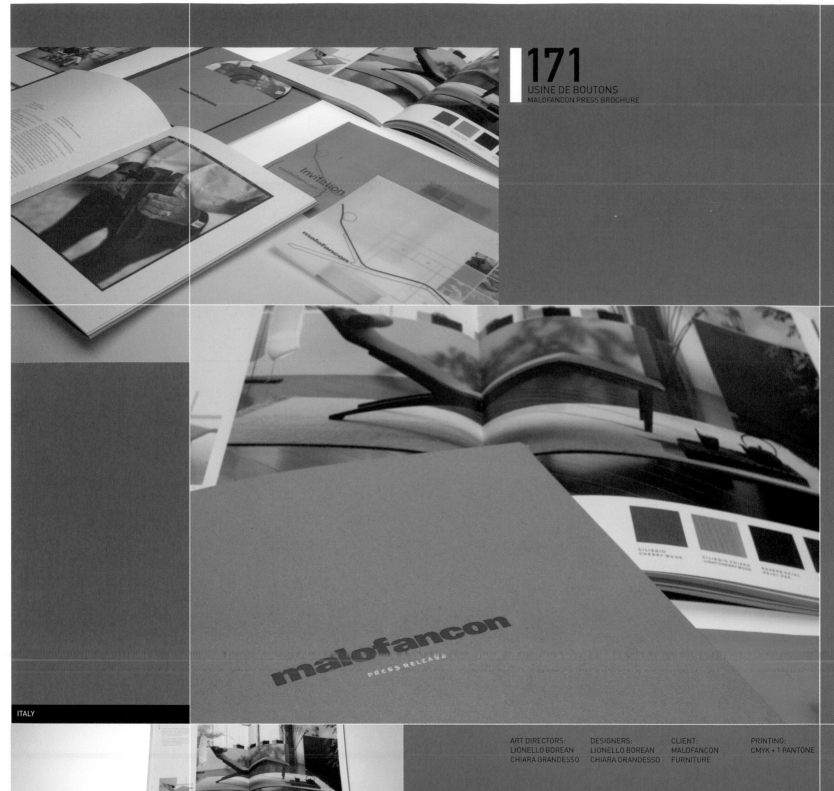

ITALY

ART DIRECTORS:	DESIGNERS:	CLIENT:	PRINTING:
LIONELLO BOREAN	LIONELLO BOREAN	MALOFANCON	CMYK + 1 PANTONE
CHIARA GRANDESSO	CHIARA GRANDESSO	FURNITURE	

5453

SOME TRAINS IN AMERICA

ART DIRECTOR:
VINCE FROST

DESIGNER:
VINCE FROST

PHOTOGRAPHER:
ANDREW CROSS

CLIENT:
CHRIST BOOT/
PRESTEL

MATERIALS:
EURO ART SILK
170GSM

PRINTING:
EBS. ITALY

0006: SOUTHERN CALIFORNIA 0030: TEXAS 0040: APPALACHIA 0062: NORTHEAST 0088: MIDWEST 0114: NORTHWEST 0140: CENTRAL CALIFORNIA

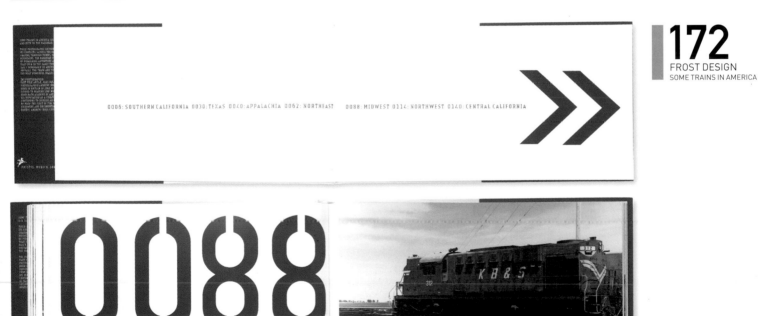

0088

SOME TRAINS IN AMERICA: MIDWEST IROQUOIS JCT IL 2001

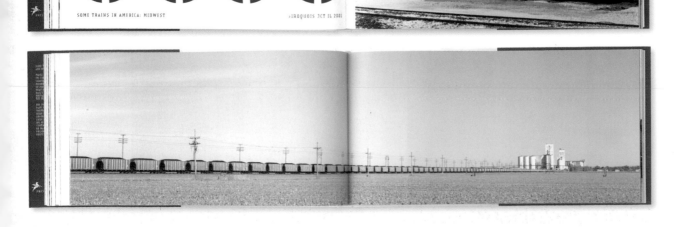

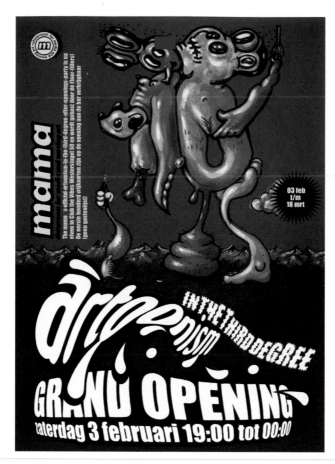

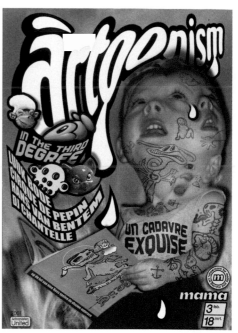

ART DIRECTOR:	DESIGNER:	ILLUSTRATOR:	CLIENT:	SOFTWARE:	MATERIALS:	PRINTING:
PING-PONG DESIGN	PING-PONG DESIGN	PING-PONG DESIGN	MAM SHOWROOM	ILLUSTRATOR	REVIVA OFFSET	OFFSET
		LUUK BODE	FOR MEDIA AND	PHOTOSHOP	POLAR SUPER	
		CIRQUE DE PEPIN	MOVING ART	QUARKXPRESS	GESATINEERD	
		HANS VAN BENTEM				
		DJ CHANTELLE				

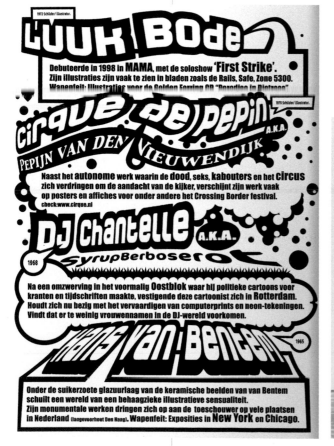

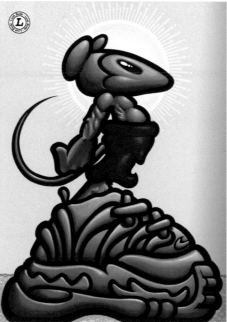

173

PING-PONG DESIGN
ARTOONISM

AUSTRALIA

ART DIRECTOR:
FABIO ONGARATO

DESIGNER:
JAMES LIN

CLIENT:
KAREN WALKER

MATERIALS:
SILK GLOSS

PRINTING:
ENERGI

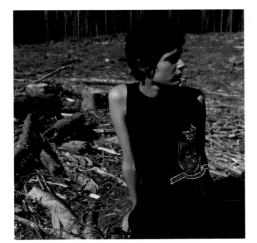

KAREN WALKER WOMAN STOCKISTS	SANTA MONICA	SYDNEY	WELLINGTON	NEW ZEALAND	ART DIRECTION AND DESIGN
	SHARON SEGAL	ORSON & BLAKE	KAREN WALKER	KAREN WALKER	FABIO ONGARATO
UK	420 BROADWAY	83-85 QUEEN ST	126 WAKEFIELD ST	MURRAY BEVAN	DESIGN
LONDON	SANTA MONICA	WOOLAHRA	CENTRAL WELLINGTON	PO BOX 6694	
GOLD KIOSK	PH: 1 310 576 6062	SYDNEY	PH: 64 4 499 3558	WELLESLEY ST	PHOTOGRAPHY
SANDERSON STORE		PH: 61 2 9326 1155		AUCKLAND 1036	DEREK HENDERSON
50 BERNERS ST	HONG KONG		CHRISTCHURCH	NEW ZEALAND	ASSISTANT
LONDON	LANE CRAWFORD	ORSON & BLAKE	PLUME	PH: 64 9 358 0964	TANIA VELLA
PH: 1 212 582 4437	70 QUEEN'S ROAD	489 RILEY ST	83 CASHEL ST	FAX: 64 9 358 0865	FILM PRODUCTION
	CENTRAL HONG KONG	SURRY HILLS	CHRISTCHURCH	EMAIL:	
GOLD KIOSK	PH: 85.2 2118 3388	SYDNEY	PH: 64 3 366 1663	murray@karenwalker.com	HANAH CO
ST MARTIN'S LANE STORE		PH: 61 2 8099 2525			62 MODELS
48 ST MARTIN'S LANE	LANE CRAWFORD		DUNEDIN	EDITORIAL	NICK AUST
LONDON	PACIFIC PLACE 03	NOBBY INGHAM	91 IMF		HOIPOLLOI
PH: 1 212 582 4437	QUEENSWAY	422-428 OXFORD ST	310 GEORGE ST	USA ASIA & EUROPE	
	HONG KONG	PADDINGTON	DUNEDIN	THE NEWS	WITH GENE
USA	PH: 85.2 2118 3388	SYDNEY	PH: 64 3 477 9354	TAHLIA MCLEOD	SUPPORT F
NEW YORK		PH: 61 2 9332 2124		495 BROADWAY	GPI PAPERS
HEDRA PRUE	SISTYR MOON		QUEENSTOWN	LEVEL 5	PRE PRESS
281 MOTT ST	SHOP 1U WINDSOR HOUSE	MYER GRACE BROS	ANGEL DIVINE	NEW YORK	COLOUR SG
NEW YORK	CAUSEWAY BAY	426 GEORGE ST	SHOP 12 THE MALL	NY 10012	PRINTING
PH: 1 212 343 9205	HONG KONG	SYDNEY	QUEENSTOWN	PH: 1 212 925 9700 EXT121	ENERGI PO
	PH: 852 2895 6336	PH: 61 3 9661 4495	PH: 64 3 442 8988	FAX: 1 212 925 1550	
TG-170				EMAIL:	
170 LUDLOW ST	SOUL SISTYR	BELINDA	INVERCARGILL	tmcleod@495news.com	
NEW YORK	GROUND FLOOR	MLC CENTRE: SHOP 703	LIZ THOMAS		
PH: 1 212 995 9660	24 WYNDHAM ST	CNR KING & MARKET STS	PROVINCIAL CHAMBERS	AUSTRALIA	
	CENTRAL HONG KONG	SYDNEY	32 KELVIN ST	SPIN COMMUNICATIONS	
NEW JERSEY	PH: 852 2525 0992	PH: 61 2 9233 0781	INVERCARGILL	ALISON HAINSWORTH	
ZOE			PH: 64 3 214 1139	99 STANLEY ST (CNR	
10 HULFISH ST	JAPAN	BELINDA		STANLEY & PALMER STS)	
PRINCETON	TOKYO	8 TRANSVAAL AVE	KAREN WALKER	DARLINGHURST	
PH: 1 609 497 0704	BARNEYS	DOUBLE BAY	MENSWEAR STOCKISTS	NSW 2010	
	3-19-5 SHINJUKU	SYDNEY		AUSTRALIA	
WELLSELEY	SHINJUKU KU	PH: 61 2 9328 6298	NEW ZEALAND	PH: 61 2 9361 4655	
GRETTA LUXE INC	TOKYO 160-0022		AUCKLAND	FAX: 61 2 9361 4547	
94 CENTRAL ST	PH: 81 3 3352 1200	FLINDER'S WAY	CRANE BROTHERS	EMAIL:	
WELLSELLEY MA		236 FLINDERS LANE	2-4 HIGH ST	a.hainsworth@spin.com.au	
PH: 1 781 237 7010	BARNEYS	MELBOURNE	DEBRETTS HOTEL		
	36-1YAMASHITA-CHO	PH: 61 3 9654 3331	CENTRAL AUCKLAND	NEW ZEALAND	
BURLINGHAME	NAKA-KU		PH: 64 9 377 5333	KAREN WALKER	
SUSAN OF BURLINGHAME	YOKOHAMA CITY	PERTH		MURRAY BEVAN	
1403 BURLINGHAME AVE	KANAGAWA 231-0023	PERISCOPE	WELLINGTON	PO BOX 6694	
BURLINGHAME	PH: 81 45 671 1200	68 KING ST	AREA 51	WELLESLEY ST	
PH: 1 650 347 0452		PERTH	CORNER CUBA MALL	AUCKLAND 1036	
	BEAMS	PH: 61 8 9321 9896	& LUKON STREETS	NEW ZEALAND	
LOS ANGELES	1-15-1 JINNAN		CENTRAL WELLINGTON	PH: 64 9 358 0964	
STACEY TODD	SHIBUYA-KU	CARLTON	PH: 64 4 385 6590	FAX: 64 9 358 0865	
13025 VENTURA BLVD	TOKYO 150-0041	RPM		EMAIL:	
STUDIO CITY	PH: 81 3 3780 5501	SHOP 350	AUSTRALIA	murray@karenwalker.com	
LOS ANGELES		LYGON ST	SYDNEY		
PH: 1 310 308 8964	DIPTRICS	CARLTON	ORSON & BLAKE	PRESS	
	7-10-10-502	VICTORIA	489 RILEY ST		
NOODLE STORIES	MINAMIAOYAMA	PH: 61 3 9347 4245	SURRY HILLS	USA ASIA & EUROPE	
8323 WEST 3RD ST	MINATO-KU		SYDNEY	THE NEWS	
LOS ANGELES	TOKYO	SORRENTO	PH: 61 2 8099 2525	TAHLIA MCLEOD	
PH: 1 323 651 1782	PH: 81 3 3409 0089	DEB'S BOUTIQUE		495 BROADWAY	
		24 OCEAN BEACH RD	TRADE ENQUIRIES	LEVEL 5	
MIAMI	AUSTRALIA	SORRENTO	WHOLESALE	NEW YORK	
MERCURY GIRL	MELBOURNE	PH: 61 3 5984 1617		NY 10012	
920 LINCOLN RD	DERNIER CRI		USA ASIA & EUROPE	PH: 1 212 925 9700 EXT121	
MIAMI	7 LEAKE ST	NEW ZEALAND	THE NEWS	FAX: 1 212 925 1550	
PH: 1 305 534 0211	ESSENDON	AUCKLAND	KYOKO KAGEYAMA	EMAIL:	
	MELBOURNE	KAREN WALKER	495 BROADWAY	tmcleod@495news.com	
GOLD KIOSK	PH: 61 3 9379 5122	6 BALM ST	LEVEL 5		
DELANO STORE		NEWMARKET	NEW YORK	AUSTRALIA / NEW ZEALAND	
1685 COLLINS AVE	MAGGIE POTTER	AUCKLAND	NY 10012	KAREN WALKER	
MIAMI BEACH	258 TOORAK RD	PH: 64 9 522 4286	PH: 1 212 925 9700 EXT 104	MURRAY BEVAN	
PH: 1 212 582 4437	STH YARRA		FAX: 1 212 925 1550	PO BOX 6694	
	MELBOURNE	RUBER BRULILTI	EMAIL:	WELLESLEY ST	
SEATTLE	PH: 61 3 9827 5488	15 O'CONNELL ST	k.kageyama@495news.com	AUCKLAND 1036	
FAST FORWARD		CENTRAL AUCKLAND		NEW ZEALAND	
1918 FIRST AVENUE	SHREW	PH: 64 9 309 6799	AUSTRALIA	PH: 64 9 358 0964	
SEATTLE	189C BARKLY ST		PAUL MALONEY FASHION	FAX: 64 9 358 0865	
PH: 1 206 728 8050	ST KILDA		AGENCY	murray@karenwalker.com	
	MELBOURNE		PAUL MALONEY		
SAN FRANCISCO	PH: 61 3 9534 7337		PO BOX 3148		
TAXI			TAMARAMA	KAREN WALKER	
1615 HAIGHT ST	ESSENCIA		SYDNEY 2026	MENSWEAR	
SAN FRANCISCO	510 MALVERN RD		AUSTRALIA	ALL ENQUIRIES	
PH: 1 415 431 9614	PRAHAN EAST		PH: 61 2 9130 3403	MURRAY BEVAN	
	MELBOURNE		FAX: 61 2 9300 8979	PH: 64 9 358 0964	
	PH: 61 3 9510 8220		EMAIL:		

174
FABIO ONGARATO DESIGN
KAREN WALKER WINTER 2001

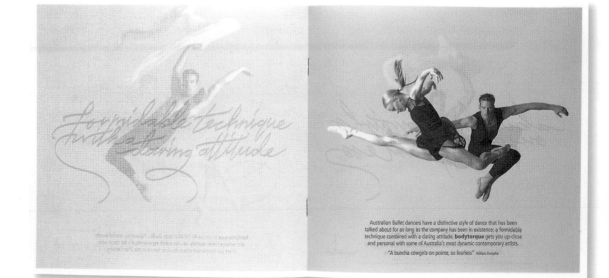

175
HATCH CREATIVE
BODYTORQUE

ART DIRECTOR:
SASKIA ERICSON

DESIGNER:
SASKIA ERICSON

PHOTOGRAPHER:
LOIS GREENFIELD

CLIENT:
THE AUSTRALIAN
BALLET

SOFTWARE:
ILLUSTRATOR
PHOTOSHOP
STREAMLINE

MATERIALS:
GILCLEAR OXFORD
GILBERT PAPER

PRINTING:
4-COLOUR PROCESS
BAMBRA PRESS

Australian Ballet dancers have a distinctive style of dance that has been talked about for as long as the company has been in existence: a formidable technique combined with a daring attitude. **bodytorque** gets you up-close and personal with some of Australia's most dynamic contemporary artists.

"A buncha cowgirls on pointe, so fearless" William Forsythe

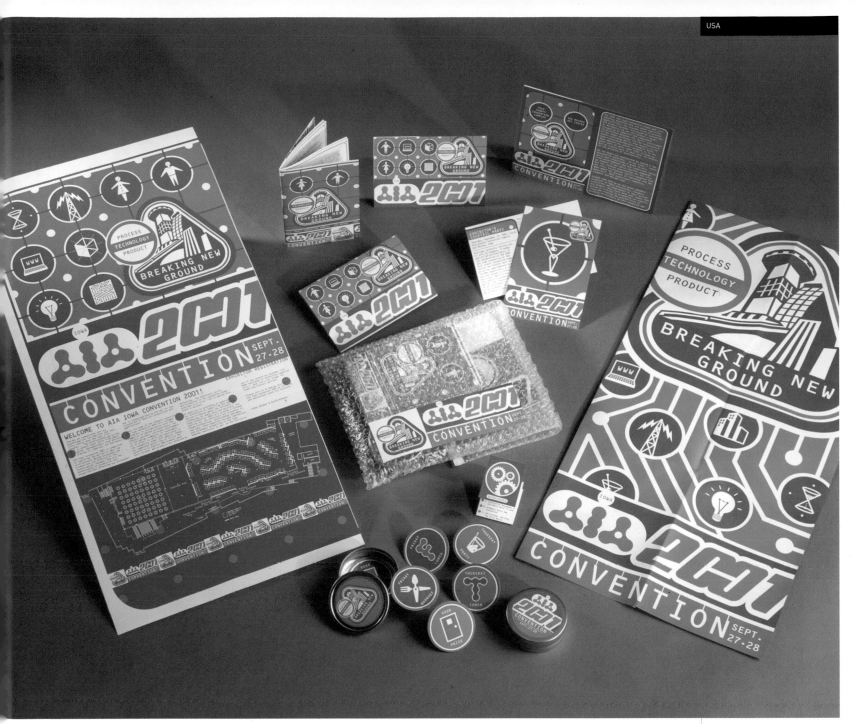

ART DIRECTOR:
JOHN SAYLES

DESIGNERS:
JOHN SAYLES
SOM INTHALANGSY

ILLUSTRATOR:
JOHN SAYLES

CLIENT:
AMERICAN
INSTITUTE OF
ARCHITECTS,
IOWA

SOFTWARE AND
HARDWARE:
ILLUSTRATOR
QUARKXPRESS
MAC

MATERIALS:
MOHAWK NAVAJO
WHITE, VARIOUS

PRINTING:
OFFSET

176
SAYLES GRAPHIC DESIGN
BREAKING NEW GROUND
CONFERENCE 2001

AGENCY DIRECTORY

090 AJANS ULTRA
ASLAN YATAGIS. FEZA AP. 33/1/12
80060 CIHANGIR
ISTANBUL 80060
TURKEY
T: 0212 243 0854
NAZLIONGAN@YAHOO.COM

046
050 ALLEMANN ALMQUIST
& JONES
301 CHERRY STREET
THIRD FLOOR
PHILADELPHIA, PA 19106
UNITED STATES
T: 215-829-9442
JAN@AAJDESIGN.COM

013
068 ATTIK
100 3RD FLOOR
1 HEDDON STREET
LONDON W1B 4BD
UNITED KINGDOM
T: 020 7439 9918
JULIEM@ATTIK.COM

146 BISQIT DESIGN
5 THEOBALDS ROAD
LONDON WC1X 8SH
UNITED KINGDOM
T: 020 7413 3028
DAPHNE@BISQIT.CO.UK

084
092 BLOK DESIGN
822 RICHMOND STREET WEST
SUITE 301
TORONTO, ON M6J 1C9
CANADA
T: 416-203-0187
BLOKDESIGN@EARTHLINK.NET

152 BLUE RIVER DESIGN
THE FOUNDRY
FORTH BANKS OFFICES
FORTH BANKS
NEWCASTLE UPON TYNE NE1 3PA
UNITED KINGDOM
T: 0191 261 0000
INFO@BLUERIVER.CO.UK

021
123 BOSTOCK & POLLITT
83-84 LONG ACRE
LONDON WC2E 9NQ
UNITED KINGDOM
T: 020 7379 6709

170 BÜRO 7
HUMBOLDSTRASSE 64
BREMEN 28203
GERMANY
T: 49 421 73706
INFO@BURO7.DE

032
039 CAHAN & ASSOCIATES
044 171 SECOND STREET
048 5TH FLOOR
063 SAN FRANCISCO, CA 94105
UNITED STATES
T: 415-621-0915
SHANNONHW@CAHANASSOCI
ATES.COM

019 CAMPAÑEROS
053 SCHULTERBLATT 36
056 HAMBURG 20357
096 GERMANY
098 T: 49 407809380
099 MDECKELMANN@CAMPANEROS.DE

169 CARTER WONG TOMLIN
29 BROOK MEWS NORTH
LONDON W2 3BW
UNITED KINGDOM
T: 020 7569 0000
V.SHRIMPTON@CARTERWONGTOM-
LIN.COM

114
117 CHEN DESIGN
126 ASSOCIATES
589 HOWARD STREET
FOURTH FLOOR
SAN FRANCISCO, CA 94105
UNITED STATES
T: 415-896-5338
INFO@CHENDESIGN.COM

105
115 CHENG DESIGN
UNIVERSITY OF WASHINGTON
BOX 353440
ART BUILDING ROOM 102
SEATTLE, WA 98195
UNITED STATES
T: 206-685-2773
KCHENG@U.WASHINGTON.EDU

055
168 CHIMERA DESIGN
OFFICE 2
102 CHAPEL STREET
ST KILDA, VICTORIA 3182
AUSTRALIA
T: 613 9503 6966
NAOMI@CHIMERA.COM.AU

104 CLARK CREATIVE
GROUP
251 RHODE ISLAND STREET #204
SAN FRANCISCO, CA 94103
UNITED STATES
T: 415-487-9500
ADMIN@CLARKCREATIVE.COM

073 C375
TARIK ZAFER TUNAYA SOKAK 3/6
GUMUSSUYU
ISTANBUL 80040
TURKEY
T: 90 212 249 77 09
CERUTKU@C375.COM

016
095 DESIGN ASYLUM
46B CLUB STREET
SINGAPORE 069423
SINGAPORE
T: 65 6324 7827
CHRIS@LUNATICSATWORK.COM

071 DESIGN5
7636 NORTH INGRAM 102
FRESNO, CA 93711
UNITED STATES
T: 559-432-5110
STEPH@DESIGNFIVE.COM

132 ELFEN
TY MEANDROS
54A BUTE STREET
CARDIFF BAY CF10 5A5
UNITED KINGDOM
T: 02920 484824
GWION@ELFEN.CO.UK

072 EMERSON,
WAJDOWICZ
STUDIOS
1123 BROADWAY
SUITE 1106
NEW YORK, NY 10010
UNITED STATES
T: 212-807-8144
INFODESIGN.EWS@AOL.COM

007
036 EMERY VINCENT
042 DESIGN
097 LEVEL 1
108 15 FOSTER STREET
SURRY HILLS
SYDNEY NSW 2010
AUSTRALIA
T: 612 9280 4233
SHANNON.GRANT@EMERYVIN-
CENTDESIGN.COM

110 ENERGY ENERGY
DESIGN
246 BLOSSOM HILL ROAD
LOS GATOS, CA 95032
UNITED STATES
T: 408-395-5911
LESLIEG@NRGDESIGN.COM

034 EVOLVE
STUDIO 8
42 ORCHARD ROAD
HIGHGATE
LONDON N6 5TR
UNITED KINGDOM
T: 020 8340 9541
JH@EVOLVE-DESIGN.CO.UK

018
022 FABIO ONGARATO
026 DESIGN
088 FIRST FLOOR
162 569 CHURCH STREET
165 RICHMOND, VICTORIA 3121
166 AUSTRALIA
174 T: 613 9421 2344
RYAN@ONGARATO.CO.AU

033
076 FAUXPAS
093 HARDTURMSTRASSE. 261
149 ZURICH CH 8005
SWITZERLAND
T: 00411563 8638
CONTACT@FAUXPAS.CH

010 FORM
120 47 TABERNACLE STREET
131 LONDON EC2A 4AA
UNITED KINGDOM
T: 020 7014 1430
PAULA@FORM.UK.COM

135 FORMAT DESIGN
GROSSE BRUNNENSTRASSE 63
HAMBURG 22763
GERMANY
T: 49 40 32086970
ETTLING@FORMAT-HH.COM

170 FORM5 BREMEN
GRAF MOLTKE STRASSE 7
BREMEN 28203
GERMANY
T: 49 421 703074
BASTIAN@FORM5.DE

054 FOSTER DESIGN
GROUP
3 ELIOT STREET
SOUTH NATICK, MA 01760
UNITED STATES
T: 508-647-5678
WEB FOSTERDESIGN.COM

052 FROST DESIGN
061 THE GYMNASIUM
087 KINGS WAY PLACE
128 SANS WALK
144 LONDON EC1R 0LU
167 UNITED KINGDOM
172 T: 020 7490 7994
INFO@FROSTDESIGN.CO.UK

015
134 GRAPHICULTURE
322 1ST AVENUE NORTH
SUITE 500
MINNEAPOLIS, MN 55401
UNITED STATES
T: 612-339-8271
JANICE@GRAPHICULTURE.COM

091
155 HAMBLY & WOOLLEY
130 SPADINA AVENUE
SUITE 807
TORONTO, ON M5V 2L4
CANADA
T: 416-504-2742
BOBH@HAMBLYWOOLLEY.COM

005
011 HAND MADE GROUP
069 VIA SARTORI 16
142 STIA, AR 52017
ITALY
T: 39 0575 582083
INFO@HMG.IT

175 HATCH CREATIVE
SUITE 1
147 CHAPEL STREET
ST KILDA
MELBOURNE, VICTORIA 3182
AUSTRALIA
T: 61 3 9531 8530
SAS.E@HATCHCREATIVE.COM.AU

031
064 HAT-TRICK DESIGN
153 STUDIO 11
CLINK STREET STUDIOS
1 CLINK STREET
LONDON SE1
UNITED KINGDOM
T: 020 7403 7875
DAVID@HAT-TRICKDESIGN.CO.UK

066 HEBE. WERBUNG &
DESIGN
MAGSTADTERSTRASSE 12
LEONBERG 71229
GERMANY
T: 49 7152 309-20
W+D@HEBE.DE

014
047 HORNALL ANDERSON
DESIGN WORKS
1008 WESTERN AVENUE
SEATTLE, WA 98104
UNITED STATES
T: 206-467-5800
F: 206-467-6411
C_ARBINI@HADW.COM

001 INTERBRAND
RADAR STUDIO
COLDBLOWLANE
THURNHAM
MAIDSTONE
KENT ME14 3LR
UNITED KINGDOM
T: 016 2273 7722
ZOE@UNTITLED.CO.UK

094 IRIDIUM,
109 A DESIGN AGENCY
112 43 ECCLES STREET
129 2ND FLOOR
OTTAWA, ON K1R 653
CANADA
T: 613-748-3336
F: 613-748-3372
IDEAS@IRIDIUM192.COM

130 IRON DESIGN
120 NORTH AURORA STREET
SUITE 5A
ITHACA, NY 14850
UNITED STATES
T: 607-275-9544
F: 607-275-0370
TODD@IRONDESIGN.COM

049 KINETIC SINGAPORE
2 LENG KEE ROAD THYE
HONG CENTRE
#04-03A SINGAPORE 159086
SINGAPORE
T: 65 6379 5320
F: 65 6472 6440
ROY@KINETIC.COM.SG

004 KO CRÉATION
057 6300 PARK AVENUE
058 SUITE 420
139 MONTREAL, QC H2V 4H8
157 CANADA
160 T: 514-278-9550
F: 514-278-7253
DULUDE@KOCREATION.COM

138
158
KOLÉGRAMDESIGN
37, BOULEVARD ST-JOSEPH
HULL, QC J8Y 3V8
CANADA
T: 819-777-5538
F: 819-777-8525
MIKE@KOLEGRAM.COM

008
024
025
LAVA GRAPHIC DESIGNERS
VAN DIEMENSTRAAT 366
1013CR AMSTERDAM
THE NETHERLANDS
T: 3120622640
FIEKE@LAVA.NL

137
LEAD DOG DIGITAL
245 E 25TH STREET 3J
NEW YORK, NY 10010
UNITED STATES
T: 212-779-5950
NLAM@BRIDGE-LINE.COM

141
LOEWY GROUP
CROWN REACH
147A GROSVENOR ROAD
LONDON SW1V 354
UNITED KINGDOM
T: 020 7798 2000
VTRAINER@LOEWYGROUP.COM

060
124
MADE THOUGHT
SECOND FLOOR
181 CANNON STREET ROAD
LONDON E1 2LX
UNITED KINGDOM
T: 020 7488 4005
BEN@MADETHOUGHT.COM

145
MARCO MOROSINI
VIA BONCIO, U9
61100 PESARO
PESARO, PG 61100
ITALY
T: 328 4781280
TO@MARCOMOROSINI.COM

082
085
118
MARIUS FAHRNER DESIGN
SUTTNERSTRASSE 8
HAMBURG 22767
GERMANY
T: 4904043271239
MARIUS@FORMGEFUEHL.DE

045
051
METAL
1210 WEST CLAY SUITE 17
HOUSTON, TX 77019
UNITED STATES
T: 713-523-5177
PJ@METALSTUDIO.COM

062
MORLA DESIGN
463 BRYANT STREET
SAN FRANCISCO, CA 94130
UNITED STATES
T: 415-543-6548
INFO@MORLADESIGN.COM

035
037
089
MUTABOR DESIGN
BARNERSTRASSE 63/HOF
HAMBURG 22765
GERMANY
T: 49 40 399 224 0
INFO@MUTABOR.DE

113
NBBJ GRAPHIC DESIGN
111 SOUTH JACKSON STREET
SEATTLE, WA 98104
UNITED STATES
T: 206-223-5088
KCOLLER@NBBJ.COM

017
081
163
NB:STUDIO
24 STORE STREET
LONDON WC1E 7BE
UNITED KINGDOM
T: 020 7580 9195
WWW.NBSTUDIO.CO.UK

159
NET INTEGRATORS
POSTBOX 59016
AMSTERDAM 1040 KA
THE NETHERLANDS
T: 31 20 5305530
JASONC@CCNI.NI

156
NEW MOMENT, NEW IDEAS COMPANY
BEZIGRAD 10
LJUBLJANA 1000
SLOVENIA
T: 38614369734
WWW.NEWMOMENT.COM
INFO@SD-NEWMOMENT.SI

101
ORIGIN
CHETHAM HOUSE
BIRD HALL LANE
CHEADLE HEATH
CHESHIRE SK3 02P
UNITED KINGDOM
T: 01614 954562
MARK-ORIGIN@APSGROUP.CO.UK

065
OUT OF THE BLUE
62 STATION ROAD
LONG MARSTON
TRING
HERTFORDSHIRE HP23 4QS
UNITED KINGDOM
T: 01296 662596
NICK@OUTOFTHEBLUEDESIGN.CO.UK

074
PENTAGRAM SF
387 TEHAMA STREET
SAN FRANCISCO, CA 94103
UNITED STATES
T: 415-896-0499
ANDERSON@SF.PENTAGRAM.COM

173
PING-PONG DESIGN
ROCHUSSENSTRAAT 400
3015 ZC ROTTERDAM
HOLLAND

002
PINKHAUS
2424 SOUTH DIXIE HIGHWAY
MIAMI, FL 33133
UNITED STATES
T: 305-854-1000
ANDREW.SMITH@PINKHAUS.COM

009
103
116
150
POULIN + MORRIS
286 SPRING STREET
6TH FLOOR
NEW YORK, NY 10013
UNITED STATES
T: 212-675-1332
RICHARD@POULINMORRIS.COM

078
Q
SONNENBERGERSTRASSE 16
WIESBADEN 65193
GERMANY
T: 49 611 181310
TVD@G-HOME.DE

003
RADFORD WALLIS
THE OLD TRUMAN BREWERY
91 BRICK LANE
LONDON E1 6QN
UNITED KINGDOM
T: 020 7377 5258
SR@RADFORDWALLIS.COM

027
102
RADLEY YELDAR
326 CITY ROAD
LONDON ECN 2SP
UNITED KINGDOM
T: 020 7713 0038
R.RICHE@RY.COM

147
151
REBECCA FOSTER DESIGN
UNIT 7.1.1
THE LEATHER MARKET
WESTON STREET
LONDON SE1 3ER
UNITED KINGDOM
T: 020 7407 1010
DESIGN@REBECCAFOSTER.CO.UK

012
023
083
ROSE DESIGN ASSOCIATES
STUDIO 229
GREAT GUILDFORD BUSINESS SQ
30 GREAT GUILDFORD STREET
LONDON SE1 0HS
UNITED KINGDOM
T: 020 7620 3300
REBECCA@ROSEDESIGN.CO.UK

164
SAGMEISTER INC
222 WEST 14 STREET
NEW YORK, NY 10011
UNITED STATES
T: 212-647-1789
SSAGMEISTER@AOL.COM

006
029
030
SALTERBAXTER
8 TELFORD ROAD
LONDON W10 5SH
UNITED KINGDOM
T: 020 7401 9401
ADELGADO@SALTERBAXTER.COM

041
043
127
148
154
SAS
6 SALEM ROAD
LONDON W2 4BU
UNITED KINGDOM
T: 020 7243 3232
GWENDT@SASDESIGN.CO.UK

176
SAYLES GRAPHIC DESIGN
3701 BEAVER AVENUE
DES MOINES, IA 50310
UNITED STATES
T: 515-279-2922
SAYLES@SAYLESDESIGN.COM

077
080
SEA DESIGN
70 ST JOHN STREET
LONDON EC1M 4QT
UNITED KINGDOM
T: 020 7566 3100
BRUAN@SEADESIGN.CO.UK

028
SQUIRES & COMPANY
2913 CANTON STREET
DALLAS, TX 75226
UNITED STATES
T: 214-939-9194
MURPHY@SQUIRESCOMPANY.COM

161
STEERS MCGILLAN
6–8 COTTERELL COURT
MONMOUTH PLACE
BATH BA1 ZNP
UNITED KINGDOM
T: 01225 465546

125
STILRADAR
PFAFFENWEG 55
70180 STUTTGART
GERMANY
T: 00497118875520
INFO@STILRADAR.DE

067
070
075
THE KITCHEN
52–53 MARGARET STREET
LONDON W1W 8SQ
UNITED KINGDOM
T: 020 7291 0880
PHIL@THEKITCHEN.CO.UK

020
122
143
THIRTEEN DESIGN
9–10 KING STREET
BRISTOL BS1 4EQ
UNITED KINGDOM
T: 0117 908 1313
MAIL@THIRTEEN.CO.UK

038
111
119
2D3D
MAURITSKADE 1
DEN HAAG 2514 HC
THE NETHERLANDS
T: 31 070 362 4141
INFO@2D3D.NL

086
107
UNA (LONDON) DESIGNERS
5.5 ALASKA BUILDINGS
61 GRANGE ROAD
LONDON SE1 3BA
UNITED KINGDOM
T: 020 7394 8838
AXELFELDMANN@UNADESIGNERS.CO.UK

059
121
140
171
USINE DE BOUTONS
VIA GUIDO FRANCO 99/B
CADONEGHE
PADOVA 35010
ITALY
T: 39 049 8870953
LIONELLO@USINE.IT

040
VINJE DESIGN
1043 CONTRA COSTA DRIVE
EL CERRITO, CA 94530
UNITED STATES
T: 510-528-3578
F: 510-528-3576
AKELLER@VINJEDESIGN.COM

106
WILLIAM HOMAN DESIGN
1316 WEST 73RD STREET
MINNEAPOLIS, MN 55423
UNITED STATES
T: 612-702-9105
WHOMAN@MN.RR.COM

079
136
WILLOUGHBY DESIGN GROUP
602 WESTPORT ROAD
KANSAS CITY, MO 64111
UNITED STATES
T: 816-561-4189
TKENAGY@WILLOUGHBYDESIGN.COM

WILSON HARVEY
SIR JOHN LYON HOUSE
HIGH TIMBER STREET
LONDON EC4V 3NX
T: 020 7420 7700
PAULB@WILSONHARVEY.CO.UK